RUDE BRITANNIA

Tim Batchelor
Cedar Lewisohn
Martin Myrone

With essay contributions by
Paul Gravett
Sally O'Reilly

RUDE BRITANNIA

British Comic Art

Tate Publishing

First published 2010 by order of the
Tate Trustees by Tate Publishing,
a division of Tate Enterprises Ltd,
Millbank, London SW1P 4RG
www.tate.org.uk/publishing

on the occasion of the exhibition

RUDE BRITANNIA: British Comic Art
Tate Britain, London
9 June – 5 September 2010

British Library Cataloguing in Publication Data
A catalogue record for this book is available from
the British Library

ISBN 978-1-85437-886-6

Distributed in the United States and Canada by
Harry N. Abrams, Inc., New York

Library of Congress Cataloging in Publication Data
Library of Congress Control Number: 2009943196

Designed by Fraser Muggeridge studio
Cover design by Why Not Associates
Colour reproduction by DL Interactive Ltd, London
Printed in Spain by Grafos

Measurements of artworks are given in centimetres,
height before width, and refer to image size.

Front cover (left to right): Thomas Rowlandson,
*A French Dentist Shewing a Specimen of his Artificial
Teeth and False Palates* 1811 (see cat. 41); Donald
McGill, *A Stick of Rock, Cock?* (see cat. 76); Angus
Fairhurst, *The Problem with Banana Skins Divided /
Inverted* 1998 (see cat. 99).

Back cover (left to right): David Shrigley, *I'm Dead*
2007 (see cat. 90); Anonymous, *Idol-Worship or
The Way to Preferment* 1740 (see cat. 4).

Foreword

Understanding humour is never easy, and understanding it in a historical sense is especially difficult. This exhibition, which has been conceived by Martin Myrone with Tim Batchelor and Cedar Lewisohn, hopes to tease out some of those complexities, but adopts a light touch in its approach. The collaborative nature of the project has been extended by means of inviting contemporary satirists and comedians to respond to individual sections, interpreting them as they thought most appropriate. We are grateful to *Viz*, to Gerald Scarfe, Steve Bell and Harry Hill for their thoughtful engagement with the exhibits. As a whole the exhibition provides a portfolio within which we can consider different aspects of comic art, and in different ways. The overall effect is pluralistic, and its parameters porous.

The exhibition's foundations lie squarely in the eighteenth century, and in many ways it is the association of British art with the comic in the persons of Hogarth, Gillray and Rowlandson, that provokes the question at the heart of the exhibition. What is it about British culture that has produced artists of the calibre of Hogarth, working within a context that draws as much upon low life as high art, and yet transcends those potentially limiting origins to create works of enduring satisfaction? That an artist like Hogarth could make work that was both topical and timeless, satirical and beautiful, poses questions as relevant today as they ever were.

Moving away from its basis in the Georgian and Victorian periods, the curators have also interjected works by contemporary British artists at intervals throughout the show. In this way they ask us to reflect on the relationship between comedy and art today, on how an object or an image makes us smile (or even laugh), and on how this affects its artistic values. We are very grateful to these artists for entrusting Tate with their work within an environment that might be seen as uncharacteristically risky.

Over and above complex questions about the nature of the comedic, the exhibition also returns us in a new way to some conventional topics, looking as it does at the nature of representation, of likeness, of sexuality and identity. The close association between a British attitude to sex and art is brought into play, and it is an irony, perhaps, that the curatorial team has been exclusively male. Their take on the 'bawdy' includes female artists, but is couched within a more generally masculine space. The selection also points to the ways in which comedy can be used as a means to an end, to tell a truth or to bend the truth, and as a means of propaganda. The figuring of iconic British enemies – Napoleon and Hitler – is a case in point.

This exhibition includes a diverse range of material, from different periods, and different kinds of collections. In ranging from the small to the large, the mass-produced to the unique, from the popular to the rarefied, the selection comprehends the scope of visual culture. In embracing this range of media (whether in print, paint or ceramic), and its multifarious functions, the exhibition resists the temptation to define the 'comic'. Demonstrating instead its affinities to all that is rude (whether socially, politically or sexually), as well as simply silly, we are challenged by an exhibition which takes risks in seeking out the comic within British art.

Penelope Curtis
Director, Tate Britain

Curators' Acknowledgements

In the course of preparing an exhibition as wide-ranging in its content as the present project, the curatorial team have, naturally, accumulated many debts of gratitude. Firstly, we would like to thank all of the artists involved in the exhibition, and their galleries, for their tremendous support. Similarly, we are grateful to all the lenders of works to the exhibition, institutional and individual. Among these, the Department of Prints and Drawings at The British Museum and Andrew Edmunds have been especially generous. Gerald Scarfe, Steve Bell, Harry Hill and the team from *Viz* have all had significant input on the formation of the show. Early conversations with Paul Gravett have proved to have had a long-lasting significance. Paul has also produced an essay for this catalogue, along with Sally O'Reilly. We would like to thank them both for their illuminating contributions. We have benefited from the advice and suggestions, and practical input, of very many people, including Stella Beddoe, Tim Benson, David Bindman, James Bissell-Thomas, Mark Bryant, Michael Burden, Stephen Calloway, Lucy Chadwick, Henry Channon, Sadie Coles, Steven Connor, Fionnuala Croke, Pauline Daley, Julie Davies, Maggie Davies, Xanthe Edmunds, Christopher Frayling, Andrea Fredericksen, Vic Gatrell, Nickos Gogolos, Beth Greenacre, Nick Hackworth, Yvonne Hardman, Malcolm Hay, Nicholas Hiley, Vincent Honoré, Laura Houliston, Roger Law, Andrew Loukes, Andrew MacLachlan, Bill McLoughlin, David McNeff, Erin Manns, Francis Marshall, Paul Maslin, Hannah Matthews, Jane Newton, Anita O'Brien, Sheila O'Connell, Barbara O'Connor, Kate Owens, Nina Pearlman, David Peckman, Lucy Peltz, Janice Reading, Jane Rick, Martin Rowson, Roger Sabin, Michael St John-McAlister, Jonathan Saville, Glenn Scott-Wright, David Scrase, Florian Simm, Margaret Stone, Christopher Taylor, Jaimie Thomas, Stuart Tulloch, James Ulph, Nicky Verber, Robin Vousden, Ella Whitmarsh, Phil Wickham, Jess Wilder, Jenny Wood and Liz Woods.

The exhibition design has been developed by Nicola Antaki, Richard Cottrell and Brian Vermeulen from Cottrell & Vermeulen Architecture, with graphic design by Ben Chatfield and Mark Hopkins of BCMH. At Tate Britain, the former Director, Stephen Deuchar, set the original agenda for this exhibition, while Judith Nesbitt and Carolyn Kerr steered the project to its final form. Alice Chasey has been wonderful as our editor at Tate Publishing, working with Tim Holton and Deborah Metherell on production, and with Fraser Muggeridge and Sarah Newitt on design. Kiko Noda was our registrar, while Andy Shiel, Juleigh Gordon-Orr, Geoff Hoskins, Kwai Lau and their team worked on the installation of the show. We are also grateful to our colleagues in Conservation: Susan Breen, Vanessa Griffiths, Charoulla Salt, Nelson Crespo, Piers Townshend and Shuja Rahman. Many curatorial colleagues have offered their support and input, providing important steers and suggestions at various points of the exhibition's development, including David Blayney Brown, Lizzie Carey-Thomas, Ann Gallagher, Nigel Llewellyn, Philippa Simpson, Katharine Stout, Robert Upstone, Clarrie Wallis, Ian Warrell and Andrew Wilson. We should also like to thank our interns on the last stages of the project, Mareike Spendel and Melissa Emery, who provided crucial support for Cedar Lewisohn throughout the organisation of the exhibition.

Tim Batchelor, Cedar Lewisohn, Martin Myrone

What's so Funny about British Art?

Martin Myrone

There are plenty of reasons to approach the task of writing about comedy and art with a degree of trepidation. The topic itself is potentially vast, spanning centuries, even millennia, encompassing an array of different media, and even when focused around the visual culture of a 'nation' (which in the case of Britain is a slippery concept in itself), embraces a multiplicity of perspectives reflecting a range of identities and histories. Any survey of 'British Comic Art' could touch on medieval carvings, eighteenth-century engravings, shop signs and advertising design, Toby jugs, conceptual art, comic books, newspaper illustrations and much more, and might then need to situate these in a wider context of humour in language, literature and performance.[1] Moreover, at the heart of the intersection of art and humour lies the potential for profound misapprehension, the possibility that grappling with the one means that the other is misunderstood or distorted. Comedy and art either don't seem to belong together at all or may have only a complicated and compromising relationship, and both or either are reputed to defy any and all attempts to define, analyse, break down and discuss them.[2] As Jennifer Higgie noted in introducing a recent anthology of artists' writings on the topic, 'if humour has a common characteristic, it is to thumb its nose at pigeonholes'.[3]

So any attempt to define British comic art, even in the sketchiest form, is likely to be beset by hesitation, and might well be simply foolhardy. This was not, perhaps, always the case. From the later nineteenth century onwards there has been a succession of publications dealing with humour and art in Britain, usually focusing on the graphic arts. There were the broad surveys, including James Parton's wide-ranging *Caricature and Other Comic Art* (1878) which dwelt on British materials, Cornelis Veth's *Comic Art in England* (1930), David Low's

British Cartoonists, Caricaturists and Comic Artists (1942) and the pioneering works of F.D. Klingender on graphic satire in the 1940s that insisted on a social and economic understanding of the genre. Then there were the books on British art as a whole that dealt with the comic as a strand within national cultural history or looked at 'The English Sense of Humour' (the title of an essay by Harold Nicolson from 1946 that makes mention of the visual arts).

Arising from such earlier histories is an enduring idea that there is something distinct about British comic art, and that, more importantly still, the comic is a singularly important element in the make-up of the British national character (a claim often demonstrated by comparison with the fabled lack of humour of the French or Germans, or the oft-repeated line that 'Americans don't get irony').[4] The 'British sense of humour' (only complexly and incompletely to be identified with the ostensible sub-genres of Irish, English or Scottish humour) is a prominent feature of the mythology of British 'exceptionalism' (the idea that Britain is simply, essentially, not quite like other countries).[5] 'Humour' we can note, was first used in the modern sense in 1682 and was early observed to be referring to a peculiarly British trait without a close equivalent in other European languages.[6]

If this could lead to a kind of 'ethnic' definition of Britishness, which we would now find dubious, there are surer historical foundations for such claims. The emergence of comic British art in its various forms can be seen as tied to the political, social and religious compromises of the late seventeenth century and to the concomitant development of modern global capitalism and empire. Britain's material wealth supported an expanding art world in the eighteenth century, and Britain's political culture and economy depended upon the free circulation of ideas and opinions. Meanwhile, the *idea* of British culture that took shape in the eighteenth and nineteenth centuries put great store by the notion of good humour and freedom of speech. Comic art (in the form of printed images and commissioned works) could flourish in this context.

Veth's admiring acknowledgement that 'in English art, at least, laughter survives' (in contrast to the continental European situation), ties British humour to specific

democratic political traditions, which, it was argued, permitted a degree of political resistance or even heterodoxy.[7] The comic might, in fact, embody political freedom itself. It has been suggested that the idea of comedy is intrinsically 'agonistic', refusing ready definition; yet it is also regularly asserted that the comic is based on social opposition, antagonism towards the status quo.[8] One of the central pillars of the British state may, indeed, be this belief in the carnivalesque as part of national life, which is given life in the institution of satire in the media – the 'corrective impulse' that helps define a national culture.[9]

Importantly, the comic has also come into play in relation to the perceived failures or shortcomings of British art; Britain (according to a dominant art-historical story) may have failed to produce any noble 'old masters' to equal those of Renaissance Italy, but we have, instead, comic artists like William Hogarth or Thomas Rowlandson. Their robust, vigorous art stands in for the more refined, elevated, rarefied forms preferred (supposedly) by high-minded continentals. Few people outside of extreme 'patriotic' groups would even hint at a racial basis for British humour (as has been claimed, if only tacitly, in the past), but the idea that there has to be something distinctly British about our comedy and comic art is persistent, insistent, insidious – notwithstanding so much evidence to the contrary (ranging from Hogarth's use of French engravers, through to the New Zealand origins of David Low, to the global character of contemporary art and the wide currency of jokes, pranks and humour in this international context).

Evidently, 'British comic art' is now a slippery, complicated concept, overlaid with several, potentially competing, claims. One version of British comic art would insist that it be identified with a tradition of graphic illustration (caricatures, comic strips, graphic novels), whether humorous or not, produced for publication and circulated in the larger realm, rather than aimed at the art gallery. This account has perhaps the best-established iconography, running from Hogarth, Rowlandson, James Gillray and George Cruikshank, through David Low, Leo Baxendale and Ronald Searle, to modern masters

of illustration, comic-book art and cartooning such as Raymond Briggs, Posy Simmonds, Ralph Steadman, Steve Bell and Gerald Scarfe. Another would argue for British comic art as a mode of popular cultural production in a broader sense, perhaps including comic books and caricatures, but also encompassing the decorative arts and design, all of which may have been marginalised or overlooked by the art establishment, which has tended to pursue a relatively delimited version of what is legitimate art – hence the absence of Beryl Cook or Staffordshire pottery in most mainstream accounts of British art. Still another argument might be to claim that the comic is a *tendency* that is innate to the character of British art and can recede, be repressed or be brought forth, so that British art is 'at its best', most truly itself, when comic elements are brought to the fore whether within specific genres or media (the caricature print throughout history) or at particular moments (Hogarth's work matching the robust patriotism of the mid-eighteenth century, and the so-called YBAs, or Young British Artists, of the 1990s appearing in the context of 'Cool Britannia'). This last has strong historiographical and political foundations: the distinct sense of a native art history that emerged in the late eighteenth and nineteenth centuries was developed in large part through a narrative that had at its pivotal point the figure of Hogarth. Crudely speaking, what these accounts would propose was that before Hogarth there was only false, foreign art in Britain; with Hogarth, and with those artists who followed him (in spirit if not literally), there was a truer national character in art, based on common-sense, robust good humour and a healthy lack of respect for authority.[10] Accordingly, the best British art is, almost by definition, comic.

A further viewpoint, which might overlay and shape any of the perspectives sketched out here, would be to resist categorisation or analysis at all. A considerable theorisation of comedy may now be emerging from the fields of philosophy, cultural studies, anthropology and linguistics, with theories of laughter, play and the joke referring to the fundamentals of human existence and the most expansive historical schemes, and allowing the commentator to evoke some of the most potent names

in philosophy and cultural theory (Sigmund Freud, Friedrich Nietzsche, Henri Bergson). Even so, it can be asserted that 'we are still without an adequate general theory of laughter'.[11] There is a sense, too, that such work leaves questions when it comes to the specificities of visual form and art history: 'We lack a solid connection between localized comic effect – the pun, joke, filmic sight gag, and visual humor in art – and the ultimate ends and nature of comedy.'[12] In the field of contemporary art, the discussion of humour is proclaimed as still only emerging as a serious topic.[13]

There is even an active resistance to analysing comedy, as in the much circulated (and adapted) witticism of the American writer E.B. White: 'Humor can be dissected, as a frog can, but the thing dies in the process and the innards are discouraging to any but the pure scientific mind.' White continues by insisting that comedy is like a 'bubble': 'it won't stand much blowing up, and it won't stand much poking. It has a certain fragility, an evasiveness, which one had best respect. Essentially, it is a complete mystery.'[14] The precious, organic, transient image of the bubble is peculiarly expressive, setting out an ideal of comic excellence (or at least efficacy) as an almost miraculous, thing: whether we find it funny or not is (ostensibly) less to do with our understanding than with our innate tastes. If the viewer is not moved to laughter by comic art and is instead stirred to analysis, could we say that he or she simply hasn't got the point? We might wonder at the striking comments of the esteemed art historian Ernst Gombrich to James Elkins, 'By the way, I have spent a lot of time on the history of caricature, but hardly ever *laughed*, and barely smiled!'[15]

Comedy is, in this respect, like art is imagined to be for many people – beyond words, sense, analysis, a matter of instinct and honesty rather than intellect and theory. As the comedian Harry Hill notes in an interview quoted on p.138: '[Comedy] polarizes people. In a certain way it can be like art.' In a doubled fashion, then, comic art may expose our strategic (which is not to say cynical or self-conscious) sense of ourselves[16] – it may prompt us to make a show of the judgements and assessments that feel to be most personal and true ('that's art/not art', 'that's funny/not funny'). So, despite all the claims which are made about the pure, spontaneous, innocent nature of our responses to comic art, looking at funny pictures engages us in acts of classification, distinction, and assessment. And given that the idea of British comic art is always already deeply embedded in the historical narratives of British culture and intertwined with myths and ideals of Britishness, thinking about it might, if we wanted, even lead us to consider how these highly personal responses sit within a larger idea of the 'national' (history, tradition, character, values).

Carry on Tate

Cedar Lewisohn

The British are famous for a lot of things: their dodgy empires; their stiff upper lips; David Beckham, the Queen and Simon Cowell. The Brits are known for doing things differently, perhaps eccentrically: driving on the wrong side of the road, electric plugs that only work on their own island. Some would call it a pioneering mentality, others pig-headedness. This unique perspective on life also produces many oddities in the world of art. The British relationship with art is one that would give any marriage guidance counsellor a hernia. It's a love/hate thing to say the least. Britain is probably the only country in the world where you could stop anyone on the street and ask them to name three living artists and they could do it. It's also the only country in the world where the purchase of an artwork by a museum can be front-page national news. The *Daily Mirror*'s 'WHAT A LOAD OF RUBBISH' headline from 16 February 1976 is still a perfect example of just how upset the British can get with art they don't see the point of. Media-led mock fury most often manifests itself in the form of 'humorous' ridicule. This idea of national art jokes is powerfully embedded in the popular consciousness: bricks in the Tate – joke; Picasso – joke; Shark in a tank – joke; unmade bed – joke. The problem the majority have is that they believe the joke is on them and that the artist is the one laughing, most likely all the way to the bank. So in the UK we have this strange dichotomy when it comes to art and humour. On the one hand there is the art that the public think is a joke, and on the other there is art that is made with the intention of being funny.

British newspapers and the general public used to laugh at James McNeil Whistler paintings in the 1870s, so this fear of the new in art is far from a contemporary phenomenon. The great thing about British artists is that they've taken the tabloid mentality of mistrust and cynicism about their work and used it as a subject for more work. Contemporary British artists, perhaps more than any other, hold a position comparable to that of the jester or licensed fool. So they always have to be one step ahead of the game to avoid a public whipping. They make work that deliberately fulfils the expectations of what a tabloid piece of contemporary art should be. Being badly made or appearing to lack any skill in production are two favourites. Then sticking an exuberant, publicly funded price tag on it really winds up the red-top brigade. But if the works are good, they can do all of these things while at the same time transcending them. The antagonistic relationship between the artists and jokers of the world remains and even goes both ways. Humour is certainly a weapon that artists have used to attack society. Introducing objects and ideas to the world that are ridiculous and incomprehensible is part of the job spec for a certain breed of contemporary practitioner. Perhaps ironically, these artists are usually deadly serious about their creative shenanigans. One way of looking at great art and great humour is as some sort of alternative form of philosophy. Both art and humour can delve into the darkest recesses of the human psyche while appearing to be flippant or nonchalant. I think it was Martin Heidegger who said that 'modern art exerts itself to establish the world's formula, while humour entitles the modern human to be human'.[1] Or was that Monty Python?[2] Similarly, there are certain philosophical attributes a comedian must take on. You have to look at the world, analyse it and then report back in the form of a gag. Philosophers however have the luxury of abstruseness. If you're going to be an artist, it helps if people connect to your work. If you're going to be a comedian, people kind of need to laugh at your jokes.

The antecedents of much humour found in contemporary art can be linked back to Dada, an art movement borne out of the horrors of the First World War. Millions and millions of people died and the Dadaists made booby jokes. They used humour, pranks and general piss-taking as a response to mass death and political/financial turmoil. Their work was often dark and anarchistic, and didn't offer easy readings. To quote Marcel Duchamp, 'There's a humour that is black humour which doesn't inspire laughter and which doesn't please at all.' We live

in different, anesthetised times, but the power to provoke a reaction and ultimately change the way people think through satire or absurdity is just as potent today. No one is claiming Guantanamo Bay jokes are in good taste. But no one would claim there are no Guantanamo Bay jokes either. Contemporary artists can also tap into this jaundiced view of the world. As Dada showed, the more deplorable a situation, the easier it is to make art or a joke out of it. Conversely, sometimes the best way to mock a shallow and superficial world is with shallow superficiality. A resistance to the idea of being 'easy' is perhaps why many artists today avoid the grand themes of yesteryear and instead hone in on the more subtle or obscure nuances of life. Art and humour also share the idea that they can be beautiful, but don't have to be. Sometimes they're ugly and offensive and disturbing. We might be oblivious to this when we laugh, we might feel guilty at our complicity or we might dismiss such things as lowly and beneath us. Much humour is, whether we like it or not, sexist, racist or un-PC in countless other ways. This type of humour works fine as an oral form of communication in pubs and so on, but it's much harder for humorists or visual artists to mirror this aspect of society without themselves becoming the subject of censorship and derision. When considering these devices, it is therefore important to note the difference between humour that promotes a received political or social position and humour that uses the vernacular to provoke new ways of thinking.

If an artist walks into a gallery, farts and says that's my work, that's fair enough. That may be very funny (or not); the joke gets lost, however, when the museums and education departments and curators (like me) come along with all their supposedly intellectual interpretations. Everybody knows that the best way to kill a joke is to explain it. The same is true for artworks that use humour. You either get it or you don't. This ridiculousness, paranoia and pseudo-intellectualism of the art world itself also provide ripe material for artists to mock and satirise. In the end, what links great art, contemporary or otherwise, with humour is that they both need to surprise us in some way and question preconceived assumptions. What separates them is just a label. Why not think of Tommy

Cooper as a performance artist? Or Martin Kippenberger as a clown? Maybe it's ok to go to the Tate at the weekend, look at the bricks and have a giggle (misguided as you may be). The best jokes can be funny, sad, true and deceptive all at the same time and so can the best artworks.

BRITISH COMIC ART

The relationship between art and comedy is a vast, unwieldy topic, involving questions of social and technological change, genre and technique, the social environments in which visual materials are disseminated and consumed, and what indeed we mean by 'art'. Even in its narrower definition as a form of graphic art (caricatures and cartoons), British comic art is still historically complex and highly various in its social significance.

The modern style of graphic satire and the comic strip really started to take shape with seventeenth-century Dutch and Flemish allegorical and emblematic prints, many of which circulated in Britain. Using complicated imagery and lots of texts, such images may be distinctly unfunny to our eyes. However, some of these visual methods were taken up and adapted by British artists like William Hogarth as the basis of a more immediate style of visual comedy that connected profoundly with contemporary audiences. Caricature – the technique of exaggerating physical characteristics for humorous effect – became joined to political satire and social comment in satirical prints from the mid-eighteenth century.

Although many observers commented on how print-shop windows gave the population at large visual access to these satires, the prints that were produced up to the early nineteenth century were generally luxury items. Social and economic change after that date promised that comic art might become genuinely 'popular', at least in numeric terms. However, despite some politically radical engagement, the growing dominance of bourgeois culture led ultimately to greater conformity and restraint in visual humour, exemplified by the success of the magazine *Punch* (1840–2002).

Comic books in the modern sense emerged at the very end of the century, with the enduring kids' titles *The Dandy* and *The Beano* appearing in the 1930s. Over time these have become subject to a vigorous fan culture, with many people insisting that they should be taken more seriously as an art form. Through the 1970s and 1980s the new discipline of cultural studies, and changes within the more established traditions of art history, led to academic discussions of the comic and comic books. In the wider culture the distinction between legitimate 'high art' and the everyday, the transient and the esteemed, is being actively re-imagined, and slapstick, jokes and cartooning have entered the repertoire of many artists working today. (MM)

ANONYMOUS, printed by Robert Ibbitson
(fl. 1646–61)

1. *Dr Dorislaw's Ghost, presented by T[ime]
to unmask the Vizards of the Hollanders* 1652
Engraving on paper, with letterpress
67.6 × 43.1 (printed area)
The British Museum

To a modern eye the allegorical and emblematic
graphic satires of the mid-seventeenth century
can appear complex and cryptic.

Produced at the outset of the First
Anglo-Dutch War (1652–4), this print shows
the 'barbarous and bloody cruelties and murders,
massacres and base treacheries' purportedly
committed by the Dutch against the English.
On the right is the allegorical figure of father
Time, presenting his daughter Truth to the
Dutch ambassador. Strangely, the female figure
of Truth also represents the ghost of Dr Isaac
Dorislaw (1595–1649), a diplomat who was sent
from England to The Hague by the Cromwellian
government to develop contacts with European
allies and was murdered in May 1649. With the
passing of time Truth had been revealed, and his
fate is presented as a presage for Dutch injustices
against the English.

Produced both in English and Dutch as
propaganda, the English version has the added
dimension of representing the ambassador in the
guise of the hated Spanish ambassador Gondomar
(1567–1626). He notoriously suffered from an
anal fistula (long ulcer), meaning that he required
a specially adapted chair – his 'chair of ease' – to
sit comfortably, depicted here as a close-stool for
scatological comic effect. (TB)

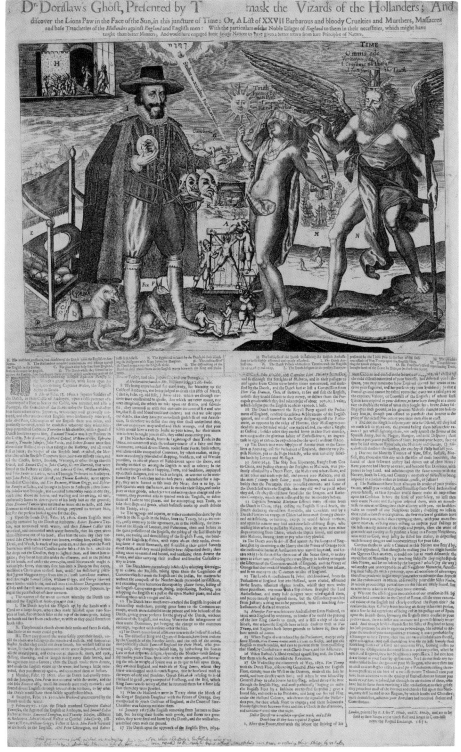

1.

15

Attributed to **ROMEYN DE HOOGHE** (1645–1708)

2. *Sic itur ad Astra Scilicet ('This way to heaven of course')* 1688
Engraving on paper with letterpress
56.5 × 42.4 (printed area)
The British Museum

The political and religious upheavals of the later seventeenth century helped generate a vigorous culture of graphic satire, much produced in the Dutch Republic as anti-Catholic propaganda. Although still basically allegorical in character, and often dependent on lengthy explanatory texts (in Dutch, English, or Latin), these sometimes took on a more immediately visual character. The works of the Dutch artist Romeyn de Hooghe are especially notable in this regard.

This scene of excess and orgy centres on Sir Edward Petre, 2nd Baronet (1631–99), known as 'Father Petre', a Jesuit appointed Dean of the Chapel Royal and chaplain to the Catholic King James II. A deeply unpopular figure, he was the butt of much of the public dissatisfaction at having a Catholic monarch. Father Petre can be seen seated at the table on the far right-hand side, using the Bible as a footstool and leaning on bags of money. Surrounded by female personifications of the seven deadly sins, he is attended by Pride with her peacock headdress, the priest removing his mask as he turns to her. The fat monk gorging himself represents Gluttony, while another monk turns round to leer at a naked woman on the bed, representing Lust. An old woman in the corner representing Avarice is counting money obtained from the sale of indulgences and masses. (TB)

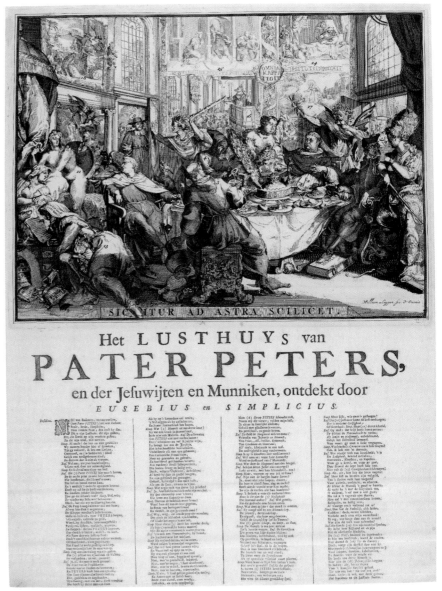

2.

WILLIAM HOGARTH (1697–1764)

3. *The South Sea Scheme* c.1721
Etching and engraving on paper, 26.5 × 32.7
Andrew Edmunds, London

The financial crisis of 1720, known as the 'South Sea Bubble', was one of the greatest disasters of early global capitalism. Feverish speculation on the stock price of the South Sea Company, which traded with Spanish colonies in South America, had created a 'bubble', with many people losing fortunes when it burst. A flood of satirical writings and images followed, lamenting the greed, folly or cynicism of those involved.

This is one of the earliest works by William Hogarth, generally considered the founding father of British satirical art. The print is allegorical, incorporating some bizarre and inventive images, but it is also topographically specific. The setting is outside the Guildhall, the centre of trade in the City of London, with the devil tearing pieces of meat from blind Fortune and throwing it to a crowd of hungry speculators. In the foreground the naked figure of Honesty is chained to a wheel and beaten, while Honour is flogged, punishments being meted out as if these virtues were crimes. (TB)

3.

ANONYMOUS

4. *Idol-Worship or The Way to Preferment* 1740
Etching on paper, 39.9 × 28
The British Museum

In this landmark print a complex contemporary political issue is reduced to an immediately legible and literal image of arse-kissing. The target is Robert Walpole (1676–1745), the Whig politician who led the government through an era of huge commercial development in the 1730s and early 1740s and who is usually thought of as the first 'prime minister'. While the growth of a strong government acting independently from (and sometimes against) the monarch helped fashion a modern political state in this era, it also aroused a great deal of suspicion. This print offers a grossly physical indictment of the preferment that it was suspected could lead to power, in place of the divinely ordained structures of authority traditionally associated with monarchic states. (MM)

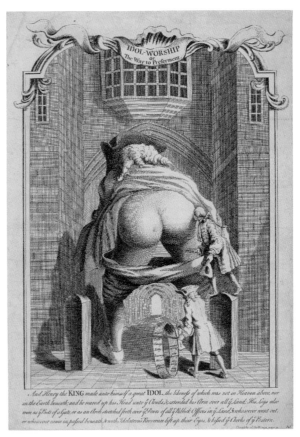

4.

WILLIAM HOGARTH

5. *Characters and Caricaturas* 1743
Etching on paper, 25.7 × 20.2
Andrew Edmunds, London

WENCESLAUS HOLLAR (1606–77)

after Leonardo da Vinci (1452–1519)
6. *Caricature and Deformities after Leonardo* 1665
Etching on paper, 6.8 × 4.7
The British Museum

ANONYMOUS after Pier Leone Ghezzi (1674–1755)

7. *Dr Tom Bentley* c. early 18th century
Etching on paper, 34 × 22
The British Museum

Caricature (the amplification of physical characteristics for comic effect) originated in earlier Italian and Spanish artists' drawings of disfigured or exaggerated faces. Among the most famous of these were the heads produced by Leonardo da Vinci. These were well known in Britain through reproductive prints, most notably etchings by the Bohemian-born artist Wenceslaus Hollar.

In eighteenth-century Italy a number of artists drew on such images for comic portraits of visiting travellers, especially British Grand Tourists. Between 1736 and 1742 the British printmaker Arthur Pond produced a series of engraved portraits after such drawings by Ghezzi, probably incuding this work showing the classical scholar Thomas Bentley (1690/91–1742). These prints helped inspire many amateur artists, encouraging the development of caricature in the modern sense.

Both Leonardo's grotesque head and Ghezzi's caricature of Bentley can be spotted (in reverse) in the bottom row of Hogarth's *Characters and Caricaturas*. Although Hogarth is often thought of as a caricature artist, he was disdainful of the comic exaggerations associated with what was then still a largely amateur and aristocratic pursuit. He claimed, instead, to be dealing with 'characters', the truthful, accurate representation of social types and personalities. The text at the bottom of this print points the viewer to the preface of the novel *Joseph Andrews* (1742) by Hogarth's friend Henry Fielding: 'For sure it is much easier, much less the Subject of Admiration, to paint a Man with a Nose, or any other feature of preposterous Size, or to expose him in some absurd or monstrous Attitude, than to express the Affections of Men on Canvas.' (TB/MM)

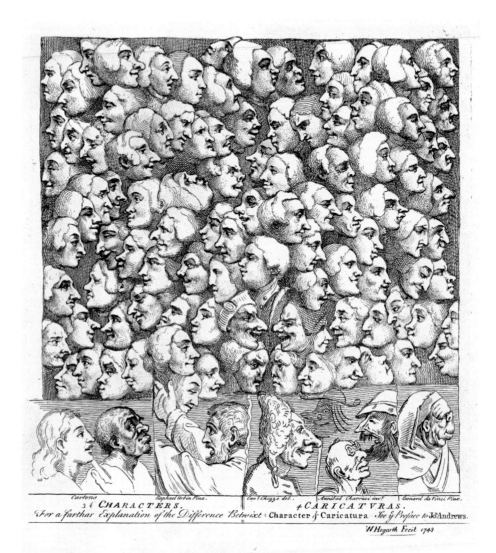

5.

18

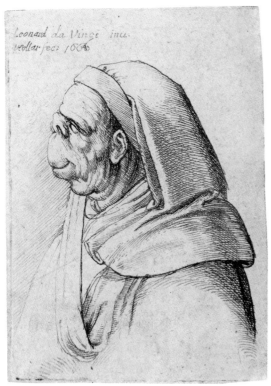

6.

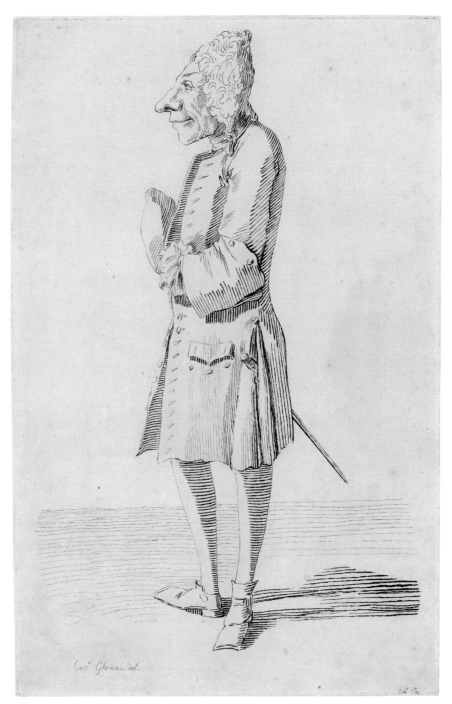

7.

19

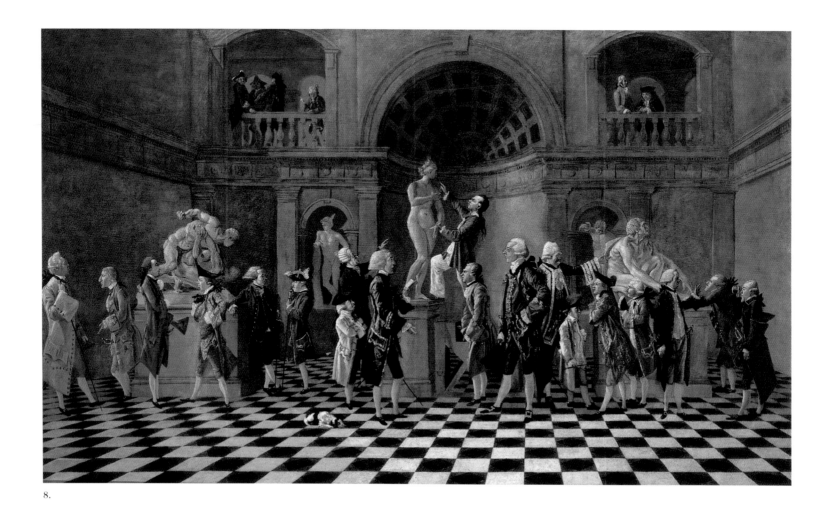

8.

THOMAS PATCH (1725–82)

8. *A Gathering of Dilettanti in a Sculpture Hall*
 c.1760–1
 Oil on canvas, 137.2 × 228.6
 Collection of the late Sir Brinsley Ford CBE FSA

Patch specialised in painting caricature portraits
of British aristocrats on their Grand Tour. In
this, his most ambitious painting, Patch himself
can be seen wearing white seaman's trousers
and sacrilegiously 'canonising' the *Medici Venus*,
assisted by Sir Horace Mann (1706–86), the
British Resident in Florence, who points directions
from the other side. The foppish Grand Tourists
grouped at either side appear completely
uninterested in the sculptural masterpieces that
surround them. Part of the comedy comes from
the mismatch between the ideally proportioned
naked bodies of the classical sculptures and the
ill-shaped (and in some cases miniaturised) figures
of the modern tourists. Although such images
can appear cruel, the tourists themselves were
in on the joke. Patch often produced multiple
versions of such compositions to satisfy the
various individuals represented in them. (TB)

JAMES GILLRAY (1757–1815)

9. *Doublûres of Characters; or Strikeing Resemblances in Phisiognomy* 1798
Etching, soft-ground etching and engraving, with publisher's watercolour on paper, 19.1 × 25.4
Andrew Edmunds, London

THOMAS ROWLANDSON (1756–1827)

10. *The Judge*
Pencil and watercolour on paper, 21.8 × 17.4
Tate

Even the most immediately physical of earlier eighteenth-century graphic satires tended not to indulge in the gross exaggeration or distortion of physical features that underlies the modern art of caricature. But by the 1770s several artists, most importantly Gillray, were making caricature a regular feature of political and social satire. Rather than being mainly an aristocratic pastime, caricature emerged now as a tool of professional artists, creating more ambitious images that reached a relatively large public.

Gillray's *Doublûres of Characters* suggests the moral and psychological subtlety of the process. He has lined up barely caricatured likenesses of public figures with their more grotesque 'doubles'. Paradoxically, by exaggerating the appearances of individuals, caricature claims to reveal the truths of their characters.

Along with Gillray, Rowlandson is considered one of the masters of this Golden Age of British caricature. While Gillray was primarily a political satirist, Rowlandson's imagery usually focused on social types and characters. He was a prolific draughtsman, creating very large numbers of character studies and sketches in pen and ink and watercolour. These convey a powerful sense of physicality, whether in the form of chaotic slapstick, robust eroticism or, as here, sheer grotesquery. Such images play to deeply rooted beliefs that physical appearances express inner values – here, that this judge may be as gross and foul in his morals as he appears in his person. (MM)

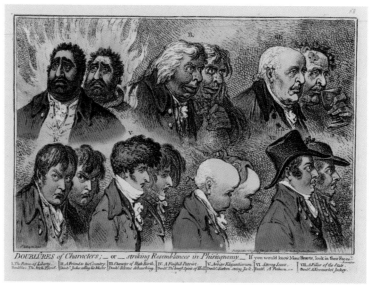

9.

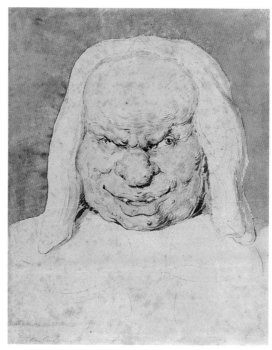

10.

11.

THEODORE LANE (1800–28)

11. *Honi Soit Qui Mal Y Pense* 1821
Etching and engraving, with publisher's
watercolour on paper, 26.5 × 41.4
Andrew Edmunds, London

By the end of the eighteenth century satirical
prints were being treated as a kind of collectable
art form. The audience for these relatively
expensive images is hard to characterise precisely.
Certainly, there were some very eminent
collectors of satirical prints, not least George,
Prince of Wales, later George IV (1762–1830),
so often a target of the satirists. But images like
this, and many written accounts, suggest how the
displays of print-shop windows gave a much larger
public access to these images. The French title of
this anonymous print is the motto of the chivalric
Order of the Garter: 'Shame be to him who
thinks evil of it.' (MM)

CHARLES JAMESON GRANT (fl. 1830–46)

12. *The Penny Trumpeter!* 1832
Hand-coloured lithograph on paper, 40.5 × 24
The British Museum

13. *The Penny Satirist* 18 June 1842
Woodcut and letterpress on paper, 49 × 37.2
Private collection

The progress of printing technology and the building of the railways in the early nineteenth century meant that magazines and journals were cheaper and more easily available than ever. Comic publications such as *Figaro in London* (1831–9) and *Every Body's Album* (1834) were aimed at this emerging mass market. The cheapest magazines could also provide an outlet for more radical views and opportunities for artists who had not been conventionally trained – such as C.J. Grant.

The *Penny Magazine*, published between 1832 and 1845 by the worthily minded Society for the Diffusion of Useful Knowledge and supported by Lord Brougham (the Lord Chancellor), tried to monopolise this new lower-class market. Those on the radical left saw this as a political attempt by the establishment to divert attention away from the more radical penny magazines. In *The Penny Trumpeter!* Grant satirises Brougham as a sort of 'pied piper', leading the masses with his dubious 'useful knowledge'. A fervent radical and defender of the working man, Grant promoted his views through his series 'The Political Drama', produced as woodcuts on cheap paper to make them as affordable as possible to the working class. He also contributed to the radical *Penny Satirist*. This example shows John Bull (the stock satirical figure representing free-born Englishmen) in a 'Promethean Travestie' chained to the rock of Albion by national debt and being torturously pecked at by the vultures of the political and social establishment. (TB)

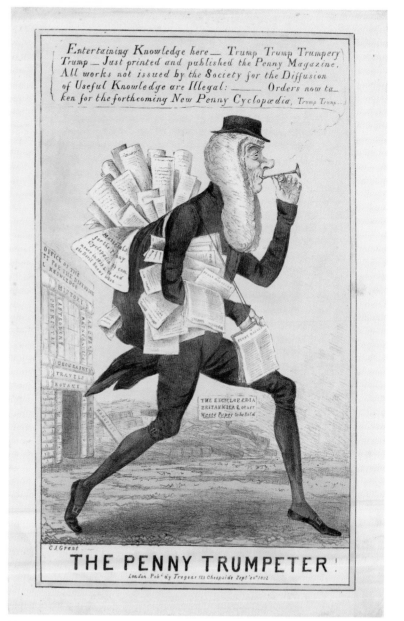

12.

THE PENNY SATIRIST.

No. 270. LONDON, SATURDAY, JUNE 18, 1842. Vol. 6.

JOHN BULL AND THE VULTURES.
A PROMETHEAN TRAVESTIE.

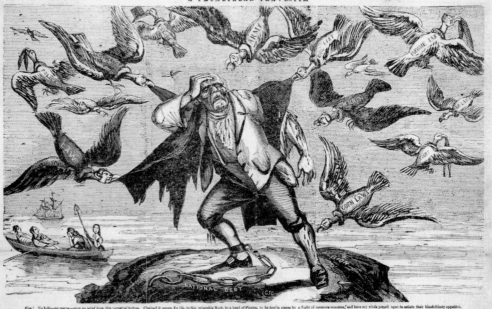

Alas! No help—no rescue—soon no relief from this perpetual torture. Chained it across, for life, to this miserable Rock, by a band of Pirates, to be torn to pieces by a flight of ravenous monsters, and have my vitals preyed upon to satiate their blood-thirsty appetites. Luxury vs vux Bull—Ah! Water Justice—we may well moan at your melancholy case as the Rock—but we can tender no assistance to the Poor Old Martyr. We are *Forced* from that once happy Isle, to emigrate to Foreign climes. Oh! for the spirit of the *Murdered Botanists*, to rise and scare away the hell-born Brood.

COURT CIRCULAR.

HOAX AT WINDSOR.

PLANT TREES.

WHISKEY.

DON'T BE DEPENDENT ON FOREIGNERS.

13.

ANONYMOUS?

14. *Bull-Baiting Group* c.1830
Pearlware, 28 × 34.5 × 13.5
Brighton & Hove Museums

CAROLE WINDHAM (b.1949)

15. *Obadiah, Mastrr of Bursley* 2000
Ceramic earthenware, oxides, underglazes,
lead glaze, enamels, 120 × 60 × 35
Private collection

The lurid colours and strongly stylised design
of nineteenth-century Staffordshire pottery has
meant that it has been classed as a form of 'folk'
or 'popular' art. The cartoonish vigour has held
a powerful appeal for generations of collectors,
helping to evoke an 'olde world' rustic simplicity
while demonstrating a curiously modernistic
aesthetic. As the leftist art historian Herbert
Read put it in a classic study of 1929:

> The porcelain figure was destined to grace
> the mantelpieces of the aristocracy and rich
> bourgeoisie; the pottery figure was never
> meant to be more than a cheerful ornament
> in a farm-house or a labourer's cottage.
> The potter who made the figure was himself
> a peasant with a simple mind and a simple
> sense of humour. But because of this simple
> sense he often strays unconsciously into
> a realm of purer forms.

Read attributed the design of this famous bull-
baiting group to Obadiah Sherratt (1775–1842),
although the evidence for this assertion is
unclear.

The stylisation and democratic associations
of Staffordshire pottery have been utilised by
a number of contemporary artists working in
ceramics. Carole Windham's oversized rendition
of Obadiah seems to emphasise the garish
modernity of the 'Sherratt' style. (MM)

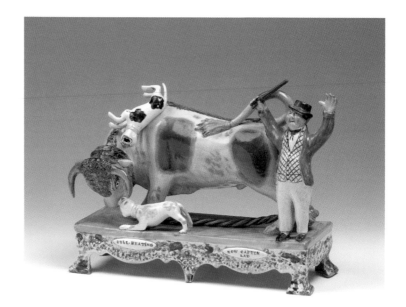

14.

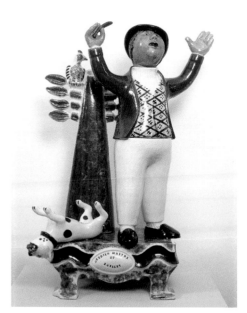

15.

JOHN TENNIEL (1820–1914)

16. *Frontispiece* Punch, or the London Charivari,
Vol. 61, 1871
Private collection

JOHN LEECH (1817–64)

17. *Cartoon, No. 1, Substance and Shadow*
Punch, or the London Charivari, Vol. 5, 1843
Private collection

Punch magazine was the most popular and
successful comic publication of the nineteenth
and early twentieth centuries. Launched in 1841,
it was initially subtitled 'the London Charivari',
taking its inspiration from the French comic
journal *Le Charivari* (founded 1832). A mixture of
comment, news and comedy sketch, the magazine
reflected the more straitened moral climate of
the times, and its generally rather conservative
and innocent approach was intended to appeal
to the prevailing middle-class values of the time.
Notably, it was read and enjoyed by the distinctly
bourgeois, family-orientated Queen Victoria
and Prince Albert.

 From *Punch* comes the origin of the meaning
of 'cartoon' in the modern sense, as a comic
illustration rather than preparatory drawing.
Following the burning of the Houses of
Parliament in 1834, there was a competition
open to artists to paint decorative frescoes for
the walls of the new building. The preparatory
sketches of these designs (cartoons) were
exhibited and John Leech made a series of biting
satires on the display, contrasting the excessive
extravagance of these commissions with the poor
of London in his drawing *Cartoon, No. 1. Substance
and Shadow* (1843). (TB)

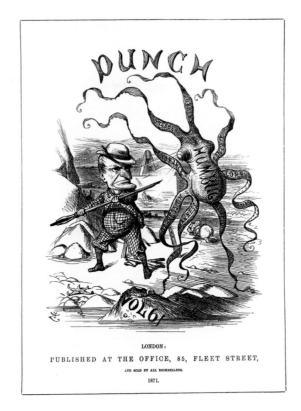

16.

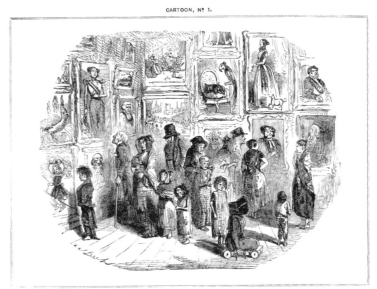

17.

27

CHARLES SPENCELAYH (1865–1958)

18. *The Laughing Parson* 1935
Oil on canvas, 50.7 × 40.7
Grundy Art Gallery, Blackpool

In a 1941 essay on humour the American writer
E.B. White observed: 'Punch, which is as British
as a vegetable marrow, is socially acceptable
everywhere an Englishman is to be found. The
Punch editors not only write the jokes but they
help make the laws of England.'

This painting of an English clergyman chuckling
over the latest copy of *Punch* in his comfortable
sitting room epitomises how ingrained the
comic publication had become in British life
and culture. A largely forgotten figure in British
art history, Charles Spencelayh followed in the
tradition of Victorian genre painting. Originally
trained as a miniature painter at the South
Kensington Schools (later the Royal College
of Art), he used this highly detailed approach
in his larger canvases, earning him the nickname
of 'the Human Camera'. His works are often
described as Dickensian in character, with figures
reminiscent of those from the great novels or
depicting scenes recalling *The Old Curiosity Shop*;
both artist and author came from the Rochester
area. (TB)

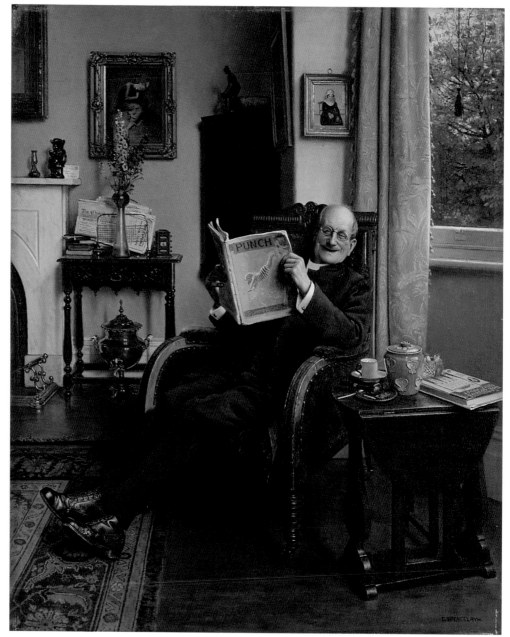

18.

WILLIAM GILES BAXTER (1856–88)

19. *Ally Sloper's Half Holiday*: 'The Russian Bear' 1887
Pen and brush and ink on paper, 25 × 32.6
Victoria and Albert Museum

Ally Sloper, Europe's first really enduring comic-strip cartoon character, was introduced in 1867 in the magazine *Judy*, illustrated by Marie Duval (the professional name of Emilie de Tessier, 1847–90). A cheap (twopenny) publication, *Judy* was aimed at the lower classes and especially a female readership (notably, the magazine employed at least two women as staff cartoonists). A spin-off magazine *Ally Sloper's Half Holiday* (1884–1923) with artwork by William Giles Baxter proved hugely popular, focusing on the everyday comic capers of the red-nosed schemer and drunkard as he tries to avoid the rent collector by 'sloping' through the back alleys. In this drawing Ally Sloper is shown lobbing bombs to the Russian bear while the Tsar, the Kaiser and Bismarck look on. This is a satire on the events in Russia in 1887 when the revolutionary Russian group Narodnaya Volya (People's Will) attempted to assassinate the Russian Emperor Alexander III. (TB)

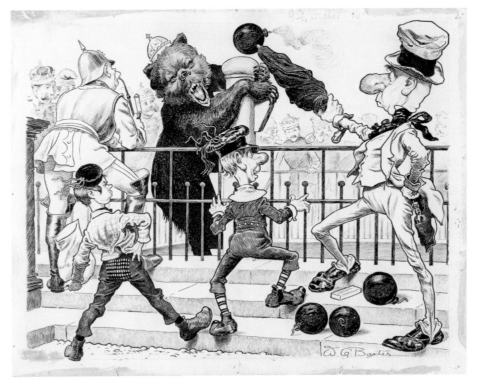

19.

LEO BAXENDALE (b.1930)

20. *When The Bell Rings* published in *The Beano*,
10 December 1955
Pen and ink on card, 48.4 × 36.3
D.C. Thomson & Co. Ltd.

The success of publications such as *Ally Sloper's Half Holiday* opened the door to the mass proliferation of comics in the twentieth century, particularly aimed at children, as epitomised by *The Beano* with its well-known characters Dennis the Menace, Minnie the Minx and the Bash Street Kids. First published on 30 July 1938, it was a companion to *The Dandy* comic, which had started eight months earlier. The smaller format and introduction of speech bubbles rather than narrative text proved hugely popular and influential. Leo Baxendale's creation of the Bash Street Kids first appeared in 1954 under the title of 'When the Bell Rings', inspired by a drawing by the famous cartoonist Carl Giles (1916–95) of jostling children bursting out of school. However, they soon became known as the Bash Street Kids to their fans, taking that title from 1956. (TB)

"A PICTURE WHOSE PICTORIAL FORM
IS LOGICAL FORM IS CALLED A LOGICAL
PICTURE, EDNA" CORRECTED THE BOSUN

Glen Baxter 2005

21.

GLEN BAXTER (b.1944)

21. *A picture whose pictorial form is logical form is called a logical picture, Edna corrected the Bosun*
2005
Ink and crayon on paper, 78 × 57
Courtesy the artist and Flowers Gallery, London

Glen Baxter is an artist whose work crosses the boundaries between fine art and comic books. His images, which are often borrowed from pop culture, seem to have a particularly British absurdist outlook on the world. The text captions which are placed underneath the images often provide a wry and surreal take on the depicted scene. (CL)

BOB AND ROBERTA SMITH (b.1963)

22. *10th October 2008 (Freedom George Michael)*
2008
Signwriter's paint on board, 248 × 252
Courtesy the artist and Hales Gallery, London

Bob and Roberta Smith's paintings borrow heavily from the typographic style of signage painting. This is mixed with texts that are often politically or socially motivated, but presented with a sense of humour, akin to a slightly desperate teenage protester. This work puts forward the notion that George Michael's music has deeper political relevance than it is usually given credit for. Is this a joke? It's hard to tell. (CL)

1October2008 FREEDOM GEORGE MICHÆL HAS DONE MORE 4 HUMAN RIGHTS THAN THE JAM, THE CLASH, THAT BLOKE FROM The Boomtown Cats AND BONO AND STING, ALL PUT TOGETHER

22.

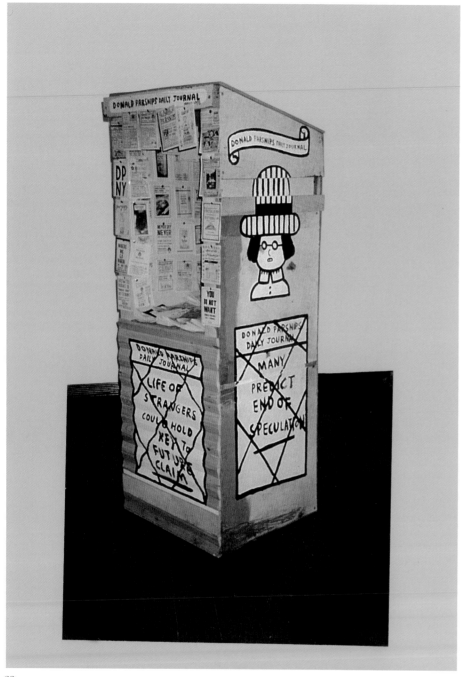

23.

23. *Donald Parsnips Daily Journal newstand* 1997
Painted found materials, 213.4 × 76.2 × 76.2
Courtesy the artist and Hales Gallery

Adam Dant's 'Parsnips Project' took place
between 1994–9. For the project, the artist
drew a limited edition newspaper each day over
a five-year period, and gave them away at various
locations throughout London. The content of
the journals varied from the study of bugs to
roaring parrots and the spectacle of bees. The
artist has recently reprinted the entire collection
of publications for archival purposes. (CL)

DAVID SHRIGLEY (b.1968)

24. *Untitled* 2000
Ink on paper, 26.5 × 23
Courtesy the artist and Stephen Friedman Gallery

David Shrigley's work often deals with macabre or black humour. Deceptively simple in style, his line drawings show a twisted childlike glee. The work *Untitled* depicts an unseemly and dishevelled man with the words 'Ha Ha Ha' repeatedly written under the image. The juxtaposition of the disgusting face and the joyous text plays a joke with our perception of cruelty and humour: who's doing the laughing is not quite clear. (CL)

HA HA HA HA HA HA HA HA HA HA HA HA HA HA HA HA HA HA HA
HA HA HA HA HA HA HA HA HA HA HA HA HA HA HA HA HA HA HA HA
HA HA HA HA HA HA HA HA HA HA HA HA HA HA HA HA HA HA HA
HA HA HA HA HA HA HA HA HA HA HA HA HA HA HA HA HA HA HA
HA HA HA HA HA HA HA HA HA HA HA HA HA HA HA HA HA HA HA HA
HA HA HA HA HA HA HA HA HA HA HA HA HA HA HA HA HA HA HA
HA HA HA HA HA HA HA HA HA HA HA HA HA HA HA HA HA HA HA
HA HA HA HA HA HA HA HA HA HA HA HA HA HA HA HA HA HA HA HA
HA HA HA HA HA HA HA HA HA HA HA HA HA HA HA HA HA HA
HA HA HA HA HA HA HA HA HA HA HA HA HA HA HA HA HA HA HA
HA HA HA HA HA HA HA HA HA HA HA HA HA HA HA HA HA HA HA
HA HA HA HA HA HA HA HA HA HA HA HA HA HA HA HA HA HA HA
HA HA HA HA HA HA HA HA HA HA HA HA HA HA HA HA HA HA
HA HA HA HA HA HA HA HA HA HA HA HA HA HA HA HA HA HA
HA HA HA .

24.

25.

KLEGA (b.1961)

25. *Kit Cut* 2005
Acrylic ink on paper, 29.7 × 21
Private collection
(not exhibited)

Klega's simple line drawings, often drawn
in the dictatorial tones of black and red are
slightly reminiscent of Gary Larson's *The Far Side*.
Stripped of text and with a typically apocalyptic
take on the world, the images have a quiet
relentlessness that gives rise to the humour. (CL)

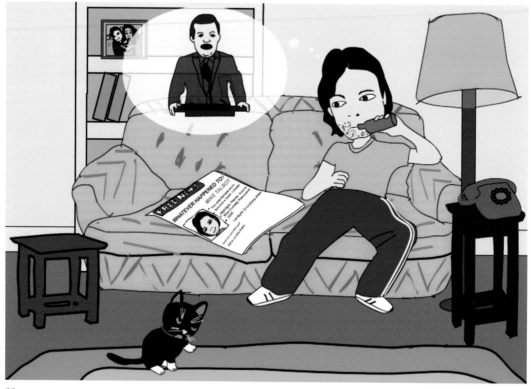

26.

JANETTE PARRIS (b.1962)

26. *Talent* 2010
 Animation, 14 mins
 Courtesy the artist

Janette Parris's video piece uses the format of
mainstream TV animated-cartoon humour but
twists the narrative slightly beyond the realms
of acceptable television fare. Her characters are
just that bit too depressed, too melancholic and
too morbid for the mainstream. Citing references
such as Lenny Bruce, her animations, just that
bit too long, further play on the tensions of what
should be comfortable viewing. (CL)

SIMONE LIA (b.1973)

27. *Voted Off* 2009
Ink, photoshop, 25 × 21
Courtesy the artist

Simone Lia's comic strip was originally
commissioned by Tate to illustrate a debate
around public participation in the museum
process. As well as parodying contemporary
art practice, the piece also gently questions the
audience's blind faith in the power of art. Lia's
comic strip uses deceptively cute characters to
put forward complex satirical ideas. The reader
is lulled into a false sense of conceptual security
which is later cut to bits with her sharp wit. (CL)

27.

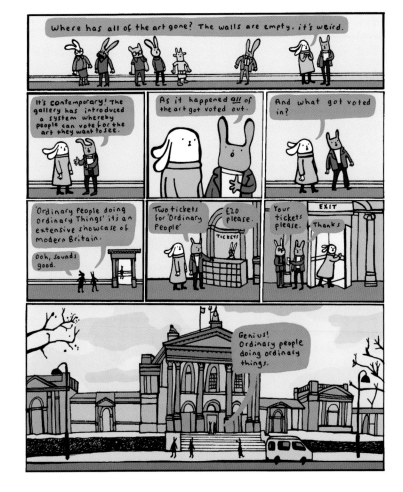

Frames of Reference: The Progress of Comics

Paul Gravett

Who could have imagined thirty years ago that some Geordie teenagers who had started a crude, rude magazine from their bedroom would not only have their satirical scrawls on the walls of Tate Britain but would be invited to interpret a whole room in a survey of humorous art in Britain? The gallery's invitation to *Viz* is yet another example of the acceptance, even ascendance, of the comics medium into this country's cultural echelons. Within the traditional hierarchy of the high and low visual arts, cartooning, in the sense of the art of writing and drawing comedy, has tended to come low on the ladder of esteem, lower than illustration and lower even than advertising. What's more, within cartooning itself the comics have usually been relegated to the very bottom rung below the somewhat classier categories, in descending order, of caricatures, political cartoons, and social or gag cartoons. Looking back along the road to supposed respectability, from the gutter to the gallery, modern comics have been beset by delays, detours and dead ends, taking two steps forward but often one step back, but, however erratically, they have progressed in response to changing traditions, technologies, tastes and foreign influences. To explore how British comics seem to have arrived, let us examine a few chance turning points that they encountered on the way.

William Hogarth would seem to be pivotal, if not primary, by making a series of fateful decisions that led to him self-publishing his first of five suites of narrative engravings, *A Harlot's Progress*, in April 1732 (fig.1). It might never have happened if he had not heeded the casual suggestions by visitors to his studio to turn his single picture of a pretty prostitute into a pair, a 'Before' and 'After'. From there he would eventually transform the initial piece into the third in a sequence of six paintings and crucially marketed relatively cheaper engravings of them. Not that his Harlot's and Rake's Progresses are the Year Zero of comics. Hogarth had plenty of precedents and was consciously harking back to popular seventeenth-century genre engravings imported from Venice, which were posed, po-faced and edifying. As in many cases of satirical humour, then and now, for anyone to get the full joke often requires an awareness of a repertoire of references, both to the times and to earlier sources. So Hogarth could count on his clients understanding the irony of ennobling such commonplace genre material first into imposing history paintings and then into carefully crafted engravings, where stiff classical types were recast as typical, topical Londoners, acutely observed from life. For all his avowed moralising, Hogarth also knew that he was scandal-mongering and serving up saucy sex for his male-only customers, so in the final sixth print he leavened the potentially gloomy wake for his deceased harlot with more prostitutes plying their trade.

Some have questioned whether these Progresses truly belong among the ancestors of comics. To Belgian comics historian Thierry Groensteen, for example, Hogarth 'seems more decisive for the history of caricature than for that of comics, of which he is only one relatively marginal milestone among others'.[1] Groensteen has a point, provided that the foundation of comics is to be defined, and confined, by 'the sequential logic of action', whereas Hogarth's five main narrative sequences are made up of small sets of large pictures – four, six, eight, twelve at most – that are dense with meanings and separated by great leaps in time, place and story. They seem remote from the multiplicity and seeming simplicity of drawings, often neatly boxed into panels, in moment-to-moment modern comics, as in a 'proper' comic page of Sid the Sexist or the Bash Street Kids today. In contrast, Hogarth's images set out no one specific path to follow within them and, even with accompanying textual commentaries placed beneath in some cases, they operate more like cryptic visual puzzles that entice the eye and mind of the reader/viewer to wander at leisure through each picture, spotting clues, connections, references and differences within and between the prints. And that

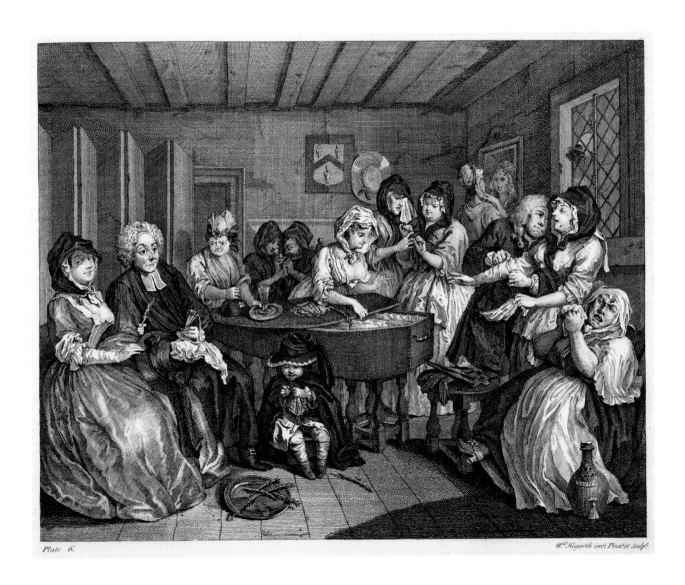

Fig.I William Hogarth, *A Harlot's Progress* April 1732, plate 6 of six prints, Andrew Edmunds, London **41**

Fig. 2 Posy Simmonds, from *Tamara Drewe*, London 2007

processing capacity is precisely what is needed still to navigate comics. Putting the Progresses into a broader perspective, Belgian theorist Thierry Smolderen emphasises the subsequent significance of Hogarth's 'arabesque' digressions, adopted by such contemporary novelists as Laurence Sterne and Henry Fielding, and his invention of a 'polygraphic language of irony and humour, capable of conveying the complexity, tensions and contradictions of the times',[2] which clearly continues to underpin the medium.

Hogarth's heirs during Britain's rumbustious Golden Age of Caricature, roughly 1770 to 1820, included James Gillray, who occasionally used the term and simplified the visual and narrative levels of the Progresses. For example, in *John Bull's Progress* of 1793 Gillray combined four captioned pictures on one sheet, while his 1806 *Rake's Progress at the University* charted the faux pas that lead to a student's expulsion and his 1810 *Progress of the Toilet* showed three fixed-view stages in a lady's elaborate preparations, from 'stays' and 'wig' to 'dress completed'. That said, such examples of sequential visual narratives were few and far between compared to the single cartoons, albeit with abundant billowing speech balloons.

Across the continent, however, the Genevan teacher Rodolphe Töpffer was evolving his seminal comic strip albums, true prototypes of today's graphic novels, and invoked Hogarth's considerable reputation by association to bolster their credibility. He claimed to have been particularly struck as a boy by Hogarth's *Industry and Idleness* parable. Through what Töpffer called Hogarth's 'romans en estampes' (novels in engravings), he identified the Englishman as 'less a gifted artist than an admirable, profound, practical and popular moralist' and as the 'master of the genre'.[3]

Töpffer had been anxious that his 'trifles' would undermine his academic advancement, so he took several years before plucking up the courage to self-publish, like Hogarth, the first of his extended satirical albums. The Swiss schoolmaster had been encouraged, however, over the winter of 1830–31 by none other than Goethe. Though nearing the end of his life, the great German writer and polymath wrote to Töpffer to express delight at an early draft of his Dr Festus story. In fact, his drawing in this was inspired less by Hogarth and more by the greater lightness of line, refinement of detail and exaggerated faces and figures of Thomas Rowlandson, well known for his character Dr Syntax. In another of those turning points a nineteen-year-old William Makepeace Thackeray happened to be spending that same winter in Weimar and came into Goethe's circle. Though Thackeray makes no specific mention, it seems highly likely that during these encounters he, too, enjoyed Töpffer's manuscripts, because he was soon producing his own in a similar vein. Thackeray's 'two stories told in caricature sketches with captions' to entertain a young lady were later published in his *Weimar Sketch-Book in 1830*.[4] Although *Vanity Fair* (1847–8) brought him fame as a writer, humorous drawing, often in narratives, remained a lifelong yet sidelined passion.

Significantly, Smolderen suggests that Thackeray probably introduced his friend George Cruikshank to the first Parisian editions of Töpffer's successful albums in London in the late 1830s.[5] Cruikshank caught the bug and tried his own. The illustrator of Dickens wanted to be seen as a writer as well. In the multi-panelled, single-page skit, *The Loving Ballad of Lord Bateman* in 1839, each of its eleven 'Plates' is counterpointed beneath by amusing text, all in the same hand. His attempt in 1844 at a comical album, *The Bachelor's Own Book,; or The Progress of Mr. Lambkin, (Gent.) in the Pursuit of Pleasure and Amusement, and also in Search of Health and Happiness*, was an oddity. It looked back more to Hogarth a century before, as its title hints, than to Töpffer's modern, wittier, looser comedy. The public did not get the joke and it was a flop. A discouraged Cruikshank dropped plans for a sequel. Once the crusade for temperance gripped him and literary limelight lured Thackeray away, neither would fulfil the promise of their early forays into comics, but the seeds were planted.

As literacy and the press burgeoned, newspapers and magazines offered other cartoonists more opportunity, immediacy and regular column inches. While Cruikshank refused to work for *Punch* magazine, launched in 1841,

Thackeray would write for the weekly from July 1842. Early on, *Punch*'s literary editorial committee indulged some recurring characters and serialised stories, such as Richard Doyle's travelogue lampoon 'The Foreign Tour of Messrs. Brown, Jones and Robinson', John Leech's bumbling amateur sportsman Mr Briggs and George du Maurier's diminutive Tom Tit. Most *Punch* cartoons, however, were originated by writers as lengthy, word-driven playlets for two or more actors, which artists would have to condense into one cramped scene, when they would have benefited from being unpacked into several drawings to convey changing facial expressions and body language.

Comics were let out of the box in the pages of *Judy*, one of *Punch*'s undisguised imitators, when Charles Henry Ross introduced the bulbous-nosed East End scoundrel Ally Sloper, his Dickensian name referring to his tendency to slope off down an alley to evade his debtors. Sloper debuted in five stories of scams from 14 August 1867 and then disappeared until 1 December 1869, when Ross was joined by Marie Duval, pen-name of his young Parisian wife, Isabelle Emilie de Tessier. After the first two weeks Duval took over the drawing and in nearly sixty yarns during the next two years established British comics' first anti-hero, a loveable, lower-class rogue. Duval, probably the first woman cartoonist in Europe, imported some of Töpffer's faux-naif line mixed with the latest slapstick physicality of Germany's Wilhelm Busch, creator in 1865 of the mischievous boys Max & Moritz. Sloper took on a life of his own: admired for his brazen cheek as if he really existed, widely merchandised and brought to life in fairs, music halls and other venues across the country.[6] In 1873 the Sloper comics were compiled into the first such book collection, subtitled ironically 'A Moral Lesson', and in 1884 he was awarded his own weekly, *Ally Sloper's Half-Holiday*. On its front pages, however, the childlike vitality of his comics was replaced by more polished but non-sequential, single tableaux, another retrograde step back to Hogarth.

Nevertheless, by this time Victorian comics for the newly literate masses were flourishing and artists were experimenting with a wider range of styles. Phil May's Cockney types and Tom Browne's tramps, Weary Willie and Tired Tim, would declutter the decorous rendering and streamline the medium with a crisper, more expressive approach, better suited to cheap printing and swifter deciphering. Starting in 1888, the weekly pages of *Pick-Me-Up* showcased short, simple, wordless comics, most from France and Germany. Synthesising the work of Russian emigré Caran d'Ache in Paris, H.M. Bateman established 'silent' purely visual strips as a successful homegrown format in, of all places, *Punch*.

With all the elements in place, the twentieth century saw British humour comics wildly diversify in style, subject and voice as newspaper strips, children's weeklies, underground comix, fanzines, graphic novels and now webcomics, blogs and apps. In the twenty-first century comics' inherent multidisciplinarity is seeing them connect and interact with all the other media, adopted and adapted by their diverse practitioners. Beyond this very exhibition, if one turning point can sum up their arrival, it may be the election in 2005 of Raymond Briggs and Posy Simmonds, the first graphic novelists (not counting Thackeray of course), into the Royal Society of Literature (fig. 2).[7] In the same way that Hogarth sent up those earlier high-minded Venetian prints or *Viz* undermined *The Beano*, *The Sun* and the Photo Love series in *Jackie*, so works like Briggs's *When The Wind Blows*, by no means a children's book, or Posy Simmonds's *Tamara Drewe*, more than an update of *Far from the Madding Crowd*, draw on many frames of reference, literary and artistic, to subvert expectations. Far from resting on their laurels, both authors are at work on their next projects. They are not alone. More tipping points in the 'polygraphic' progress of comics lie ahead.

SOCIAL SATIRE AND THE GROTESQUE

The late eighteenth and early nineteenth century is often considered a 'Golden Age' of social satire. Following the model set by William Hogarth, artists lampooned the greed, self-delusion and depravity that seemed to characterise modern consumer society. Hogarth had shown how an artist could become famous by commenting comically on the contemporary world, playing to the prejudices and anxieties of the public. His art made use of a strong sense of social and topographical specificity; the characters and settings of his paintings and prints were instantly recognisable to his contemporaries.

From the 1770s consumer society itself expanded enormously, fuelled by industrialisation and Britain's growing empire. This created new commercial opportunities for comic artists, while consumerism itself, with its fast-moving and ever more outrageous fashions and fads, proved ripe for satire. Working in this context, James Gillray and Thomas Rowlandson set challenging new levels of explicitness and grotesquery for comic art. The graphic vigour, startling violence and outright rudeness of their social satires are generally considered to have been greatly toned down by the illustrators working in their wake in the more morally straitened nineteenth century, and arguably have only been recaptured in modern times in the underground comics of the 1960s and 1970s and the present-day cartoons of artists like Steve Bell and *Viz*. (MM)

previous page: illustration by Simon Thorp for *Viz*

WILLIAM HOGARTH (1697–1764)

28. *Hogarth Painting the Comic Muse* c.1757
Oil on canvas, 45.1 × 42.5
National Portrait Gallery

29. *O the Roast Beef of Old England
('The Gate of Calais')* 1748
Oil on canvas, 78.8 × 94.5
Tate

In this self-portrait Hogarth – often considered
the 'father' of British art – shows himself at
work in his studio. He presents himself in plain
clothes and without a wig, suggesting that he
is a down-to-earth workman rather than a
fancy, wig-wearing gentleman. The figure shown
sketched on his canvas is the allegorical character
of the Comic Muse, suggesting that comedy can
be a source of inspiration for serious art.

Hogarth himself features again in his famous
painting *O the Roast Beef of Old England*, this
time tucked away behind the figure of a French
soldier at the left of the composition. Here
Hogarth makes fun of the French, playing on
established stereotypes about the greed and
power of the Roman Catholic Church and the
poverty of ordinary French people. The scene
is set in Calais, with a fat French monk drooling
over a sirloin of imported English beef. Underfed
French soldiers look at it with relish, their
'soupe-meagre' (the nasty-look gruel in the big
pot) being an unappetising alternative. Cowering
in the bottom right hand corner is a fugitive
Scottish rebel wearing red tartan, his hands
clasped in despair. He is eating what Hogarth
described as the 'scanty fare' found in France:
an onion and stale bread. Skulking in the left-hand
corner are three old fishwives, cackling over the
resemblance of a face they can see in the belly
of a fish. (TB)

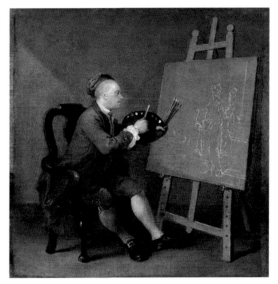
28.

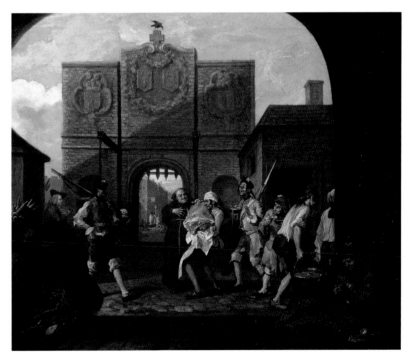
29.

49

WILLIAM HOGARTH

30. *Taste in High Life* c.1742
Oil on canvas, 63 × 75
Private collection

Here Hogarth sends up the modern fashions
prevalent among the British aristocracy. In an
ornate and fashionably decorated drawing room
an effeminate 'connoisseur' in exaggerated French
clothing and an old maid in a ridiculous dress are
delighting at the latest design in porcelain: a tiny
cup and saucer that are so small as to be almost
useless. Meanwhile, a richly dressed lady takes
an interest in the black servant boy, eyeing him
up as if he was another luxury item, as 'exotic'
as the ceramic Chinese deity he holds in his hand.
His presence may also offer a satirical comment
on his masters, who are themselves 'slaves' to
fashion. In the foreground a monkey dressed in
clothing of the day and reading a list of exotic
dishes represents mimicry, luxury and vanity. (TB)

WILLIAM HOGARTH partly assisted by
Gérard Jean-Baptiste Scotin (1690 – after 1755)

A Rake's Progress June 1735
31. Scene 3: *The Rake at the Rose Tavern*
32. Scene 6: *The Rake at the Gaming House*
Etching and engraving on paper
Each approx. 35.5 × 40.5
Andrew Edmunds, London

Hogarth's *Rake's Progress* was a hugely important
innovation in comic art. It is made up of a
series of eight images that tell the story of Tom
Rakewell, a young man who inherits a fortune
that he proceeds to squander, leading to a life of
immorality and his ultimate downfall. Each image
is like a chapter in a book, packed full of comic
details and narrative incident. Contemporaries
would have been able to recognise the different
characters and even the specific London locations
used by Hogarth.

Hogarth created the images as a series of
oil paintings (now in the Soane Museum) and
had them reproduced as prints by the very
best French engravers. These made Hogarth
famous around Europe and have been emulated,
copied and pirated many times since. Hogarth
considered such 'modern moral subjects' to
be serious and visually complex contributions
to a distinctly modern kind of art; however,
their commercial success also encouraged the
market for more straightforward comical and
satirical imagery, and their format anticipated
the narrative techniques of the comic book.

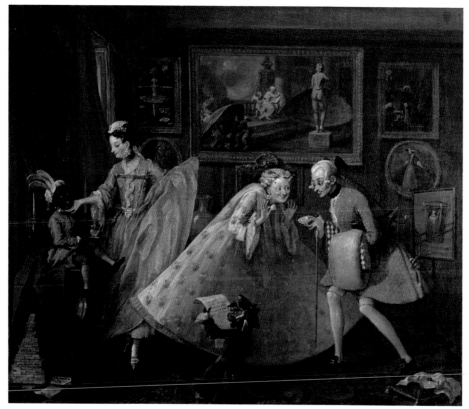

30.

Scene 3: *The Rake at the Rose Tavern*

The Rake has fallen into a life of drunkenness and debauchery. This scene shows him in the Rose Tavern (a notorious tavern-cum-brothel off Drury Lane) cavorting with prostitutes. Tom can be seen slumped on the left, a prostitute (with black pox marks on her face indicating she is syphilitic) caressing him with one hand as she robs him of his pocket watch with the other. At the table two prostitutes are in a fight, one spitting at the other who pulls a knife. To the right a prostitute is undressing in preparation for a raunchy performance. This may involve standing on the reflective silver plate, which is being brought in on the right, in order to give the clients a sneak preview of all she has to offer.

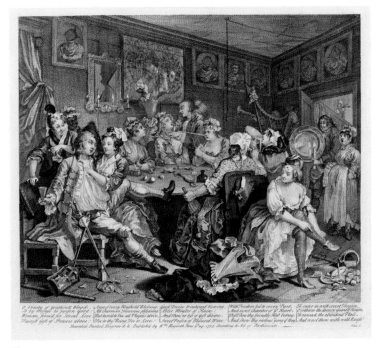

31.

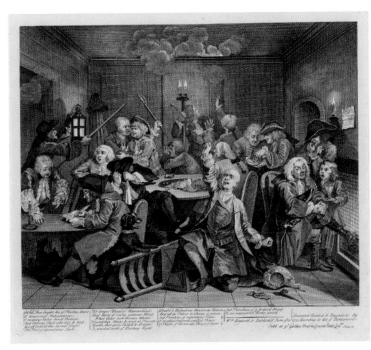

32.

Scene 6: *The Rake at the Gaming House*

With his funds replenished by his cynical marriage (in Scene 5), the Rake continues his squanderous ways at the gaming house. But he has lost another fortune and is shown kneeling and cursing his bad luck as his opponent scoops up the winnings on the table. The loss of his wig, revealing his shaved head, is a sign that he is becoming deranged. The clergyman at the same table has also lost, pulling his hat over his face in despair. On the left a moneylender is writing out a note for an aristocrat, while the highwayman warming his feet by the fire keeps an eye open for anybody worth robbing.

They are all so engrossed in their gambling that they do not notice the room is on fire: the night watchman having seen the smoke outside is coming in and raising the alarm. Tom's world is literally going up in flames. (TB)

51

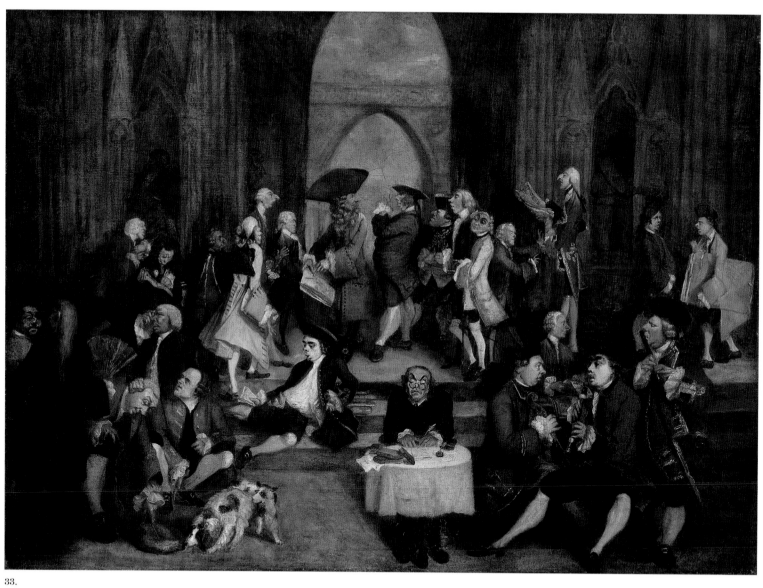

33.

JOSHUA REYNOLDS (1723–92)

33. *Parody of Raphael's 'The School of Athens'*
c.1750–2
Oil on canvas, 97 × 135
National Gallery of Ireland, Dublin

A crowd of wealthy British tourists in Italy are comically represented by Reynolds as the figures in Raphael's acclaimed composition, *The School of Athens*. Whereas the Renaissance artist had represented the greatest ancient philosophers, artists and poets engaged in high-minded debate, Reynolds shows an array of goofy, fat, skinny and silly-looking British aristocrats. While the Italian painter's exacting draughtsmanship and powerful design constituted the model of the high-minded grand style, Reynolds's picture evokes the examples of Hogarth and Thomas Patch. Reynolds became known as the leading portrait painter of his generation and, as first President of the Royal Academy, was an influential theorist and teacher. This early painting suggests an unexpected sense of humour. However, the painting must also have served him professionally, putting him in contact with a range of wealthy Grand Tourists and demonstrating the ease with which he could deal with his social superiors. (MM)

By or after JOHN COLLIER ('TIM BOBBIN')
(1708–86)

34. *The Hypocrite* c.1770–80
Oil on canvas, 65 × 100
Touchstones Rochdale

Collier was a pioneering dialect poet, who took the name 'Tim Bobbin'. He also worked as a painter producing shop signs and, most successfully, a series of vivid caricature designs to accompany poems that were published as *Human Passions Delineated* (1773). The broad humour and strongly characterised style of these prints proved to be hugely popular, and were often copied.

This painting is one of several based directly on the *Human Passions* that may be by Collier himself or by a contemporary aiming to cash in on his popularity. The broad painted style suggests a decorative or sign painter, rather than a conventional fine artist. The work illustrates Collier's anti-clerical poem:

> This hypocrite, whose holy look and dress
> Seem Heaven-born, whose heart is nothing less:
> He preaches, prays, and sings for worldly wealth,
> Till old sly Mammon takes it all by stealth,
> And leaves him naked on a dreary shore,
> Where cant and nonsense draw in fools no more.

(MM)

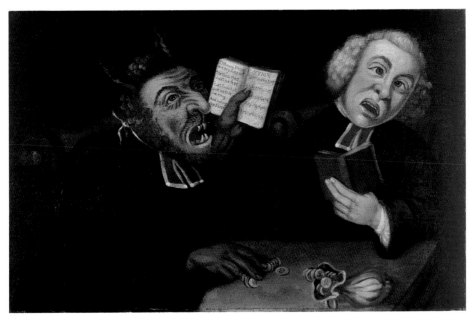

34.

35.

36.

PHILIP DAWE (1750–91)

35. *The Macaroni, a Real Character at the Late Masquerade* 1773
Mezzotint on paper, 35.1 × 25
The British Museum

36. *A New Fashion'd Head Dress for Young Misses of Three Score and Ten* 1777
Mezzotint on paper, 35.2 × 25
The British Museum

SAMUEL HIERONYMUS GRIMM (1733–94)

37. *The Macaroni* 1774
Watercolour on paper, 17.2 × 14.6
Victoria and Albert Museum

Attributed to

SAMUEL HIERONYMUS GRIMM

38. *Another Slice of Plumb Puding for Councellor Wollop* 1774
Etching on paper, 35.3 × 24.9
Museum of London

The 'Macaroni' prints satirising the outrageous fashions of the 1770s were a watershed in the history of comic art. The Macaroni style involved the adoption of outsized wigs, tiny hats, highly ornate costumes, swords and canes in what was perceived as a grotesque parody of older aristocratic styles. It was, emphatically, an urban, male style – an anticipation of the dandy style of later times. The Macaroni phenomenon marked a boom in written and visual satire, which focused on the complex, interlocking anxieties associated with the style – that modern men were becoming effeminate, that the individualism promoted by consumerism was leading to outright eccentricity

37.

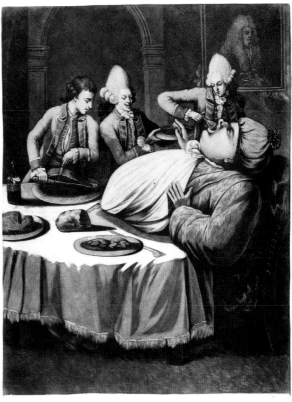

ANOTHER SLICE OF PLUMB-PUDING FOR COUNCELLOR WOLLOP.

Publish'd April 20, 1774, by I. Sledge, Hen... St... Covent Garden.

38.

and self-delusion, or that the undeserving members of the 'lower orders' (servants, the Irish) were daring to make themselves visible in polite society by adopting fashionable costumes. In the realm of female fashion there were equivalent concerns about the wearing of 'high' hair associated with a masculine-style sexual predation, ill-mannered ostentation or deceit. Graphic satire was perfectly able to articulate these anxieties to humorous effect, by dealing, by definition, with the theme of physical appearances.

The graphic culture of the Macaroni developed in 1771–3 with the long series of engravings issued by Mary and Matthew Darly. These mainly represented individuals cast as Macaronis and could be said to sit within the tradition of personal satire and private jokes associated with Grand Tour caricature. But the Macaroni print quickly became generic, with a much wider relevance. A very large number of mezzotints (a print medium normally used to reproduce paintings because of its rich tonal qualities) were produced through the 1770s. Many were anonymous, but there are groups of especially striking images designed by the Swiss-born Samuel Hieronymus Grimm and the professional printmaker Philip Dawe. These achieved an unprecedented degree of visual extravagance and stylisation.

Grimm's watercolour of a Macaroni, which was reproduced as a mezzotint print, demonstrates the level of artistic care that could be given to such images. Grimm was primarily a topographical artist, but in the 1770s had a sideline in producing satirical designs. These were published by his landlady in Covent Garden, Mrs Susanna Sledge. The fantastically gross *Another Slice of Plumb Puding for Councellor Wollop* was published by Sledge in 1774 and may derive from a Grimm design. (MM)

JAMES GILLRAY (1757–1815)

39. *Following the Fashion* 1794
Hand-coloured etching on paper, 32.7 × 35.9
The Warden and Scholars of New College, Oxford

GEORGE CRUIKSHANK (1792–1878)

40. *Inconveniences of a Crowded Drawing Room* 1818
Etching and engraving, with publisher's
watercolour on paper, 25.2 × 35.5
Andrew Edmunds, London

The basic contrasts of fat and thin, ugly and
beautiful, and old and young underlay much
of the humour of the caricature of the Golden
Age. *Following the Fashion* compounds a series
of class and sexual stereotypes. Both women
are dressed in the same fashionable costume
but are otherwise sharply visually contrasted.
The published title of Gillray's print, *Following
the Fashion: St James's giving the Ton, a Soul
without a Body, Cheapside aping the Mode,
a Body without a Soul*, adds a social dimension
to the comedy: St James's was an area in the
fashionable and affluent West End of London;
Cheapside was a street in the City that had
lower-class commercial associations.

Gillray's grotesque visual style was adopted
most successfully by George Cruikshank,
the leading caricature artist of the following
generation. In *Inconveniences* a fashionable
party is used by Cruikshank as the context
for gross physical comedy. The setting is the
glamorous interior of the Queen's House
(now Buckingham Palace), but while everyone
is dressed fashionably and the scene glitters
with rich colours, Cruikshank shows us an
array of comic collisions and slapstick accidents.
(MM)

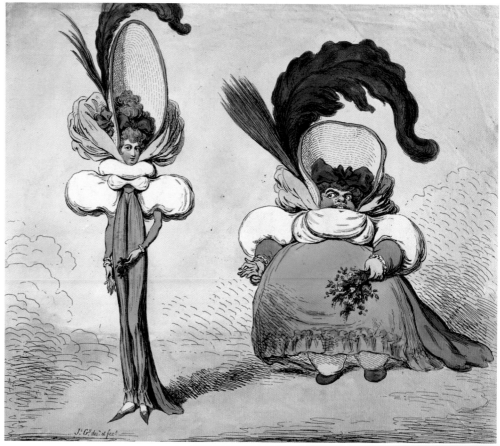

39.

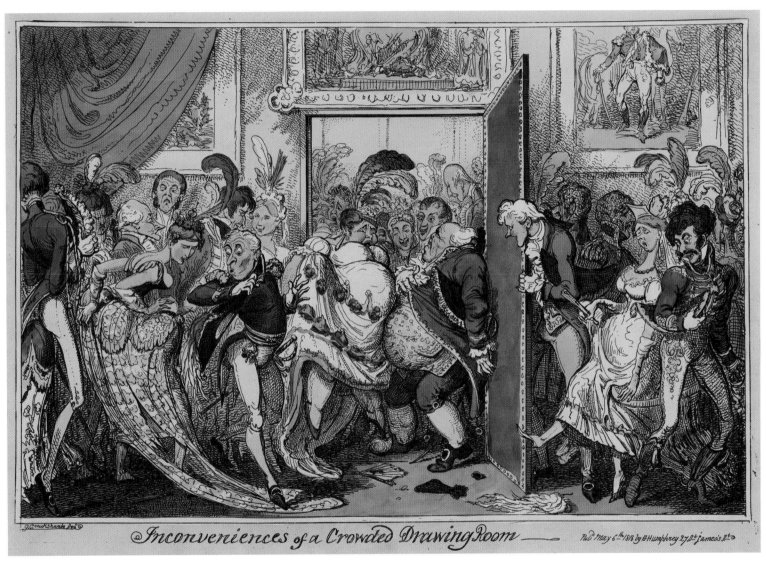

Inconveniences of a Crowded Drawing Room

40.

THOMAS ROWLANDSON (1756–1827)

41. *A French Dentist Shewing a Specimen of his Artificial Teeth and False Palates* 1811
Etching with publisher's watercolour on paper
24.8 × 35
Andrew Edmunds, London

42. *Distillers Looking into their Own Business* 1811
Etching with publisher's watercolour on paper
24.7 × 35
Andrew Edmunds, London

Thomas Rowlandson was extensively employed by the popular publisher Thomas Tegg (1776–1846) in the later part of his career. Compared to his earlier works, which display a 'sophisticated' graphic style evocative of contemporary French art and the traditions of academic draughtsmanship, these were robustly designed and usually dealt with a slapstick or grotesque theme. While they were aimed at a mass market and accordingly dismissed as 'crude' by many collectors and art historians, these are precisely the qualities that can make them feel decidedly 'modern'.

A French Dentist makes fun of the new vogue for ceramic dentures. A large woman has been fitted with a pristine new set of gnashers and is being shown off by the French dentist Nicholas Dubois de Chémant (1753–1824) to the admiration of the crooked-toothed gentleman to the right.

De Chémant had come to London in the 1790s, escaping the French Revolution and certain legal complications surrounding his claims to have been the original inventor of ceramic false teeth.

Distillers Looking into their Own Business provides a wholly gross image of unethical gin producers. Cheap gin was blamed for a host of social problems and was subject to stringent regulations. As a consequence, there was a healthy trade in illegally produced gin, which Rowlandson presents as being adulterated in a singularly unpleasant way. (MM)

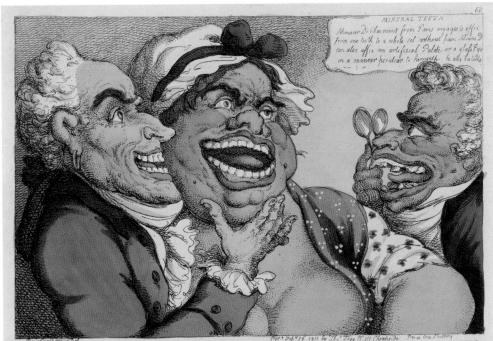

A FRENCH *DENTIST* SHEWING A *SPECIMEN* OF HIS *ARTIFICIAL TEETH* AND *FALSE PALATES.*

41.

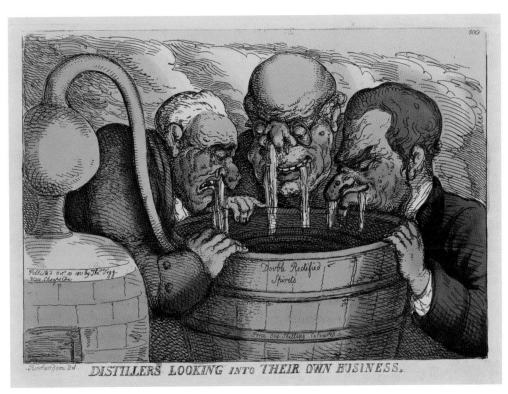

DISTILLERS LOOKING INTO THEIR OWN BUSINESS.

42.

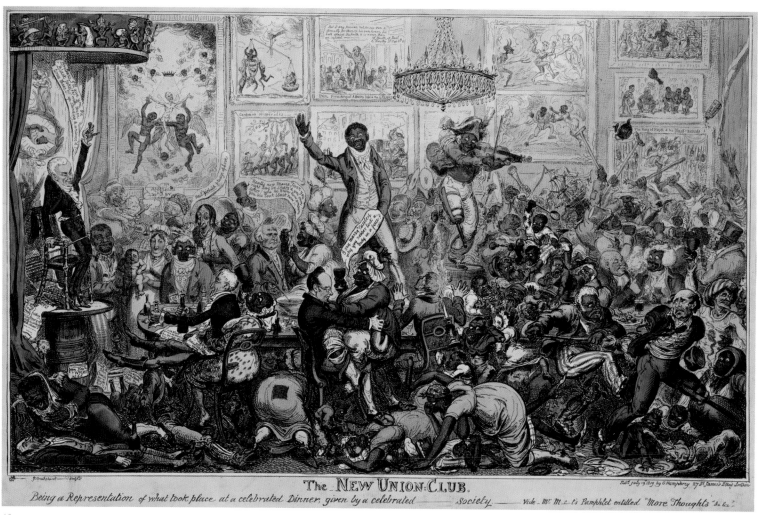

The NEW UNION CLUB.

Being a Representation of what took place at a celebrated Dinner, given by a celebrated ——— Society ——— Vide Mr M——'s Pamphlet entitled "More Thoughts" &c. &c.

43.

GEORGE CRUIKSHANK

43. *The New Union Club* 1819
Etching and engraving, with publisher's watercolour
on paper, 32 × 48
Andrew Edmunds, London

Packed full of allusions and jokes, Cruikshank's
scene of a chaotic political meeting draws
on a tradition of images of raucous gatherings
going back to Hogarth and beyond. Although
it is tempting to imagine that such images
simply illustrated the vigorous realities of urban
life or represented a healthy 'carnivalesque'
tendency lying under the surface of politeness
and liberal 'political correctness', they also
indulge a complacently middle-class sense of
anti-authoritarianism (which perhaps endures
as a feature of much mainstream satirical humour).

This drunken revel has quite a specific
political point, though. It is meant to satirise the
Abolitionists, the political movement working
to end slavery in the British empire. Cruikshank's
image is intended to evoke Gillray's earlier print
of a meeting of the Union Club (published 1801).
The 'Union' attacked in this case is the meeting
of different races as political and social equals, or
(as the coupling at the centre of the composition
suggests) sexual partners. The 'comedy' is the
suggestion that black people could dress and
behave like white Europeans, that black men
could speak for themselves (notice the young man
standing on the table, confidently proclaiming his
case), that black women could be the object
of erotic desire by white men and that the cause
of Abolition should be taken at all seriously, all of
which would require that we accept (if only tacitly)
the inferior humanity or even inhumanity of people
of African descent. (MM)

JOHN ISAACS (b. 1968)

44. *I Can't Help The Way I Feel* 2003
Wax, polystyrene, steel, expanding foam and oil paint,
220 × 150 × 170
Wellcome Collection
(not exhibited)

John Isaacs's sculpture depicts the body of a grossly
obese figure morphed out of all human proportion
to become a series of grotesque fleshy blobs. Part
fantasy, part social comment, the work anticipated
the public and media paranoia around ill health
and obesity. Though this imagery may appear to
be particularly current to the modern viewer, gross
obesity is also a theme in historical comic art by
artists such as Cruikshank and Hogarth. (CL)

44.

POLITICAL SATIRE

The essence of political satire is to point out the misdemeanours and fallibilities of politicians – those who think they're clever enough to have the ability and special qualities needed to lead us. Arrogance! Politicians are generally so thick-skinned that they actually seem to enjoy the attention: better to be caricatured than not noticed at all. It's all grist to their mill. I feel political caricature has very little effect on the general state of things; the best I can achieve is to be a rallying point for those who are like-minded. As for making an egotistical politician see the errors of his ways – fat chance. So why do I do it? Well, everybody has to do something; I enjoy it and it's a good feeling making people laugh – life without humour would be unthinkable.

GERALD SCARFE

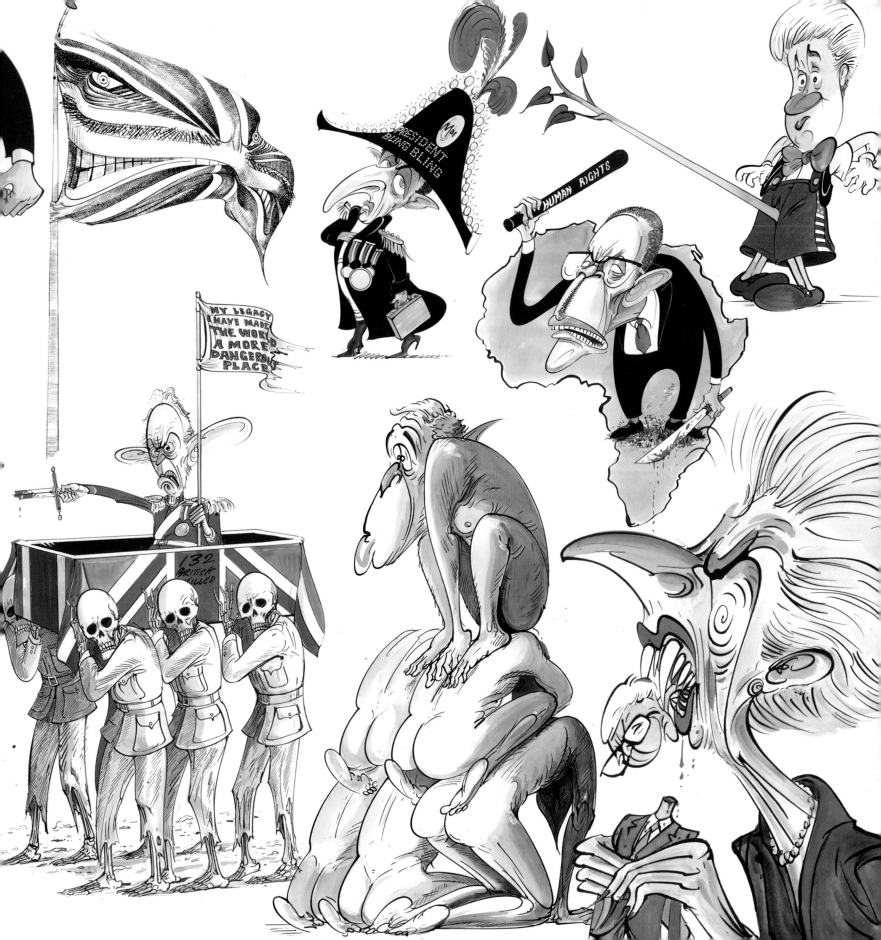

POLITICS

The economic and political changes of the late seventeenth and early eighteenth centuries ushered in a whole new environment for comic art. Economic capital, opinion and print circulated more freely than ever in a new world of debt and debate, adventure and speculation. Robert Walpole, the first 'prime minister', was the particular target of graphic satirists, standing in for the new order of politics. But political satire in the modern sense, combining allegorical and emblematic elements with portrait caricature, emerged only from the 1770s. Much of the art of visual satire has rested on effectively identifying what David Low called a 'Tab of Identity', the leading characteristic that seems to stand in for a whole personality (and policy). This has involved the pursuit of striking physical contrasts – between the thin and the fat, the uptight and the dissolute, the small and the large – sometimes invoking existing social and racial prejudices.

Political satires have often been used by historians and commentators as a measure of 'public' opinion in history and evidence of the unparalleled freedom of speech enjoyed by British people through history. However, the political efficacy of political satire must always have been in doubt. Among the early collectors of Gillray's prints were George, Prince of Wales, and several prominent politicians. The prints themselves were relatively expensive, collectable, and sometimes very clearly directed at an educated audience (with use of Latin quotes and clever literary or mythological references). So the irreverent or audacious humour of much political satire took shape in the context of elite culture, rather than in simple opposition to it. Does this remain true? Notably, the habit of collecting political caricature has continued to the present day, with notable devotees including the late Labour politician Tony Banks and the Tory peer Lord Baker. (MM)

previous page: text and illustration by Gerald Scarfe

JAMES GILLRAY (1757–1815)

45. *A Democrat or Reason & Philosophy* 1793
Etching and engraving, with publisher's
watercolour on paper, 35.3 × 24.9
Andrew Edmunds, London

46. *The Giant Factotum Amusing himself* 1797
Etching and engraving, with publisher's
watercolour on paper, 35.2 × 25.5
Andrew Edmunds, London

In place of the allegorical or punning allusions
of earlier graphic satire, Gillray produced visually
immediate political caricatures. At the heart
of this innovation lay the exaggerated physical
contrast between the Tory Prime Minster,
William Pitt the Younger (1759–1806), and
his Whig political enemy, Charles James Fox
(1749–1806). Pitt was physically slim, politically
conservative and responsible for harsh policies
on public order and taxation (notably during
his relentless 'war on terror' while Britain was
at war with revolutionary France in the 1790s).
Fox, on the other hand, was fat, a notorious
drinker and gambler, and liberal in his politics,
to the extent that he was eventually accused
of being a supporter of the French Revolution.
In *A Democrat* a farting, dancing, bloodstained
Fox is shown literally as a 'sans-culotte' (without
breeches – the term for French revolutionaries
based on the fact that they refused to wear
aristocratic breeches). *Ça ira* was the song of
the French revolutionaries, and the print's title
refers to the leading principles of the Revolution
so loathed by British conservatives: democracy,
reason and abstract 'philosophy'. In contrast,
the Giant Factotum Pitt is shown as a gigantic,
if comically skinny, colossus, standing astride the
Speaker's Chair in the House of Commons. The
suggestion is that he has achieved overwhelming
political authority: his followers cower at his right
foot, while his political enemies are crushed with
his left. (MM)

45.

46.

65

PIERANTONI (CALLED 'SPOSINO')

after Thomas Rowlandson (1756–1827)

47. *An Italian Marble Group of William Pitt the Younger as the Infant Hercules Strangling the Serpents Fox and North* c.1790
Marble, 70.2 × 70.7 × 46
Spencer House Limited

This is an extremely unusual object. On the one hand, it is a highly refined marble sculpture in the fashionable classical style, produced by a professional sculptor in Italy for a gentleman on his Grand Tour, the notoriously eccentric Frederick Augustus Hervey, 4th Earl of Bristol (1730–1803). The subject is the story of the ancient hero Hercules as a little boy, demonstrating his nascent strength by strangling snakes which had been sent to kill him by his step-mother. This is, though, a political satire based on a print by Rowlandson: Hercules has the idealised features of William Pitt, and the snakes have the heads of his political opponents Fox and North. (MM)

47.

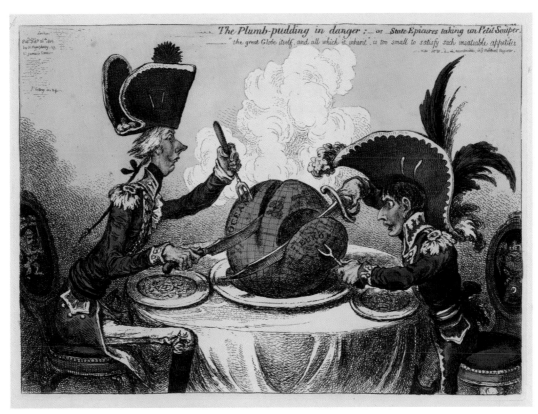

48.

JAMES GILLRAY

48. *The Plumb-Pudding in Danger: or*
State Epicures Taking un Petit Souper 1805
Etching and engraving, with publisher's
watercolour on paper, 26.1 × 36.3
Andrew Edmunds, London

This is one of Gillray's most iconic, comic images,
perhaps the most famous of all satirical prints,
which has been imitated, ripped off or emulated
many times since its initial publication in 1805
at the height of the war between Britain and
Napoleonic France.

Pitt and Napoleon carve up the world, as if
it were a huge, fleshy plum pudding. Gillray had
been in the pay of Pitt's government since the
late 1790s, but even if his prints are often broadly
pro-Pitt, they are relentlessly cynical and bleak
in their comedy; rather than simply offering
propaganda against Britain's enemy, Napoleon,
Gillray's print seems to damn both sides. (MM)

JAMES GILLRAY

49. *Maniac Ravings or Little Boney in a Strong Fit*
1805
Hand-coloured engraving on paper, 29.5 × 51
The Warden and Scholars of New College Oxford

ANONYMOUS

50. *Jaloux de leurs plaisir, epiant chaque geste. Messieurs dit Lucifer après vous s'il en reste* 1814
Hand-coloured etching on paper, 28.2 × 21.7
The British Museum

ANONYMOUS

51. *Napoleon chamber pot* early 19th century
23.5 × 43 × 28.5
Brighton & Hove Museums

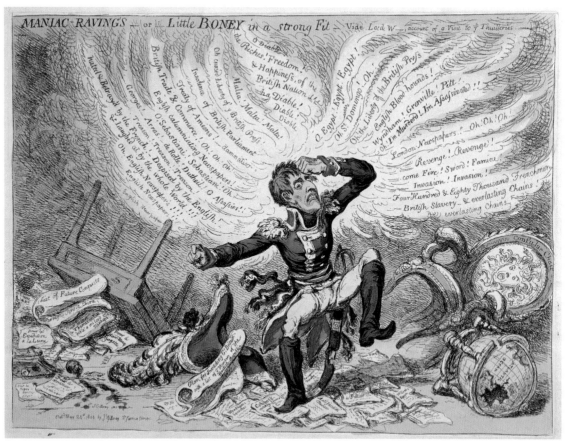

49.

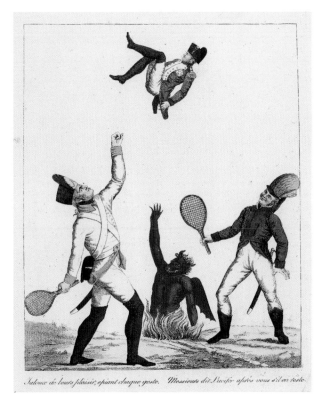

50.

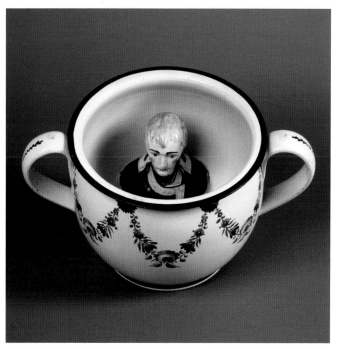

51.

Gillray's *Maniac Ravings* was published within a few days of the resumption of the war with France, after a temporary peace in 1802–3. 'Little Boney' stamps with fury, insults and threats streaming from his mouth. We know from Gillray's drawings how much thought he gave to the textual elements of his designs, drafting and re-drafting the captions and speech bubbles to get the wording just right. Such deflating characterisations of Napoleon, picking up on his relatively diminutive stature, proved enduring and cropped up in the flurry of French caricatures produced at the end of his regime. The graphic style of such prints tends to derive from conventional fashion plates and illustrations, but they often lift ideas and jokes from British satirical images. *Jaloux de leurs plaisirs*, showing the British General Wellington and the Prussian Field-Marshal Blücher making a plaything of their former enemy, derives from a contemporaneous caricature by George Cruikshank. The chamber pot shown here gives the owner the opportunity to join in with the joke in the most immediately physical fashion. (MM)

CARLO PELLEGRINI ('APE') (1839–89)

52. *William Ewart Gladstone* published in
Vanity Fair, 6 February 1869
Watercolour on paper, 30.2 × 17.8
National Portrait Gallery

53. *Benjamin Disraeli, Earl of Beaconsfield*
published in *Vanity Fair*, 30 January 1869
Watercolour on paper, 30.2 × 17.8
National Portrait Gallery

Carlo Pellegrini arrived in London from
his native Italy in 1864. After finding success
as a protégé of Edward, Prince of Wales
(later Edward VII), he came to the attention
of Thomas Gibson Bowles (1841–1922) and was
invited to work for *Vanity Fair*, the new society
magazine that he had recently launched. Pellegrini
was immediately commissioned to produce its
first portrait caricatures – Gladstone and Disraeli
– which were reproduced as colour lithographs.
As the two leading British politicians they were
prime targets, but the physical and racial (Disraeli
was of Jewish origins, to which satirists often
drew attention) contrast between them also
offered opportunities for classic comic effect
(as with Pitt and Fox in the previous century).
 Signed with the pseudonym of 'Singe'
(thereafter anglicised to the more famous
'Ape'), these images proved to be hugely popular,
initiating a long-running series of full-length
caricature portraits. Pellegrini's style owes
a great deal to the famous French satirical
artist Honoré Daumier (1808–79), who in turn
had been influenced by earlier British graphic
satirists. However, characteristically for the
period, the satirical content of such images is
relatively mild. For all their considerable technical
accomplishment and popularity, the illustrations
of *Vanity Fair* (1868–1914) and *Punch* after 1860,
are generally thought of as a low point in the
history of political satire. (TB)

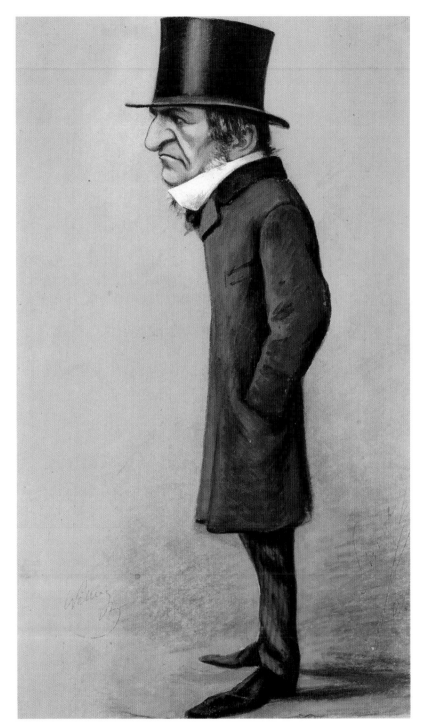

52.

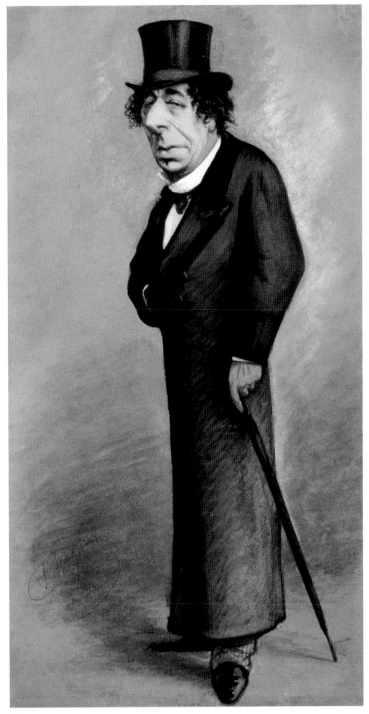

53.

HARRY FURNISS (1854–1925)

54. *William Ewart Gladstone* (c.1880s–1900s)
Pen and ink on paper, 17.9 × 11.4
National Portrait Gallery

One of the skills of the caricaturist is the identification and exaggeration of a single feature that would come to signify the subject – what David Low called the 'Tabs of Identity'. The Irish caricaturist Harry Furniss, in portraying the Prime Minister William Ewart Gladstone (1809–98), concentrated on his collar. This was born out of a sequence entitled 'Getting Gladstone's Collar Up', where his collar grows bigger and more prominent the angrier and more animated he gets. Here the 'GOM' (Grand Old Man) is shown with the trademark collar, as well as enlarged facial features as he glares at a fly on the end of his nose.

Furniss arrived in London from Dublin in 1873 and started contributing to *Punch* magazine in 1880, joining the staff artists on a retainer in 1884. He spent hours in the galleries at the Houses of Parliament sketching the various politicians during the sessions, seeking to capture the characteristic gestures and expressions of his subjects. (TB)

54.

JOSEPH FLATTER (1894–1988)

55. Illustrations to *Mein Kampf* 1939
Ink on paper with letterpress, 43.8 × 29.8
Imperial War Museum

As fascism rose to power in Europe in the 1930s
many people sought refuge in Britain, including
cartoonists. Joseph Flatter moved to England
from his native Austria in 1934 and, fearful of the
rise of Nazism, he decided to stay. Following the
outbreak of war, he was arrested and interned
as an 'alien' on the Isle of Wight, but petitioning
by David Low and others obtained his release.
He soon began working for the Ministry of
Information producing anti-Nazi propaganda
cartoons, including his series satirising Hitler's
Mein Kampf ('My Struggle'). Using captions taken
directly from the original text, Flatter's comical
illustrations undermine the grotesque narcissicm
of Hitler's autobiographical narrative. (TB)

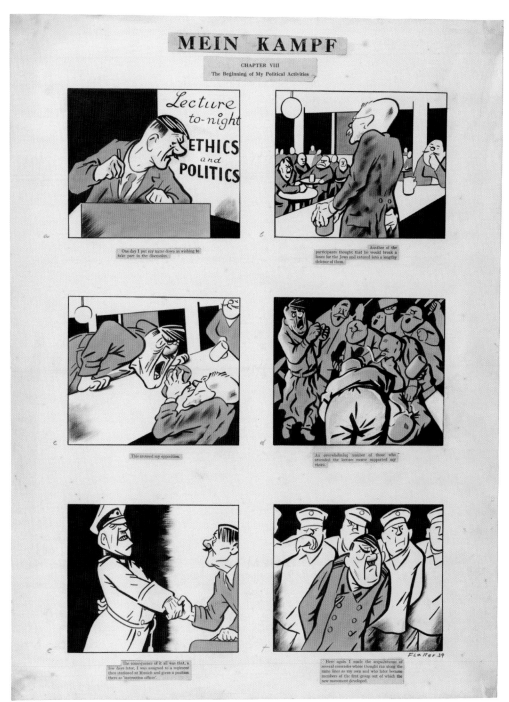

55.

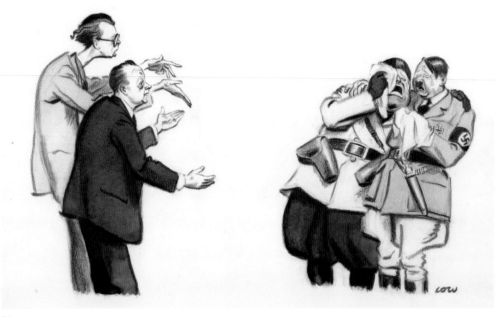

56.

DAVID LOW (1891–1963)

56. *Dick Sheppard and Aldous Huxley* 1938
Drawing on paper, 41.9 × 61
Tate

The New Zealand-born David Low is considered by many as the greatest political cartoonist of the twentieth century, noted for the level of political commitment he displayed during an era in which satire was generally seen to have become pretty tame. He recognised the threat posed by fascism in Europe at an early stage and warned against the rise of dictators, and Hitler in particular. He relentlessly parodied these figures throughout the 1930s at a time when opinion about their character and motives was split. His unflattering comic depictions of them were known to the leaders themselves: Mussolini banned the sale of publications in Italy that carried his work, and Hitler put pressure on the British government to have him reined in. After the war it was found that Low's name was high on a Nazi death list.

This image shows two well-known pacifists who advocated passive resistance to the threat of Nazism: Dick Sheppard (1880–1937) – Anglican clergyman, BBC broadcaster and founder of the Peace Pledge Union – and the tall, thin figure of the famous novelist Aldous Huxley (1894–1963). They are shown gesticulating at Hitler and Mussolini, whose ostentatiously exaggerated blubbering suggests just how effective their pleas may really be. (TB)

LESLIE ILLINGWORTH (1902–79)

57. *'What me? No, I never <u>touch</u> goldfish'*
published in the *Daily Mail*, 17 November 1939
Pen and ink on paper, 30 × 25
Timothy S Benson

A contemporary of David Low, Leslie Illingworth
has remained largely in his shadow, only recently
featuring as the subject of major monographic
studies. Based in his native Wales and working
as the cartoonist for the *Daily Mail* during
the war years (a 'reserved' occupation, which
meant that he would not be called up to fight),
Illingworth had the advantage of actually having
seen Hitler and the leading Nazis 'in the flesh'
during a visit to Garmisch, the winter sports
venue near Munich. His imaginative and visually
playful style saw him caricaturing the key
moments of the war years and beyond. This
cartoon, produced in the early months of the
war, shows Hitler and Stalin as cats eying up the
smaller fish of the Balkans and Eastern Europe.
Though they protest their innocence, it is
inevitable that they will soon pounce and devour
these smaller countries. (TB)

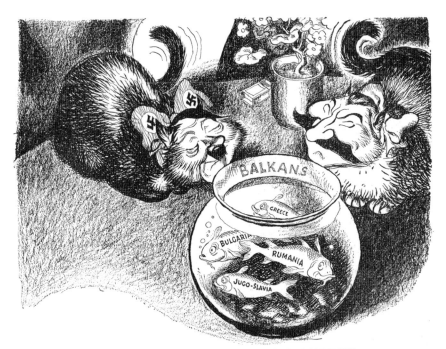

"WHAT, ME? NO, I NEVER <u>TOUCH</u> GOLDFISH"

57.

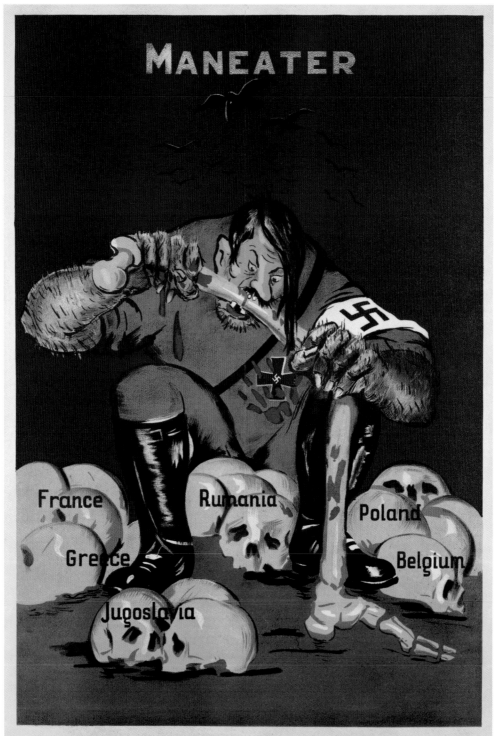

58.

Attributed to **BORIS YEFIMOV** (1900–2008)
58. *Maneater* 1941
Poster, 77 × 50
Imperial War Museum

F.D. KLINGENDER (1907–55)
59. *Russia — Britain's Ally 1812–1942* 1942
Published by George G. Harrap & Co. Ltd,
London, 1942
Private collection

Following the invasion of Russia by Hitler in
the summer of 1941, Lord Beaverbrook, the
'first baron of Fleet Street' and member of
the war cabinet, visited Moscow for discussions
with the Soviet regime. While he was there,
Stalin presented him with a collection of
anti-Nazi cartoons satirising Hitler by artists
such as Boris Yefimov and the 'Kukryniksi'
(the combined names of M. Kupryanov,
P. Krylov and N. Sokolov), and these cartoons
were subsequently used as posters in the
British war effort and propaganda campaign.
The images produced by the Soviet artists were
often much tougher and darker than anything
found in Britain at that time, perhaps reflecting
the more immediate experience of the Nazi
atrocities in occupied Europe.

In 1942 the influential Marxist art historian
Francis Klingender produced his book, *Russia —
Britain's Ally 1812–1942*, which gathered together
the early caricatures of Napoleon by Gillray
and others. It also included prints of caricatures
that Cruikshank produced after the Russian
cartoonist Ivan Terebenev, as well as more recent
Soviet cartoons of Hitler. While Stalin was careful
to distinguish between the progressive forces
fighting against the reactionary forces (Napoleon)
and its reverse with Hitler, the parallels with
the struggle against an aggressive invader 130
years earlier were clear. Both Soviet and British
cartoonists would often show Hitler in the guise
of Napoleon, wearing his trademark hat, or
depict the Nazi leader as a naughty schoolboy
not learning the lessons of history from the
French general. (TB)

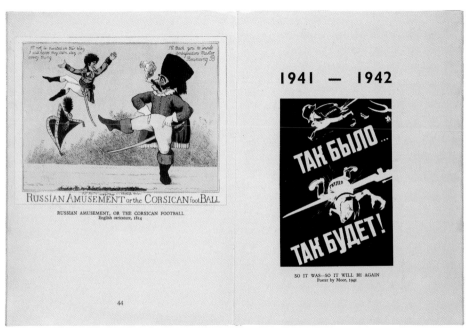

59.

GERALD SCARFE (b.1936)

60. *Belgrano Nightmare —*
Thatcher Wakes Screaming 1982
Pen and ink on paper, 84 × 59.5
The Corporate Officer of the House of Commons

The sinking of the Argentinian naval cruiser
ARA General Belgrano by the Royal Navy
submarine HMS Conqueror during the Falklands
conflict, with the loss of 323 lives, was a hugely
controversial event sanctioned by the Prime
Minister, Margaret Thatcher. The ship had been
outside of the 'exclusion zone', and the attack
galvanised those against the war. Gerald Scarfe
presents the Tory leader haunted by the skeletal
ghosts of the dead seamen, as she awakes
screaming from the nightmare. (TB)

60.

SPITTING IMAGE

61. *Thatcha! Ten Years of the Dragon* 1989
Photograph, 20 × 20
Courtesy of Spitting Image

Founded by 'Luck and Flaw' (Peter Fluck
and Roger Law), Spitting Image was the most
popular satirical TV programme of the late
1980s and early 1990s with viewing figures of
over 12 million at its peak on ITV on a Sunday
night. British celebrities and politicians were
lampooned through their cast of puppets, and
the controversial prime minister of the time,
Margaret Thatcher, proved to be their most
famous and popular character. The team
presented her as dictatorial, cross-dressing and
a dominatrix – but most of all she was entirely
masculine, one of her cabinet members (the
'vegetables') always calling her 'sir'. The character
was, indeed, voiced by a male performer, Steve
Nallon. Just as public opinion of Thatcher split
Britain, when the programme was first aired,
its cruelly satirical nature divided the press.
One reviewer for the conservative *Daily Express*
complained: 'Satire and mockery work best
when there is an underlying basic respect, even
affection for the target. Hate just turns it into
meaningless political propaganda.'(TB)

61.

STEVE BELL (b.1951)

62. *John Major – The Best Future for Britain* 1992
Pen and ink on paper, 26 × 18.5
Private collection

When 'Vicky' (Victor Weisz) portrayed Harold
Macmillan ironically as a superman – 'Supermac' –
in the 1960s it actually bolstered his public
image and backfired on the cartoonist. The
same cannot be said for John Major and Steve
Bell's incarnation of him as a hapless superhero
wearing his underpants over his trousers – the
'Superuselessnessman'. As with Low's 'tabs of
identity', in time the underpants came to stand
in for Major in his totality, so much so that at
the end of his premiership Bell simply showed the
pants burning in the Thames outside the Houses
of Parliament (a homage to J.M.W. Turner's
The Burning of the Houses of Parliament). Major's
response to satire of him was that 'it is intended
to destabilise me so I ignore it'. (TB)

62.

MARTIN ROWSON (b. 1959)

63. *Why they wanted to hold the Iraq inquiry*
in private ... 2009
Gouache over pen and ink on paper, 19 × 23
Courtesy the artist

When Tony Blair won the 1997 general election
on a wave of feverish optimism he was young,
fresh-faced and innocent – nicknamed 'Bambi'
and sometimes portrayed as such by cartoonists.
What many people perceive as the deterioration
of the hope in what his leadership might
produce was mirrored in the collapse of his
physical appearance in cartoons of him by Martin
Rowson. Rowson's early drawings of Blair were
'puppy-like', but became more and more 'raddled'
as the dream faded and reality dawned. In the
end Blair is disintegrating and decaying, the
green rotting flesh oozing from his face while
the trademark matey demeanour, toothy grin
and manic eyes remain. (TB)

ALISON JACKSON (b.1960)

64. *Blair Gives Bush a Leg Up* 2005
Chromogenic print, 91.4 × 61
Courtesy the artist and Hamiltons Gallery,
London

'Double-take' is the essence of the work of Alison
Jackson, photographic scourge of politicians and
contemporary celebrity culture. Using a cast of
look-a-likes she creates private scenes of what, at
first glance, appear to be well-known figures in
compromising situations. Just as Gillray's *Doublûres*
(cat.10) claimed to reveal the essential character
of its targets, Jackson's pictures – carefully
presented as hastily snatched, long-distance
'paparazzi' shots – set out to reveal a hidden truth
about the person portrayed. Here she reveals
what many people felt was the reality at the heart
of the 'special relationship' between the US and
Britain during the period of the Iraq war: Bush
using Blair for his own ends and Blair meekly
allowing it. (TB)

64.

KENNARDPHILLIPPS (b.1949 and b.1972)

65. *Photo Op* 2005
Lightbox, 64 × 64 × 16
Courtesy the artists

kennardphillipps – Peter Kennard and Cat
Phillipps – formed as a collaboration in 2002 to
make images in response to the Iraq war. Closely
associated with the Stop the War Coalition,
they made their photomontage artworks freely
available as downloads for people to use as
part of the anti-war protests. Rather than the
sanctified luxury art object of the modern gallery,
they see their work as part of everyday life to
be actively used for social and political change.
This image of Tony Blair capturing himself on
his mobile phone in front of the burning oil fields
of Iraq became iconic. Banksy included it in his
exhibition *Santa's Ghetto* (2006) in an empty
shop on Oxford Street, where, displayed in
the shop-front window, it shocked and amused
passing shoppers. (TB)

KARMARAMA

66. *Make Tea Not War* 2004
Poster, 84.1 × 59.4
Courtesy Karmarama

This is a humorous play on the 1960s
counterculture anti-war slogan 'Make Love Not
War', used by those who opposed the Vietnam
War. Produced to be used as part of the mass
protest march against the invasion of Iraq (2004),
this light-hearted poster became a memorable
and iconic image. As Karmarama, the design team
that produced the image, say: 'War is a stupid
thing isn't it? Disagreements that ultimately
lead to war could easily be solved over a cuppa.
Well that's what we think anyway.' (TB)

65.

66.

WORSHIP OF BACCHUS,

PAINTED AND ETCHED BY

GEORGE CRUIKSHANK,

AS DESCRIBED BY HIMSELF.

LONDON: WILLIAM TWEEDIE, 337, STRAND.

M.DCCC.LXV.

On the Sea-shore are Gibbets on which hang Pirates.

A Shipwreck.

Fires at Sea.

Many, very many, of these terrible *accidents*, as they are called, and horrible deeds, are occasioned by the "Worship of Bacchus."

A Suicide.

BUMPERS THREE TIMES THREE IN AID OF CHRISTIAN CHARITY

"The Haymakers," drinking whilst at work,

"Dinner Worship."

A Mayor's feast, at which he must give wine liberally to the guests, or he would be denounced as a shabby fellow. Upon these occasions there is always most respectable but enthusiastic worship of the jolly god!

The Mayor seated on his Seat of Justice, who is quite horrified at what the police are telling him about the drunken woman and her baby; but he ought to reflect that she has been brought to this condition by the very same stuff that he was giving the night before to the ladies and gentlemen and the sheriffs at his own table.

The Fox-hunters round their Dinner Table

"Jolly Sailor" Public House. The poor Sailor is being flogged.

The "Grog" is being served out to the sailors; they are flogged for drinking it; the naval officers very jovial at their mess tables; the officers trying a brother officer by court-martial for getting drunk

BREWERY

THE JOLLY SAILOR

"Jolly Brewer," under which there is an

Election for a Member of Parliament,

upon which occasion there is generally a large amount of drinking, as well as a loud cry for Parliamentary reform.

VOTE FOR SAWBONE, BARLLYCORN AND CHEAP WINE GIN BEER

The too numerous Breweries and Distilleries throwing their smoke over, and, at the same time, poisoning the length the breadth of the land; and the drink they make is taken to such an ex and in such excess, that even moderate drinkers designate *drunkenness* a GREAT CURSE OF THE COUNTRY.

"The Angel,"

"licensed to be drunk on the premises," and adjoining that is a building containing a "Police Station," the right wing of which is a "Reformatory," and the left wing a "Ragged School." In way with strong drink, and the police—as they themselves say—would have little to do, and there would be very few poor children to reform, and so scholars for the "Ragged Schools."

THE ANGEL

LICENSED TO BE DRUNK ON THE PREMISES

REFORMATORY

the public singers chanting forth the of "the god of w

opera dancers, holding up their glasses to Bacchus, and by their side a lame old man

a harlequin, pantaloon, scaramouch, and a clown, all very jolly with their cups, and "in their cups," at a "masquerade and supper," where there is always plenty of wine, gin, beer, and brandy, and where drunken "masquerade" fiends drag down columbines to drunkenness and ruin.

Dreadful cruelty to children by their parents, a man sacrificing his wife and child

jolly is about to who is him

GRAND MASQUERADE SUPPER

A ruffia

BACCHUS,

a genteel, smiling youth,

accompanied by the drunken brute,

Silenus,

show what a little more drink
excess produced in the man,

and in the accompanying

Bacchante,

that the pure and modest charm of
beauty in the woman was destroyed
and degraded by anything like *indul-
gence* in stimulating drink.

GENERAL HOSPITAL

HOUSE
OF
CORRECTION

UNION
WORK-HOUSE.

MACDALEN H

CEMETERY

CANTEEN

This part is intended as the "high altar" of the Pagan deity, and below
the statues are the priests and priestesses officiating, or, in other words, the
publicans, their wives, potboys, and barmaids handing the
intoxicating liquors over the bar, and taking the money from the
worshippers. One of these publicans is worshipping so devoutly himself
that he is falling a sacrifice to his deity as well as many of his customers.
This is unfortunately too often the case and there is a disease of the viscera
called the "publicans' disease," and very many of these persons also die
from *delirium tremens*. I know of many such cases; indeed not very far
from my own residence there are three public houses very near each other;
at one, the landlord was so afflicted with *delirium tremens* that he was obliged
to keep a keeper with him; and at the same time, within twenty yards
from that house, the son of another publican died from the same disease;
and about twenty yards beyond that house the publican was so afflicted
with *delirium tremens*, that he hung himself! He had gone upstairs to
lie down, and his wife sent their little boy to call his father down to tea. The
child returned, and said, "Mother! Father's got my sash, and he won't give it me."
The woman rushed upstairs fearing something wrong, and found that her
poor wretched husband had hung himself with his child's sash!

"Freemasons," the "Foresters,"
the "Odd Fellows," the "Old
Friends,"

and I may add the "Old Fools." I introduce these
societies because so many hold their meetings at gin-
shops, and by so doing, many, many of their members
are brought to ruin—yes, go to destruction, dragging
their wives and children after them.

A "Canteen" or Military Public-house,
where soldiers sometimes take too much drink, and for which
they are sometimes tied up to the halberds and flogged.

Painting, Poetry, and Music,
celebrating the praises of the "Rosy God," and holding
up their cups of alcohol, in which they are joined by
a **Chemist,** who *ought*, of all others, to know better
than to use a poison as a beverage.

offering up
dal to Bacchus

a woman
offering up her child

Thieves handing up handkerchiefs,
pocket-books, and stolen plate.

"Prize-fighters"

Men committing Suicide
with poison, pistol, razor and dagger

influence of "grog,
murdered by a ruffian
ce of drink.

Fighting the Police
ir Belts

a fellow
shooting
a girl.

two thieves, primed
with gin and beer, garrotting
and robbing a gentleman,
who has been "dining out."

Indians splitting
each others' Skulls
with their Tomahawks,
under the influence of
the "firewater."

SHEBEEN
SONS C

ting a woman
e is one mass of
d bruises;
witnessed in broad
day afternoon
woman both
ce of drink.

A Poacher Shooting
a Gamekeeper.

Man knocking his Wife down
with a Baby in her arms.
saw this at eleven o'clock one day, in the "city of London,"
and I heard the poor woman's skull crack on the pavement.

The "whisky shebeen,"
where the "sons of harmony"
are killing a policeman

A Madman in a "Strait Waistcoat;"
"Mad Tom" and his "mad companions" of the bottle.
"Mad Tom" is dancing on the tomb of his relations, having sacrificed
at the shrine of Bacchus. Many families are destroyed by one of their members being a drunkard.

a woman stabbing
her husband

SACRIFICED
AT THE SHRINE OF BACCHUS
FATHER, MOTHER, SISTER
BROTHER, WIFE, CHILDREN,
PROPERTY, FRIENDS
BODY AND MIND.

the police carrying away a woman
dead drunk upon a stretcher.
I am informed upon good authority that
upon an average there are eighteen drunken
women carried upon stretchers every week
to the police station in Bow-street,
Covent-garden.

Widows and Orphans
brought to misery, starvation, and, perhaps, death, through the husbands or
the parents drinking the liquor, sold by the publican and manufactured by the
distiller and the brewer—the *respectable* publican, and the *highly respectable*
distiller and very wealthy brewers and distiller.

GEORGE CRUIKSHANK (1792–1878)

67. *The Worship of Bacchus* 1860–2
Oil on canvas, 236 × 406
Tate

This huge painting by Cruikshank had grand ambitions in its day: to shock broken Britain into giving up the bottle and living a life of abstinence. This is a painting with a serious moral aim to change society for the better.

George Cruikshank was primarily a comic cartoonist, the son of Isaac Cruikshank, also a graphic satirist. The dangers of drink were well known to the younger artist: his father died at the age of fifty-five after downing a bottle of spirits during a drinking contest. This did not deter the young Cruikshank, who enjoyed drink and the high jinks that went with it. However, in producing his Hogarthian print series *The Bottle* (1847), he realised the drastic effects of alcohol on society and joined the growing abstinence movement.

In 1859 Cruikshank had the idea of producing a large painting about alcoholism in Britain, with the plan to sell prints of the image and tour the painting to raise funds for the abstinence movement. The complex and detailed canvas contains vignettes of the slippery slope of alcohol consumption. The harmless early beginnings of drinking such as celebrating a birthday and toasting the health of the young bride are shown in the foreground. But as the scenes progress up through the middle part of the composition, there is increasing drunkenness and violence, leading eventually to outright anarchy and destruction. In the background are various buildings referring to the ultimate outcome of excessive drinking, including the jail, workhouse and lunatic asylum. Presiding over all of this in the centre of the picture is a huge statue of Bacchus, the Roman god of wine.

After his initial enthusiasm for the project, the production of the painting and the print after it proved to be a long, financially difficult and laborious task for Cruikshank. The first exhibition of the huge canvas was held at a small gallery next to the Lyceum Theatre in London on Monday 4 August 1862, but was disappointing, with few people attending the display. The exhibition tour of the painting around the country fared little better, and the National Temperance League finally disowned the project. The fate of the painting was secured in 1869 when a group of temperance subscribers bought it for the nation and it was displayed at the South Kensington Museum. After various loans to regional galleries and its final public display in Newcastle in 1909, the painting was rolled up and languished in storage, being transferred to the Tate collection in 1959. Restoration of the painting was finally undertaken for the displays launching Tate Britain in 2001, and the layers of black soot and darkened varnish were removed to reveal the work once more.

Following Cruikshank's death in 1878, his will revealed some interesting insights into his life: he had a mistress with ten children living near his family home. The woman's name was Adelaide Archibold, and he left to her capital in trust, as well as 'all such furniture books wines and household effects belonging to me'. At the mention of his 'wines' one may wonder about his devotion to the abstinence movement and the extent to which his lifestyle had really been reformed. (TB)

previous page: detail of a key to Cruikshank's *Worship of Bacchus* by Steve Bell

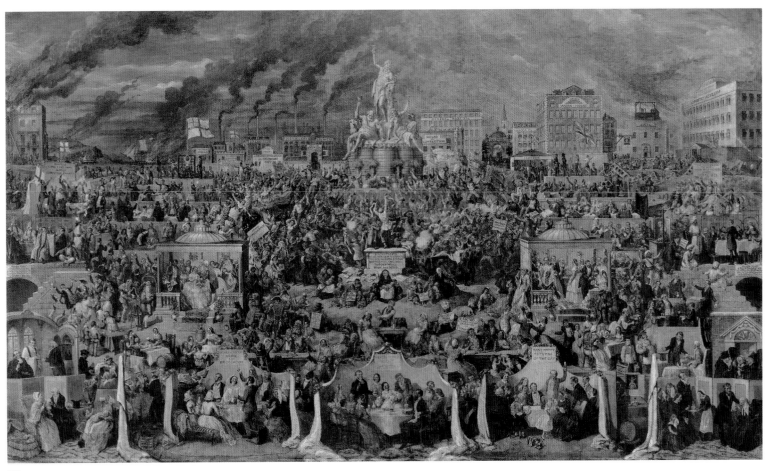

67.

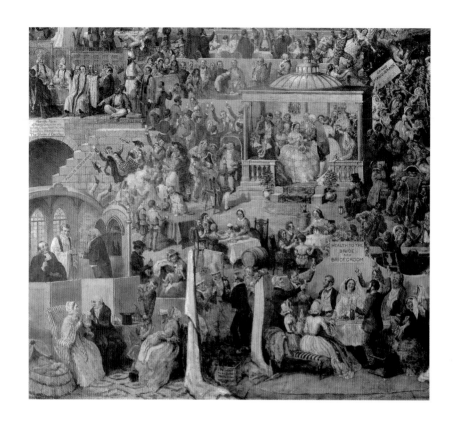

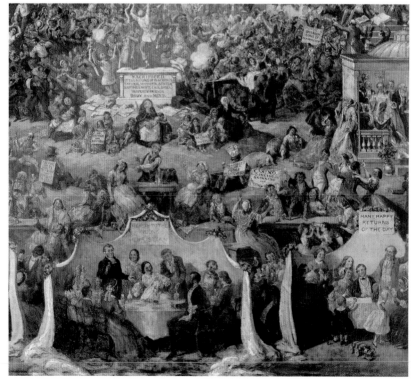

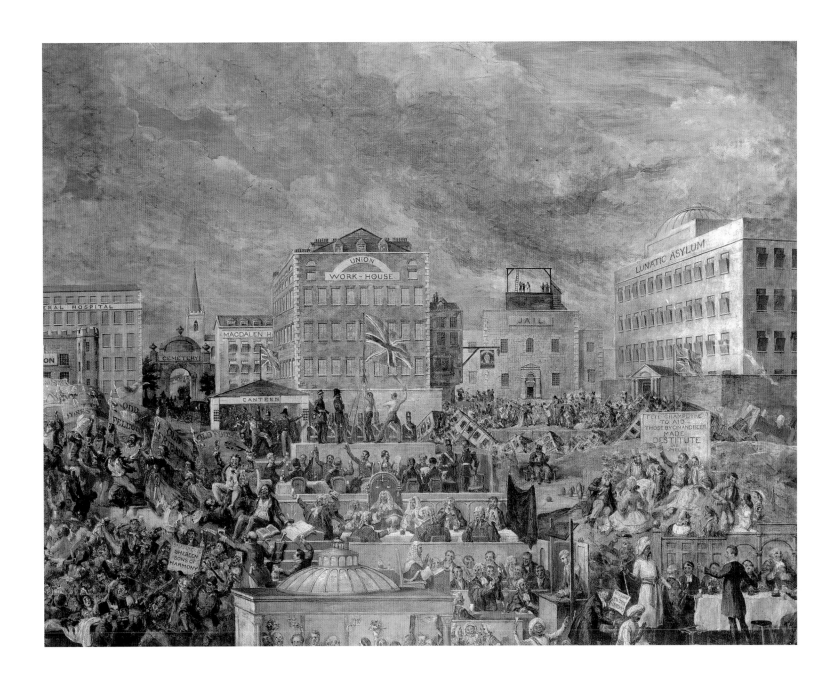

opposite and above: details of cat. 67

THE BAWDY

As Sally O'Reilly explores more fully in her essay on pp.110–11, it would be pretty hard to overlook the presence of robust sexual humour in British culture, from the low-life narratives of Hogarth, through the gross bodies of Rowlandson and Gillray, to Benny Hill, *Are You Being Served?* and Kenny Everett. Rude puns, sexual jokes and erotic imagery have a strong role to play in much contemporary art, often informed by a critical and self-aware sexual politics. Indeed, the conventionally ordained 'low points' of British comic art could be identified as those periods when it lacked a bawdy edge (notably, the prudish Victorian era, and perhaps much Modernist art). Psychoanalytic theories of humour, after Freud, would insist that almost all comedy derives from sexual anxiety, with jokes marking the letting-slip of lost or sublimated desires. Social-historical theories of comedy might suggest that sexual laughter represents a point of resistance to social and political control, a joyous eruption of basic bodily functions against the existing order. Such notions persist in many accounts of graphic satire, which would insist that caricature represents a hearty tradition of resistance to 'political correctness': perhaps, though such accounts can appear to be suspiciously complicit with the complacent anti-liberalism of dominant masculine culture and conveniently overlook the sexual, social and, indeed, racial underpinnings that can be uncovered in traditional bawdy humour. George Orwell inadvertently exposed this racial foundation for the British bawdy in commenting on Donald McGill's saucy seaside postcards (these being genetically linked to the images of rotund women by Rowlandson in the past, and by descent the familiar figures of Beryl Cook's paintings of the British social scene): 'There can be no doubt that these pictures lift the lid off a very widespread repression, natural enough in a country whose women when young tend to be slim to the point of skimpiness … The Hottentot figures of the women are caricatures of the Englishman's secret ideal.' (MM)

68. *What a Nice Bit* 1796
Etching, engraving with aquatint, with
publisher's watercolour on paper, 24.8 × 35
Andrew Edmunds, London

The tragically short-lived Newton has been
rediscovered in recent years as a prodigiously
talented and prolific caricature artist of the
1790s. Although he produced political and social
satires on contemporary themes, his work is
characterised by a vigorous graphic style and
comic immediacy that feels distinctly modern,
even compared to Gillray and Rowlandson.

Here a frail-looking, rubbery-faced man in
a nightgown is contorted with sexual excitement
at the sight of the exposed, full breasts of a
woman in bed – a simple comic situation, making
fun of the mismatch in their bodies and the loss
of masculine self-control. Newton's prints often
suggested a radical political outlook, but what
is the joke here, really? That the woman is black
can hardly be incidental. Black women, and
sometimes men, crop up in the graphic satire
of the Golden Age as the object of humorously
exaggerated sexual responses. The black
presence in British society was considerable
by the end of the eighteenth century, but there
seems to be more at stake here than simply
reflecting social realities: stereotypes of the black
body (the expansive and yielding female form,
the super-muscular male) served as a symbol of
an intensified, animalistic sexuality that perhaps
helped undermine a fuller sense of the human
reality of the white European's racial 'other'. (MM)

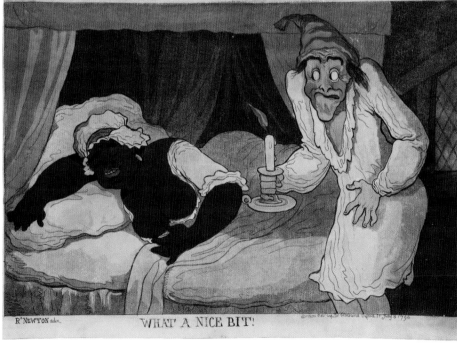

WHAT A NICE BIT!

68.

93

THOMAS ROWLANDSON (1756–1827)

69. *Cunnyseurs* c.1812–27
 Hand-coloured etching on paper
 14.6 × 15 (cropped)
 The British Museum

70. *Sympathy II* c.1812–27
 Hand-coloured etching and aquatint on paper
 20.9 × 17 (cropped)
 The British Museum

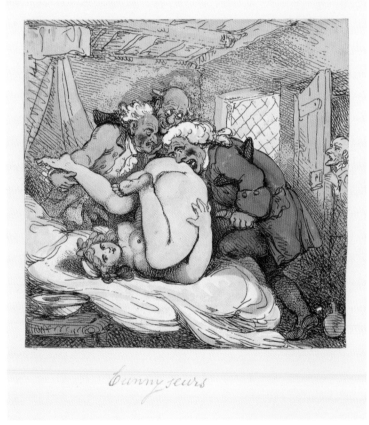

Cunny seurs

69.

These two prints are part of a series of sexually explicit images produced by Rowlandson early in the nineteenth century. These appear to be exceptionally rare impressions created in the 1810s or early 1820s. The series was reproduced in the 1840s and have been reprinted and illustrated as classic examples of 'erotic art' ever since.

Although bawdy and suggestive themes were prevalent in Rowlandson's work as a social (and more rarely political) satirist, and particularly in the works he produced for the popular publisher Thomas Tegg (1776–1846) in the 1800s, these prints focus more intently, exclusively and explicitly on sexual activity. They resemble, in that sense, what we would call pornography (the term had only emerged in France in the 1790s) – specialized, secretive imagery intended primarily to arouse. Across the series we encounter an array of humorous situations, with scenes of robust lovemaking in public contexts, masturbation, sexual display and a lot of excited looking (and comical overlooking).

In 'Cunnyseurs' a trio of old gentlemen examine the gymnastically exposed genitals of a curvaceous young woman, while another man (a servant? landlord? father?) creeps into the room. The title casts them as 'connoisseurs', playing on a tradition of comic imagery suggesting that the intense aesthetic attention of such men was misplaced, unhealthily myopic or provided a surrogate for more healthy or normative erotic looking. In this case, though, they apply a 'connoisseurial', discursive mode of appreciation to the immediate presence of female flesh ('cunny' being a diminutive form of 'cunt' – 'a nasty name for a nasty thing', according to Francis Grose's much reprinted *Dictionary of the Vulgar Tongue* of 1785, letting slip the misogyny that might be involved here). The rural setting of *Sympathy II* evokes a tradition of cottage-door imagery aimed at the sentimental tastes of the time. In this case, however, it provides a context for youthful lust among the workers, infuriating an ageing cottager who seems mistakenly to attribute their disturbing rumpus to the dogs. (MM)

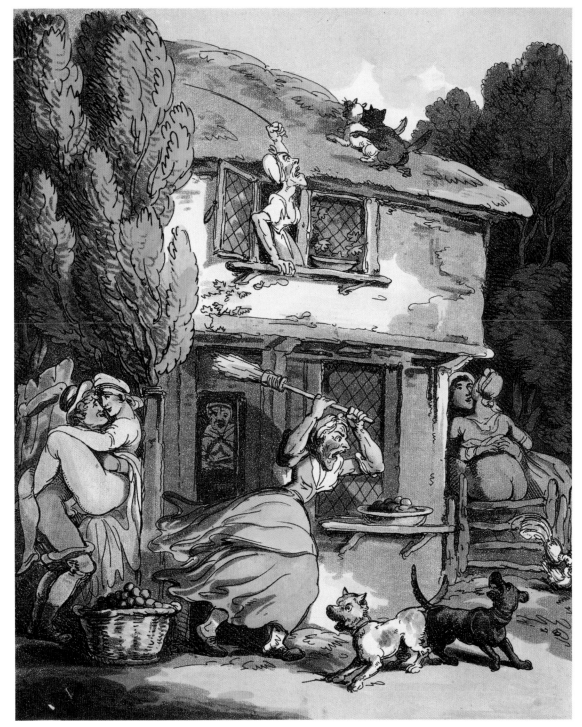

70.

AUBREY BEARDSLEY (1872–98)

71. *The Lacedaemonian Ambassadors* 1896
Pen and ink on paper, 26 × 17.8
Victoria and Albert Museum

GERALD SCARFE (b.1936)

72. *Aubrey Beardsley* 1967
Pen and ink on paper, 84 × 59.5
Courtesy the artist

The erect penis is the archetypal comic motif, the exemplary taboo image that pops up in an array of visual contexts to, almost inevitable, humorous effect. It is even more often evaded, disguised, substituted and denied (if only incompletely – hence the comic potential of bananas, sausages, sticks of rock, etc.). The bathetic physical reality of all but the most unusually well endowed men underpins an array of sexually based pyschological anxieties that have been played up for comic effect, and the effective graphic realization of a tumescent cock presents a considerable technical challenge, given the lack of established graphic conventions. Foremost among phallically inclined artists is Aubrey Beardsley, whose impressively endowed fawns and boys produced as erotic illustrations to the ancient Greek writer Aristophanes' *Lysistrata* in the 1890s have been models for many later graphic artists. (MM)

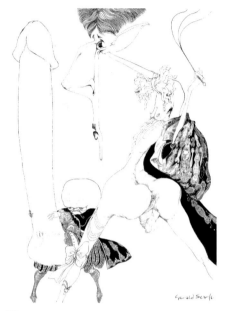

72.

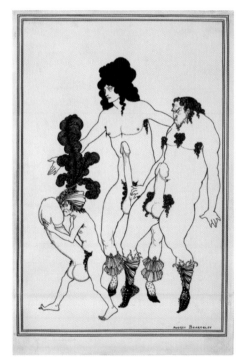

71.

GRAYSON PERRY (b.1960)

73. *Image for a Pot about Hans Christian Andersen*
2004
Pen and ink on paper, 29.5 × 21
Private collection

Grayson Perry's work as a ceramicist and graphic artist, and his public persona, express an unconventional relationship to sexuality. This work is a preparatory sketch for an element of one of Perry's ceramics, *In Praise of Shadows* 2005, about the Danish writer of fairytales Hans Christian Andersen (1805–75). It depicts a veiny penis that has taken on the role of a male escort for a dainty Victorian lady. Other than this strange metamorphosis the image is straightforwardly illustrational, thus evoking the world of children's books as well as Andersen's complex sexuality (including his possibly repressed homosexuality). It is perhaps the highly traditional setting around the phallus that makes the picture so strange. (CL)

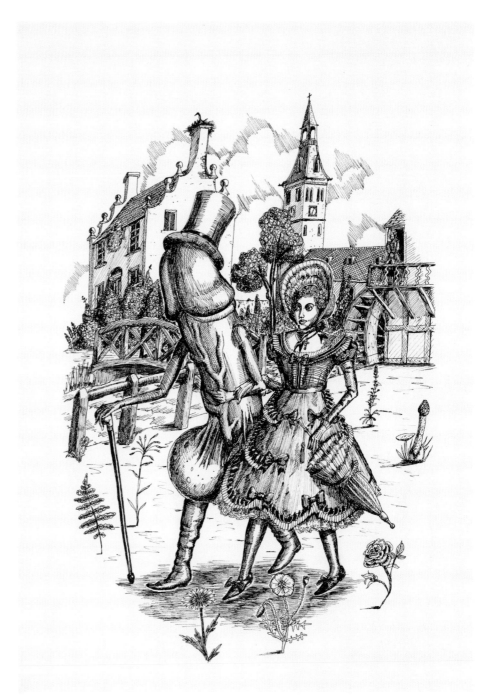

73.

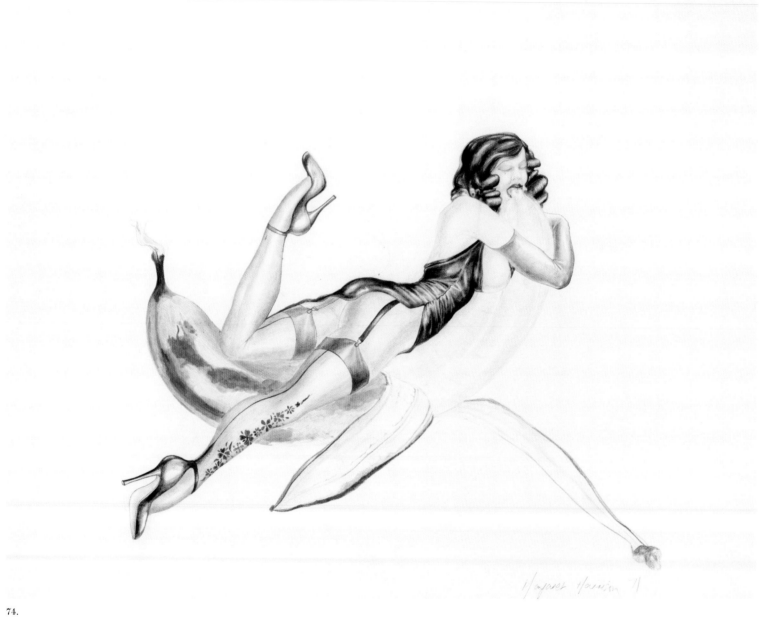

74.

MARGARET HARRISON (b.1940)

74. *Banana Woman* 1971
Graphite pencil and watercolour on paper
51.8 × 63.7
Tate

Margaret Harrison's work *Banana Woman* gives
a feminist take on popular pin-up style imagery.
Both humorous and political, it shows the leading
lady enjoying the phallic nature of a peeled banana
from a distinctly female viewpoint, thus turning
the notion of a pin-up on its head. The image is a
sexy fantasy, which like many of Harrison's works
of this period links sex with food and places
woman in a dominant role within her pictorial
narrative. (CL)

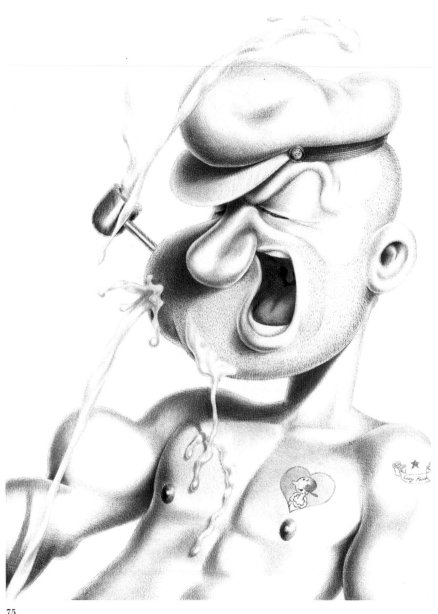

75.

CARY KWOK (b.1975)

75. *Here he Pops* 2007
Ink on paper, 29.7 × 21
Courtesy the artist and Herald St, London

Cary Kwok is interested in sexual iconography
through history. Meticulously drawn with blue
ballpoint pen and often imbued with an overtly
humorous gay sexuality, his works have featured
portraits that mix historical characters from
fashion, popular culture and comic books. Kwok's
imagery also refers to the works of the homoerotic
illustrator Tom of Finland (1920–1991). (CL)

DONALD MCGILL (1875–1962)

76. *A Stick of Rock, Cock?* 1952
Original postcard attached to Director of
Public Prosecution's index card, 21 × 15.5
British Cartoon Archive, University of Kent

The saucy seaside postcards designed by
Donald McGill and his imitators have come
to epitomise the fun and naughty nature of the
British seaside holiday. They were hugely popular
with the British public, selling over three and
a half million copies in 1953 alone. However, the
sexual nature of their content drew the attention
of the law, and from 1951 many local authorities
started bringing prosecutions against their
sale for obscenity. In a sustained campaign the
Director of Public Prosecution, Sir Theobald
Mathew (1898–1964), began collecting the
offending cards and noting down the outcome
of the various trials to ensure consistency.
This card (which is attached to the original
archiving form) was prosecuted over ten times
in seaside towns around the British coast,
with 'Order for Destruction' (i.e. found guilty
of obscenity) directed by the magistrates in
Penzance (22/9/1952), Torquay (2/10/1952),
Brighton (9/7/1953) and Weymouth (16/10/1953)
among others. (TB)

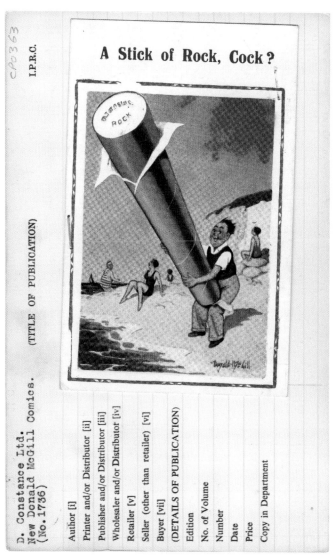

76.

BERYL COOK (1926–2008)

77. *Anyone for a Whipping* 1972
 Oil on panel, 61 × 31
 Private collection

78. *Ladies' Night (Ivor Dickie)* 1981
 Oil on panel, 46 × 54
 Tony and Gay Laryea

Beryl Cook has a claim to be one of the most
genuinely popular visual artists of her generation.
Her imagery of plump men and women drinking,
laughing, flirting and leering in bars and in the
street have become hugely well known through
affordable reproductions. Her supporters
would also draw attention to her considerable
achievements as a draughtsman and painter, and
the acute nature of her social vision.

 Anyone for a Whipping! originated as a cheeky
Christmas gift to the artist's husband and displays
the characteristically robust proportions of
Cook's female figures. *Ladies' Night* is a typically
vigorous vision of British nightlife. (MM)

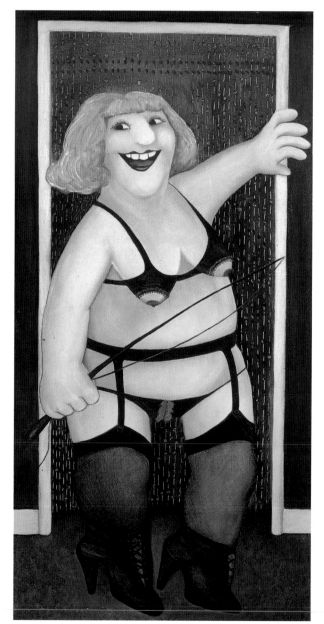

77.

102

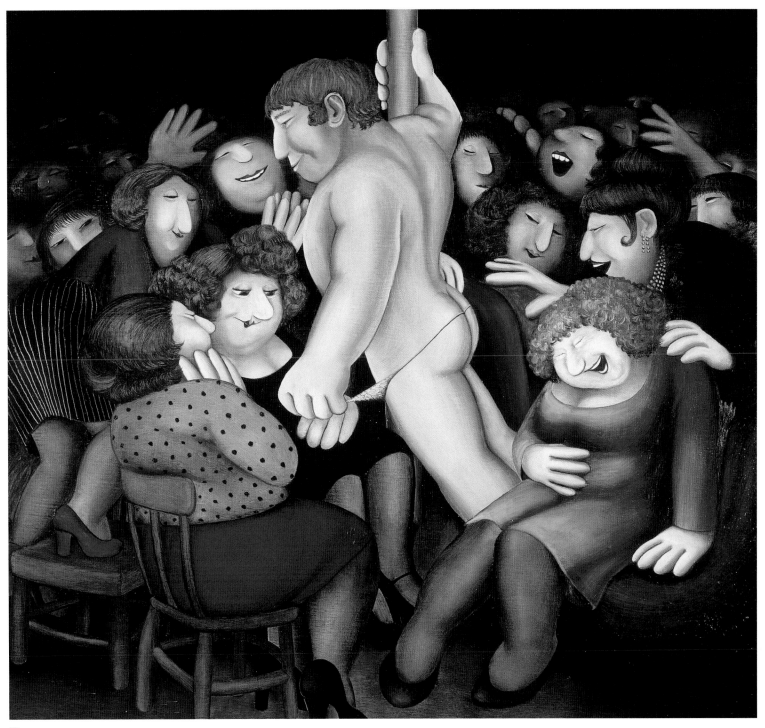

78.

GRAHAM DURY FOR VIZ

79. *Sid the Sexist Roman Orgy* January 2010, Issue 192
Ink on board, 33 × 33
Courtesy of *Viz*

Viz magazine was the original foul-mouthed British comic book for grown-ups. No subject was out of bounds and often the more grotesque or salacious the better. Born in 1979, the magazine parodied stereotyped characters from everyday life, as well as other comics such as *The Beano* and *The Dandy*. *Viz*'s outlandish humour has always been shocking and extreme. However, after more than twenty years much popular comic expression has now caught up with their vision of the world. (CL)

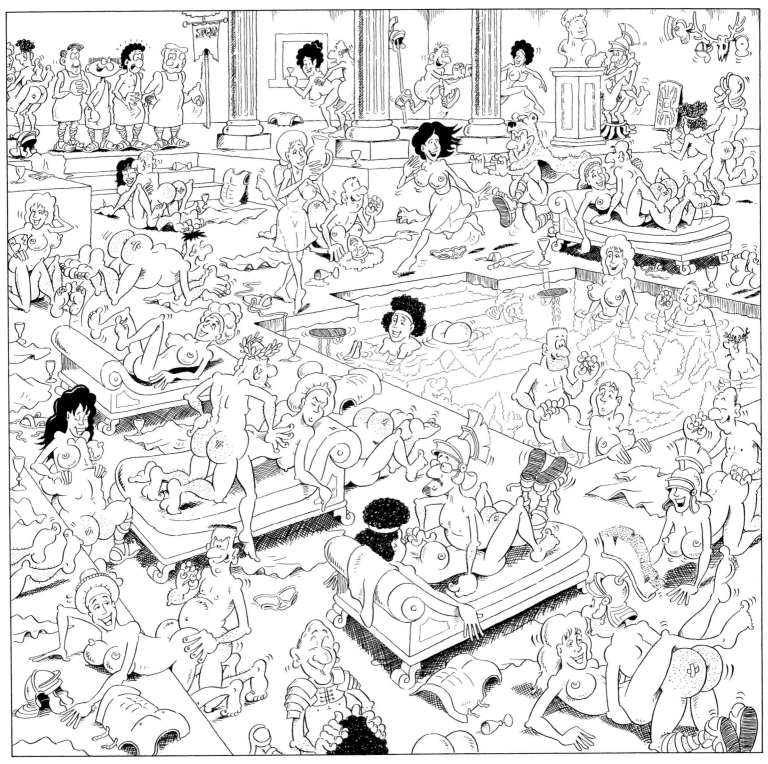

79.

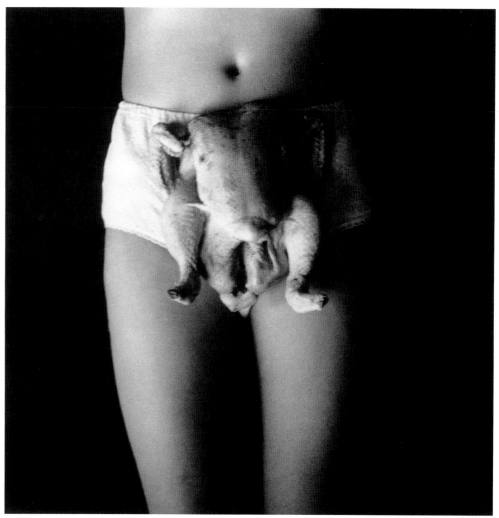

80.

SARAH LUCAS (b.1962)

80. *Chicken Knickers* 1997
Photograph, 42.6 × 42.6
Tate

81. *Five Lists* 1991
Pencil on paper in brown envelope, series of 25,
5 sheets, each sheet 23 × 18
Courtesy Sadie Coles HQ, London

Sarah Lucas's work often plays with a vernacular
language, turning laddish jokes into aggressive
visual imagery. The work *Chicken Knickers*,
for example, takes a phrase that might be
used as banter in a pub and illustrates this in
a matter-of-fact no-nonsense way to shocking
visual effect. Her earlier work, *Five Lists*, takes
swear words associated with sex and turns them
into a visual concrete poetry. By doing this, Lucas
exposes the ineptitude of the words and also
their beauty. (CL)

106

ARSE EATER
ARSEHOLE BANDIT
BENDER
BROWN HATTER
BROWN NOSE
BUMBOY
BUMCHUM
FAGGOT
FAIRY
FIST FUCKER
FRUIT
GAY
HOMO
LIMP WRIST
PANSY
POOF
QUEEN
QUEER
RAVING IRON
RENT BOY
SHIT CUNT
SHIT STABBER
TART
TEAPOT
WOOFTA

81.

TIM NOBLE (b. 1966) and **SUE WEBSTER** (b. 1967)

82. *Serving Suggestion* 2004
 Replica baked beans and sausage, tin can,
 electronic mechanism, MDF plinth
 30 × 30 × 122
 Courtesy the artists

Tim Noble and Sue Webster are interested in the
way mundane aspects of popular culture can yield
surprising pleasures. Their work *Serving Suggestion*
takes the typically British meal of beans and
sausages in a can and transforms it into a sexual
joke with a sausage at its centre. (CL)

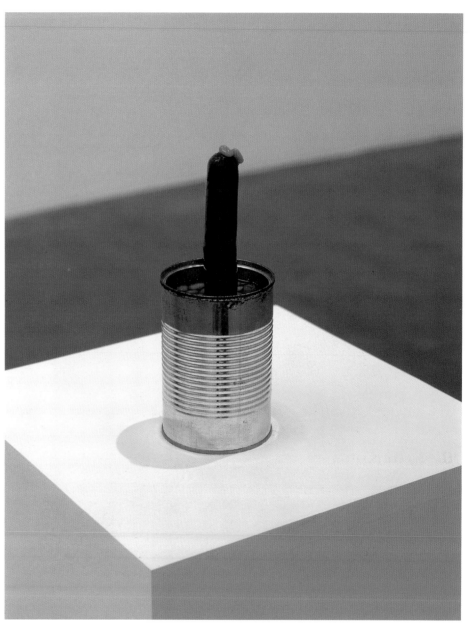

82.

83.

SHEZAD DAWOOD (b. 1974)

83. *Translation* 2003
DVD video, 3 mins 40 secs
Courtesy the artist and Paradise Row, London

Shezad Dawood's film *Translation* uses the Carry
On film, *Carry On up the Khyber* (1968) as its
starting point. Images from the film are remixed
and overdubbed with an improvised conversation
of two men speaking in Gujarati recorded by the
artist. Their conversation could be seen as highly
offensive and deeply sexist, as could the visuals
over which these sounds are dubbed. The fact
that the characters in the original movie were
'browned up' for their roles also adds a highly
questionable racial stereotyping to the mix, which
the artwork exposes rather than condones. (CL)

Bawdy Beautiful

Sally O'Reilly

Bawdy English exports such as the *Carry On* films and saucy seaside postcards have come to exemplify the nation's attitude to sex. That their plots and scenarios drip with innuendo and froth with lewdness has been put down to the perennial awkwardness and reserve of the English, for whom humour is the default mode of discomfiture. Surely, though, if the apparatus and acts of the body turn us perpetually purple, wouldn't we rather cast cerebral voluptuaries than grotesque sensualists as our heroes and heroines?

The particular strain of bawdiness that pervades kitsch smut might be better described as an echo of carnival than evidence of repression. While the traditional Victorian seaside holiday was not exactly rampant, the loosening of collar and corsetry released a faint whiff of the beastly cavalcade. Codes of behaviour were partially suspended as holidaymakers enjoyed a relaxation of the moral muscle, the postcard offering a glimpse of the warm rock pool of abandon to those back at home, as even mild innuendo draws us closer to the breach of the self-contained individual that sex entails. Perhaps, then, it is more a thumbing of the nose to isolating social conventions than personal awkwardness that the bawdy enacts.

Both the *Carry On* films and classic seaside postcards hinge on a procession of blunt stereotypes that trample over decades of hard work to achieve equality through identity politics : buxom dizzy blondes, hen-pecked weedy husbands, domineering overweight wives, shy newlyweds, kilted Scotsmen, sozzled toffs, gossiping spinsters, brazen nudists, lecherous plumbers and so on. Characters and plots generate instances of profound recognition that compel us to commit a litany of crimes of incorrectness, from sexism and racism to ageism and jingoism. In this way the bawdy also highlights an innate, and universal, duplicity – namely the conflict between private thoughts and public behaviour. While this clash is by no means confined to the English, the Victorian era is notorious for such hypocrisies and it was precisely in the rarefied atmosphere of nineteenth-century gentlemen's clubs that bawdy songs and imagery prospered. One such popular song describes an aristocrat's weakness for sex:

> The family took it much to heart
> When Lady Jane became a tart;
> But blood is blood and race is race
> And so, to save the family's face,
> They bought her an exclusive beat
> On the shady side of Jermyn Street.

The lady in question appears in less grotesque form in D.H. Lawrence's *John Thomas and Lady Jane* – an earlier version of his controversial novel of inter-class intercourse, *Lady Chatterley's Lover* (1928) (published posthumously in 1972) – where both protagonists have since lent their name to popular genital personifications. The bawdy, despite its questionable employment of stereotypes, is traditionally a great leveller, condoning consenting sex across classes and, most markedly in the case of barroom songs, portraying women not as unobtainable goddesses but as rampant and insatiable, ultimately in control of their brimming sexuality. Perhaps this fulfils yet another male heterosexual fantasy, but it can certainly be noted that bawdiness emphasises the mechanics of the act of love, rather than the metaphysics of idealised romance, replacing courtly love with something more befitting an era of pneumatic machinery.

In contrast to the common currency of the barroom, saucy postcards and mainstream films represent the commodification of social prohibition or the admittance of taboos into the commercial realm. This threshold is ambiguous, however, with the line between acceptable bawdiness and outlawed obscenity being redrawn from era to era and place to place. We may regard Donald McGill's postcards affectionately now, for example, but in the 1950s the British government considered them to epitomise a perceived slump in morality following the war. A writ was brought against them and many censored or destroyed, with the artist himself brought to trial and fined for contravening the Obscene Publications Act of 1857. However, the view of society as constituted by a cold

shower of fixed institutional structures, behavioural norms and stable identities has withered throughout the second half of the twentieth century. A new perception of societies as contingent, constructed and localised problematises definitions of totalities and margins: if centres are defined by their outer limits and boundaries established by their interior, then received ethical codes and internally generated moral imperatives are interdependent but not necessarily coincidental. Transgression and deviance are no longer universal but local, temporary and up for debate.

Bearing this in mind, distinct parallels (beyond the recurring motif of huge cocks) can be drawn between the grotesque erotica of Aubrey Beardsley and Grayson Perry, despite the century that has elapsed between them. Both confront received social and moral codes of their day. While Beardsley's vignettes of vice and decadence spotlight the unbridled duplicity of the late Victorian era, Perry operates in a time when art is no longer simply a window on to the world out there, but a public arena within which transgression can be performed. Throughout his practice Perry champions the male member as an emblem of the freedom of expression, 'decriminalising the penis', as he puts it, championing it as a symbol of emotional engagement rather than a gesture of obscenity, and redrawing erotic fantasy as a landscape for legitimate experience.

The word 'obscene' comes from the Greek for 'off stage'. It is the flipside of aesthetic, signalling that which has been banned from the proscenium arch presiding over the proper. If we recall anthropologist Mary Douglas's well-aired remark that dirt is simply matter out of place, then the dirty joke perfectly fulfils the condition of the obscene, as exemplified by Sarah Lucas's plucked and gutted chicken – a vaudeville love tunnel on the wrong side of her knickers. Whereas carnival inverts or suspends the norm, obscenity re-centres the outcast, challenging ethical frameworks head-on, as well as the legal structures that support them.

Although we may be tempted to think of the history of acceptability as a gradual development from the restrictive to the liberal, with the aperture of the permissible gradually dilating as we become more honest, tolerant and worldly, in actuality the domains of high and low, private and public, romantic and carnal, sensual and cerebral have

been more fluctuating. The eighteenth-century satirical caricatures of James Gillray, Thomas Rowlandson and Richard Newton, for instance, were emblematic of a culture of ridicule and malicious satire that was as knowing and sardonic as that of the late twentieth century. The lowest of manners and mores were at times exposed in the spirit of corrective satire, while at others the artist capitalised on the events of the day for the titillation of the populace. Such sexual candidness in the times of high manners might be attributed to a different organisation of the public and the private, just as the prevalence of scatological humour was in part due to the visibility of shit in the streets of London.

Contemporary satirical ribaldry is synonymously a function of public pronouncement on private behaviour; although, if we compare the targets of Newton's cartoons censuring the slave trade and nationalist stereotyping with the Fat Slags cartoons in *Viz*, the moral high ground of the artist is buried in a briar of cruel irony that is rather more difficult to defend. Again, though these may seem excessive, grotesque and hyperbolic, they are not necessarily destructive, as exceeding accepted limits stirs up cultural stagnation, requiring boundaries to be reaffirmed or relocated through productive debate. The bawdy also makes much of the fact that sex is experienced, for better or for worse, as a basic biological function for us all. The orgasm – also called the petit mort, or little death, due to the brief arresting of the heart that brings it into being – is a small flowering of triumph in the battlefield of mortality, and the bawdy blows this trumpet loud and hard as a rallying cry to the self-aware.

Humans are one of the few creatures that engage in sex for pleasure, and, what is more, it is thought that we are the only ones that laugh, weep and blush, too. Aristotle suggested that this is because humans can understand the difference between how things are and how they should be. The bawdy human, indulging in an excess of all of these biological functions, addresses the threshold between how things are and how they could be if only we could get over the hang-ups and letdowns of daily life. It signals a release of the private animal spirit into the public forum of human self-consciousness.

Absurd
Absurd
Absmd
Absurd
Absurd
ABSVRD
Absmd
Absurd
Absurd
Absurd
Abs
Absurd
ABSVRD
Absurd
Absurd
Absurd
Abs

Absurd Absurd
Absurd
Absurd
Absurd Absurd Abs
Absurd
Absurd Absurd Absurd
Abs Absurd Absurd
Absurd ABSVRD Absurd

THE ABSURD

If we follow the broad definition of the absurd as 'Out of harmony with reason or propriety; incongruous, unreasonable, illogical … plainly opposed to reason, and hence, ridiculous, silly' (this according to the *Oxford English Dictionary*) much comic art since the seventeenth century can be classed under this heading. Throughout history, graphic satire, comic illustration and joke artefacts have often involved disconcerting dislocations of scale, the animation of inanimate objects, anthropomorphism, and baffling inutility. Literary scholars, cultural theorists, anthropologists and philosophers have mediated on the absurd's potential to challenge our assumptions, overturn norms, and reveal the limits and limitations of normative language and thinking. Seemingly outlandish and silly, the absurd can be seen as having a central place in culture over history. It has, certainly, a very visible role to play in British culture. From Lewis Carroll's classic Alice stories, through to The Bonzo Dog Doo-Dah Band, Monty Python and The Mighty Boosh, much modern British comedy has been absurdist in its imagery, and it may be tempting to look back at earlier images from this perspective. Rather than adding up to a coherent British tradition of absurdist humour in art, though, the images brought together here may suggest the rich variety possible in this mode – with strong elements of melancholy and regret brought into the mix in several of the contemporary works. (MM)

previous page: text by Harry Hill

After **ROMEYN DE HOOGHE** (1645–1708)

84. *Arlequin sur l'Hypogryphe à la Croisade Lojoliste/Armée van de Heylige Lingue voor der Jesuiten Monarchy* 1689
Etching and engraving with letterpress
52.6 × 38.8
The British Museum

Figures riding on lobsters and frogs used as armoured carriages – it sounds like some absurd scene from an episode of *The Mighty Boosh*. However, it is a piece of seventeenth-century graphic satire with a serious political message concerning the Catholic powers of Europe, produced in Dutch and circulated as propaganda at the time of the 'Glorious Revolution'.

Riding a lobster in the foreground and depicted with ass's ears is Father Petre (see cat. 2), Dean of the Chapel Royal and influential religious figure at the court of the Catholic King James II; he is carrying the infant Prince of Wales who is shown with a windmill on his head (rumours circulated that he was the illegitimate son of a miller). In the centre of the composition is the most powerful European Catholic monarch, Louis XIV (no. 5). The title of the broadside suggests that he is riding on a Hippogriff – a strange and devilish mythical creature that was a cross between a mare and a griffin – though it appears to be just an ass, shitting on a group of councillors. Seated directly behind him is James II, carrying a banner with the motto 'Popery/Monarchy'. They are joined together wearing the same Jesuit's cap, its black and white colour presenting them as the Harlequin – the stock comic character from the theatre. Together they are marching in a frighteningly bizarre Catholic crusade over Europe, to the immediate danger of the Protestant peoples and nations. (TB)

84.

115

Coelum ipsum petimus Stultitiâ

85.

PAUL SANDBY (c.1730–1809)

85. *Coelum ipsum petimus Stultitia* 1784
Etching and aquatint on paper, 25.2 × 35.3
Museum of London

The newly invented hot-air balloon became a
hugely popular phenomenon in Britain in 1784,
with a high-profile balloon launch organised
by the Italian Vincenti Lunardi (1759–1806) on
15 September 1784. This print shows the disaster
besetting the rival and more ambitious balloon
launched by John Sheldon (1752–1808) in central
London a few days later. Sandby's print derives
from a drawing by an aristocratic eyewitness,
Charles Greville (1749–1809), who lived in
Portland Square overlooking the scene. It has,
though, the more immediate, and disconcerting
appearance of a gigantic exploding arse farting
fire into the sky.

Sandby was primarily a watercolour painter
and maker of topographical prints. The technically
accomplished nature of this print (executed in
the new technique of aquatint) and the learned
Latin text (from Horace's Odes 1:3 meaning
'we would storm heaven itself in our folly') may
help its deadpan impact, offering a buttock-based
revision of the elevated conventions of the
sublime landscape. (MM)

ANONYMOUS

86. *Flask in the Form of a Potato* c.1800
Terracotta, 8 × 21 × 10
Brighton & Hove Museums

Joke ceramics form a distinct category of
pottery design in the eighteenth and nineteenth
centuries. They include mugs which, when
almost drained, reveal a realistic frog or newt
or other creature poised in the bottom; pipes
of extravagant proportions, coiled and wrapped
around themselves in the most absurd fashion;
or, as here, curious attempts at illusion. This flask,
disguised as a potato or yam, might just possibly
be intended as a practical aid to a farm worker,
allowing for the surreptitious imbibing of an
alcoholic beverage out in the fields, although
it seems more likely to be a straightforward
bit of fun. (MM)

86.

RALPH STEADMAN (b. 1936)

87. *Courtroom Scene from Alice in Wonderland* 1967
Lithograph on paper, 57.1 × 79.7
Tate. Presented by Curwen Studios through
the Institute of Contemporary Prints 1975

JOHN TENNIEL (1820–1914)

88. Illustration to *'Through the Looking Glass
and What Alice found there': The Walrus,
the Carpenter and the Oysters* 1872
Pencil on paper, 7 × 11
Victoria and Albert Museum

Alice's Adventures in Wonderland (1865) and
*Through the Looking-Glass and What Alice Found
There* (1872) by Lewis Carroll (Charles Lutwidge
Dodgson, 1832–98) have been enduringly
popular as children's literature, and have inspired
a succession of direct illustrations, adaptations,
versions and revisions. The first illustrator
of *Alice's Adventures* (often known as Alice
in Wonderland) was John Tenniel, already
established as a *Punch* cartoonist. His versions
of Carroll's characters have become iconic, not
least through being the starting point for the
famous characterisations in the Disney animated
version issued in 1951.

Carroll's texts have, though, also proved to be
hugely provocative for adult readers. The author's
personal life, and particularly his photographs of
young children, have attracted a great deal of
attention and disagreement, which has opened
up difficult questions around Victorian sexuality
and the visual representation of children.
Meanwhile, the absurdity and literary complexity
of Alice have been explored by contemporary
philosophers and cultural theorists concerned
with the contradictions and instabilities of
language, and the limits of sense and subjectivity.
Carroll's work has, accordingly, drifted uneasily
between the realms of childhood innocence and
adult 'sophistication', the grotesque and the plain
silly. Ralph Steadman produced a set of intricately
drawn illustrations for Alice in Wonderland in
1967 and Through the Looking Glass in 1972.
This print was issued in 1975, as part of a series
published by the art-print specialist Curwen
Press, and suggests a disorientating dissolution
of the normative boundaries between human and
animal, the organic and inorganic – and, indeed,
'children's literature' and 'art'. (MM)

87.

88.

118

WILLIAM HEATH ROBINSON (1872–1944)

89. *One of those horrid after Christmas dreams*
published in *The Humorist*, 4 December 1926
Pen and ink on board, 41.5 × 33
The Cartoon Museum

Heath Robinson is best known for his strange
contraptions that are absurdly ingenious and
utterly impractical – such as an engine for blowing
out the fuses of bombs from Zeppelins before
they land. However, he was also a gifted and
respected illustrator, ranked alongside the likes
of Arthur Rackham (1867–1939) and Edmund
Dulac (1882–1953), and brought his strange
visionary world to bear in these works as well.
This drawing shows the nightmarish scenario
of a Christmas pudding, trifle and mince pies
coming to life and taking their revenge on an
over-indulged boy. (TB)

ONE OF THOSE HORRID AFTER CHRISTMAS DREAMS

89.

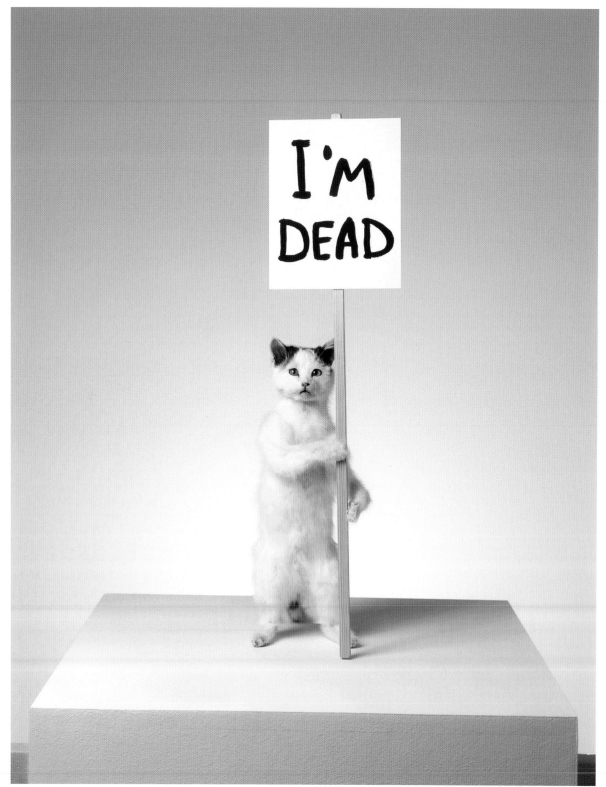

DAVID SHRIGLEY (b.1968)

90. *I'm Dead* 2007
Taxidermy kitten with wooden sign
and acrylic paint, 94.5 × 50 × 50
David Roberts Collection, London

91. *Leisure Centre* 1992
Photograph, 25.4 × 25.9
Tate

The work *I'm Dead* has a humorous yet
sadistic overtone. The idea of a cat holding
a sign proclaiming its own death is too absurd
to contemplate yet here is the object before
our eyes.

The photographic work *Leisure Centre* is
part of a series the artist made to document his
public interventions. These interventions usually
took place in the artist's home town of Glasgow.
Leisure Centre is typical of this series in that it
uses absurdist humour to make its point. What
is supposed to be gleaming, new and optimistic
ends up being shabby and grim, surrounded by
bleakness. (CL)

91.

EDWINA ASHTON (b.1965)

92. *Warm Hand of History* 2007
DVD, 2.30 min
Courtesy the artist

Edwina Ashton's work deals with the bizarre,
the melancholy and the peculiar. Her animations
delve into the strange lives of twigs, flies and
giant bugs. The characters in her films are often
isolated from the real world, yet somehow as
viewers we are fascinated to learn more about
them and become voyeurs into their strange
ramblings. Her videos are surreal vignettes that
are both humorous and doleful. (CL)

92.

BRIAN GRIFFITHS (b.1968)

93. *The Body and Ground (Or Your Lovely Smile)*
2010
Canvas, scenic paint, ropes, webbing (various),
fibre glass poles, plastic poles, vintage travel
souvenir patches, net fabric, tarpaulin, duct tape,
thread, string, fixings, 350 × 580 × 450
Installed at the Mattress Factory Museum,
Pittsburgh, USA
Courtesy the artist and Vilma Gold

Brian Griffiths's work often deals with humour,
pathos and a sense of disappointment. His
use of shabby and found materials and the
non-functionality of his structures (a tent that
you cannot enter, for example) deny the viewer
their expected experience when contemplating
an artwork. (CL)

93.

SHAUN DOYLE (b.1968) and **MALLY MALINSON** (b.1970)

94. *Death to the Fascist Fruit Boys* (detail) 2010
Installation with fibreglass and acrylic
Approx. 150 × 300 × 300
Courtesy the artists

Shaun Doyle and Mally Malinson's piece, *Death to
the Fascist Fruit Boys*, is a sequel to an earlier piece,
The Fascist Fruit Boys 2005. The works parody society's
obsession with 'five-a-day' culture by taking fruit
and veg fascism to the extreme. The sculptures are
moulded in fibreglass with the details cast from real
fruit. (CL)

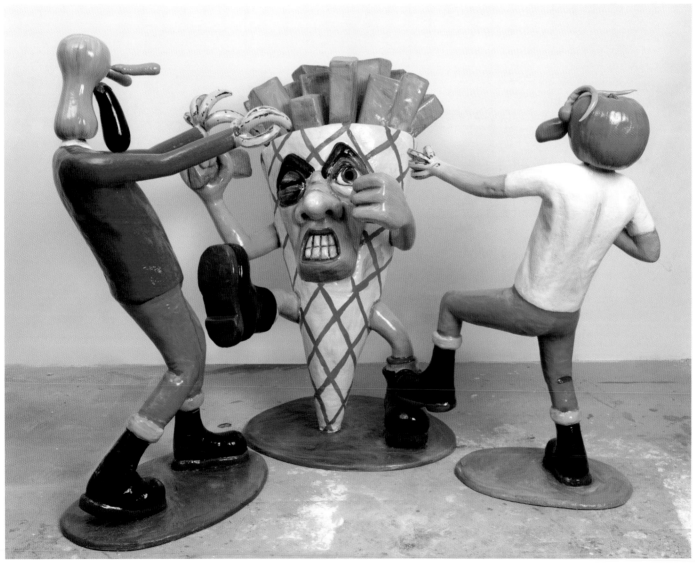

94.

DOUG FISHBONE (b. 1969)

95. *Storyboard from Stand-Up Guy* 2004
Silent video, 5 mins 50 secs
Courtesy the artist and Rokeby Gallery

Doug Fishbone's work takes a quasi-scientific approach to humour. He breaks jokes down as a way of trying to further understand their meaning. He works in many formats, including video, performance and prank-like installations, often placing his own fictional ego as the central character. His video piece, *Stand-up Guy*, delivers a stand-up routine without any sound, the audience instead having to read the jokes as subtitles. This subtle disconnect is enough to make the viewer think about the language of jokes in a new way. (CL)

A gorilla walks into a deli in New York,

and orders a pastrami on rye
with a pickle on the side to go.

The guy behind the counter puts
the sandwich together and when its
ready says: "That'll be twelve dollars."

He realizes though that he's
been staring, and apologizes...

"Uh, I'm sorry sir...but
to be honest with you, I've never
seen a gorilla in here before."

"You keep charging twelve bucks for a sandwich,"
says the gorilla, "and you never will again."

95.

OLIVER MICHAELS (b.1972)

96. *Tube Balloon Thing* 2007
Split screen sculpture, SD DV, 11 mins
Courtesy the artist

Oliver Michaels' film refers to an earlier video
piece by Swiss artists Peter Fischli and David
Weiss, *The Way Things Go (Der Lauf der Dinge)*
1987. This recorded the operation of an
elaborately-staged machine made up of everyday
objects. Viewing Michael's film, we are led to
believe that he has created a machine into which
any object can be inserted and out of which
a new object will appear. The work is, however,
a deception and has actually been constructed
using computer technology and animation. The
subtleties of the piece and its humour emerge
from the ridiculous soundtrack and precise comic
timing. (CL)

96.

126

BARRY REIGATE (b.1971)

97. *Almost* 2010

Jesmonite, gloss paint, acrylic, fibreglass matting,
spray paint, plywood, MDF, bolts, lampshade,
light fixture and bulb, wiring and plug, height 165
Courtesy the artist and Paradise Road Gallery

Barry Reigate's sculpture acts both as a
functioning lamp and as a depiction of a human
figure. For the artist the work represents
the failure of human relationships and the
tragicomedy this can often inspire. His light
is a very basic creature, seemingly driven by
lust. The sculpture is so blinded by desire that
it trips over its own plinth. (CL)

97.

HENRY VIII'S WIVES

98. *Vietcong* 1999
Photograph, 102 × 140
Courtesy the artists and Galerie Iris Kadel

For their series, *Iconic Moments of the 20th Century*, the artists' collective Henry VIII's Wives restaged various iconic photographs, replacing the settings with new scenes from suburban Scotland, as well as replacing the protagonists with unlikely pensioners from the same locations. The work is cruelly humorous and plays with our collective visual memories of these historic scenes. (CL)

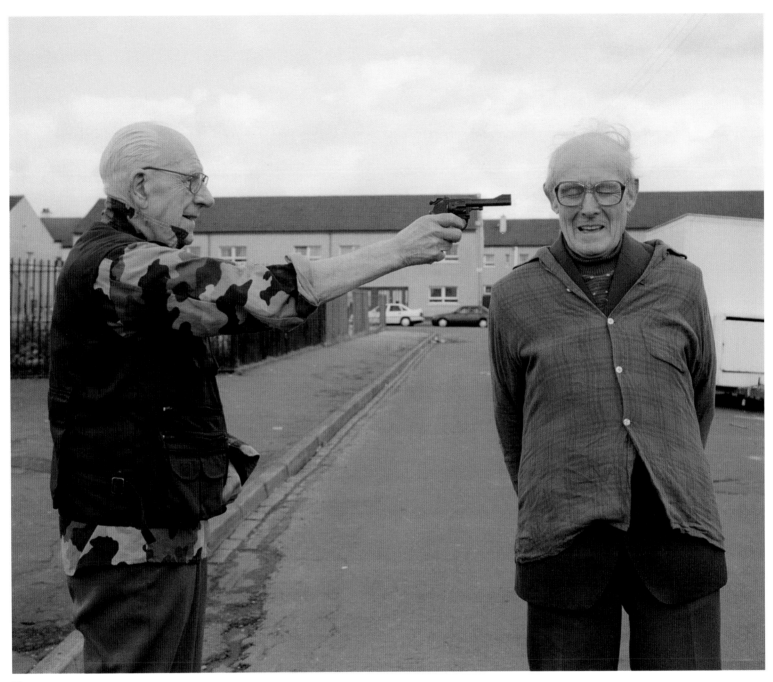

98.

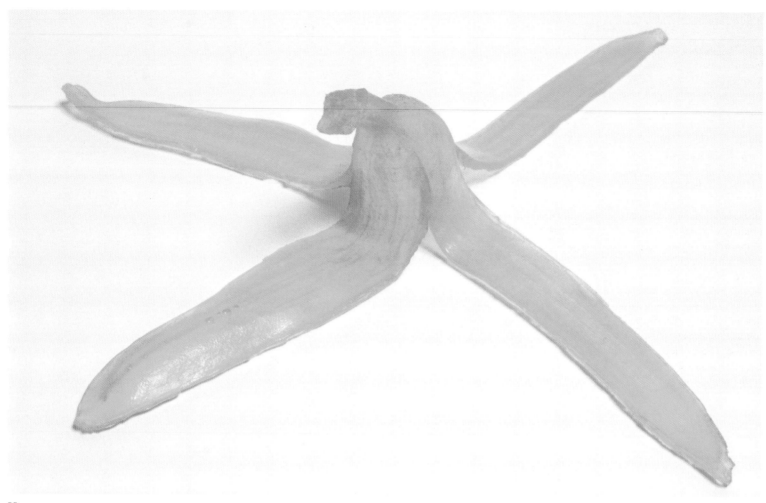

99.

ANGUS FAIRHURST (1966–2008)

99. *The Problem with Banana Skins Divided /
Inverted* 1998
Acrylic rubber, edition of ten, 7 × 36 × 36
Collection Andrew and Stephanie Hale,
courtesy Sadie Coles HQ, London

100. *A Cheap and Ill-Fitting Gorilla Suit* 1995
Video still, Betacam SP, c. 4 mins
Courtesy the Estate of Angus Fairhurst
and Sadie Coles HQ, London

Fairhurst worked across a range of media,
creating works that often have the appearance
of absurdist jokes. Images of gorillas and of
bananas recurred as motifs, suggesting slapstick
and comic disorder. Fairhurst's humour was,
though, philosophical, touching on themes
of failure, disintegration and renewal. So the
strikingly poor gorilla suit that falls away in the
course of *Cheap and Ill-fitting Gorilla Suit* puts
into play a host of ideas about man and animal,
evolution, appearance and reality. (MM)

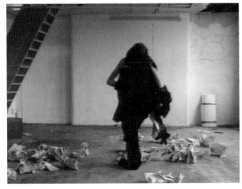 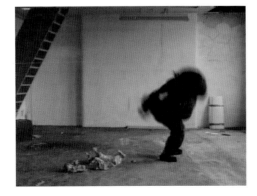

100.

JAKE AND DINOS CHAPMAN (b. 1966 and b. 1962)

101. *Exquisite Corpse* 2000
Etching on paper, from series of 20 prints;
each 23 × 18
Tate

This image is from a series of prints which were created by playing a game called *Exquisite Corpse*, a visual-arts version of the old parlour game Consequences, which was originally developed by the Surrealists. In *Exquisite Corpse*, the players take turns to draw a section of a body without seeing the other parts of the figure. The resulting imagery is inevitably absurd and incongruous, and in the images created by the Chapmans, characteristically grotesque and horrific. (MM)

101.

102.

PAUL NOBLE (b.1963)
102. *huh huh* 2002
Pencil on paper, 84 × 219
Michael and Fiona King, London

Paul Noble's *huh huh* belongs to his monumental,
fourteen year-long project, Nobson Newton.
The title words are described in a blocky
schematic typography designed by the artist.
The words huh huh emerge from or are set in to a
depiction of a brick patterned wall, the surface of
which is densely detailed. The intense imaging of
the wall contrasts with the vapidity of the words it
houses, presenting a conflict between the written
and the drawn.

Cedar Lewisohn
and Harry Hill
in Conversation

CL: What do you think is the link between comedy and art?

HH: It strikes me that a lot of humour and art is a reaction of laughter or a smile. Some art, to me anyway, seems to be a joke. There is a kind of deliberate gag to it which sometimes artists fight and say that it isn't their intention. But, for instance, I don't know who it's by but it was in that 'Sensation' show at the Royal Academy. It was of the Pope being hit by a meteorite…

CL: Yes that was the 'Apocalypse' show and was a piece by Maurizio Cattelan.

HH: That's a brilliant gag. And in some ways even things like Damien Hirst's cow's head with the flies. There's something quite funny about that. The futility of it is like a black joke. Sometimes I think that some artists want to be comedians but it's easier to be an artist because you don't need to finish it off with a punch line, which is what I was saying when we were watching those video installations. They're not quite funny enough because if you're an artist you don't actually need to have a laugh, whereas if you're a comedian you have to have a laugh and a round of applause, otherwise you're not a comedian.

CL: Surely there are examples of comedians who didn't do a punch line, say for example Lenny Bruce or Andy Kaufman?

HH: Yes there are lots of ones like that. A lot of Vic and Bob's work is almost like performance art. They're wilfully testing the audience a bit, aren't they? I used to do more of that than I do now, but then I came round to thinking

that you do need a punch line. It's nothing to do with being traditional. It's about a view. If you're a comedian and you have a funny routine and you get laughs along the way, and it finishes without a punch line, you can say it doesn't matter, it doesn't need a punch line. But if you had a punch line for it you would do it. That's what you want. And actually what it is, is that you haven't come up with a punch line.

It's not meeting the requirement. I really like Andy Kaufman. I went through a phase where I went off my stand-up a bit and I watched a couple of Andy Kaufman videos and it really instilled back in me what I started doing in the first place, which is fun. And sometimes it's easy to lose sight of that with the career. I think Andy Kaufman is great but not for everyone. And also, what you find with someone like that is that you can take so much of it. Someone like Tommy Cooper you can take forever but with Andy Kaufman you can only take so much of it.

CL: The 'fart joke' is a certain kind of humour that has been around for a long time and is still around. Why is it that we find this very simple populist humour so funny?

HH: It's not really my area. I've always avoided that kind of thing. I do a few on TV Burp but, you know, we have half an hour to fill. Anyone can do those sorts of jokes. You don't really need to be a comedian to do it. It's a taboo thing.

CL: Do you think there's a link to that in art? The Maurizio Cattelan piece for example?

HH: It's not a fart joke, it's a visual gag. I think the primary thing about it is a surprise. The reason things are funny a lot of the time is that it's a surprise. As a comedian when you're writing jokes, your job is to hide the punch line for as long as you can. You don't want people to guess what's coming.

CL: What I've been looking at and noticing is a lot of the old art of the past, the satire is quite hard core. It's very

explicit and very vicious. And it seems that the art of today or even the satire isn't so vicious. And I wonder why…

HH: If you go back far enough when we were living in caves, we used to have sex in the open air in front of other people. It's what is considered acceptable and proper in society. When they invented the printing press one of the first things that was mass produced was pornography. Man hasn't changed. We've always been the same thing. We haven't evolved in that sense. It's just about what is acceptable and what isn't.

CL: What I was thinking about was, if you think of acts like Ali G and Bo' Selecta! and the whole celebrity culture thing, those are quite vicious. There aren't that many artists that are doing that kind of vicious satire. And

maybe that's filling the gap. Hogarth's work was popular prints and would be the equivalent of being in the daily newspaper.

HH: Maybe he would have done a TV show. His outlet was probably just a printed page, he's obviously angry and had a lot he wanted to say. But I don't know anything about him. Why aren't artists doing satire I wonder?

In the end if you're a comedian like I am, you just do what you find funny and what interests you. Politics never interested me. Not party politics anyway.

With that whole Ben Elton generation, you had to have your Thatcher joke and your Gulf War joke and all this sort of stuff. And I used to do those jokes. It's easy to write those sorts of jokes as they're jokes by numbers, unless you have any passion for it that's all they are. It's just an easy laugh. The other thing is that when you're on

last everyone else has done their jokes before you. And they were probably better than yours, plus you had to keep changing your act.

CL: There is a tradition of humour and comedy that has some kind of political edge and is effective. Sarah Palin's election campaign for example…

HH: I don't know if it's ever effective. It's effective in that it gets a laugh but I don't think it changes anything.

CL: What about the 'Spitting Image' effect?

HH: I never liked Spitting Image. I thought it was pretty sledgehammer to crack a nut really. My objection to it was that they were not very good jokes. And this is where I find a lot of satire falls down. The jokes are just not very good. The Spitting Image jokes were always along the lines of Reagan is thick, Fergie is fat… It's just a bit reductive. And there are good ones. If you look at Stewart Lee who has become a sort of political comedian, I don't think he used to be, what he does is a lot more interesting and he does much better jokes.

'Yes Minister!' was about the Civil Service. It wasn't party political. It never brought down a government. It informs I suppose.

Even currently with 'The Thick of It', the other thing about that is for me is that a lot of satire became about coverage of politics rather than about politics. So actually 'The Thick of It' is about the spin really, isn't it? It's not actually about whether we should be fighting the war in Iraq or not – the detail. I do like that show, though. A lot of satire has a sort of worthiness about it. If you're a comedian like me those sorts of acts do look down on you a bit.

CL: Let's talk about the kind of comedian you are then. In the section of this show, it's more in this kind of absurdist tradition.

HH: I think it's a very British trait, isn't it? I mean it's all around the world but I think we're recognised for this.

CL: That's got to be something to do with British society and it's the reverse of it. It's this kind of Victorian society that it comes out of, very stiff, reserved, repressed – and this sort of humour is the opposite of that.

HH: Sort of, but it is quite repressed in its own way as well, isn't it?

I think Spike Milligan is a classic example of this. He was really the first one to make it more mainstream. I don't know if that's bollocks, though. If you think of the Goon show which is pretty surreal really. People talk about my TV show as being surreal but it is nowhere near as much as this one. The argument is that always with surreal or absurdist humour it's niche.

The Goons were pretty ordinary people, whereas with Monty Python for example there was definitely a class element to it. The Goons was the most popular radio show, had millions of listeners and was really broad and mainstream. But I think broadcasters these days are a bit scared of it.

I think Spike Milligan had this gift for it and realised just at the start of TV. He basically took radio with the sound effects to the most sophisticated point I think. Then I think TV was just starting so I think he was really the first one to exploit the medium of TV as well, as a lot of his stuff was about the form of it. You'd be watching it and it would be a shop and you'd pull back and see if it was a set, and then you'd walk out of the set and see all the cameras. And then what Monty Python did was polish it and remove the rough images and the hit-and-miss nature of it, which is what I really liked about it. Some of the stuff was absolutely awful.

Whereas Tommy Cooper is all about the form and the timing of things. I think what he does is a beautiful thing. It's all about the spot-on timing about moving things because what he does is not terribly funny. Written down it is not in any way funny.

I think at any one time there is always a type. So you always have a silly comedian, an absurdist comedian, you've got an impressionist, a camp comedian. There's always one of these who is always a satirist.

CL: Do you think the history of sitcoms is a good tool for discussing these social issues? What I like about Rising Damp is that you have a lot of social issues that are being reflected in that show. You've got the white aspiring working-class guy who's having his world destructed by a black guy; you've got the female characters in the time of feminism.

HH: I don't think they are necessarily setting out to discuss those issues but what a good sitcom does is just reflect what's going on. It's like the mother-in-law joke which at the time was funny because when people got married they used to go and live with their mothers-in-law. This idea of Rising Damp, with the landlord…

My idea is that if you are a comedian all you have to be is funny and that's it. And I think the challenge is to be funny and in a way that other people aren't. You give them something that they haven't seen before ideally.

CL: Tell me about your interest in art then…

HH: I'm interested in what artists are thinking when they're doing this stuff. Whether they are thinking that this is a good joke or if they are thinking that it's more than that. Because art is supposed to be something more than that, isn't it?

It's supposed to be thought, provoking. What are they actually thinking when they're doing these things? The Maurizio Cattelan piece that we were talking about earlier for example – I think he thought this is a great gag. This is going to work visually so he drew it out, and had it made. Much in a way that someone writes a joke or a sketch.

CL: Quite possibly yeah, but then also it's got wider ramifications. A lot of what art is, is that because it is placed in a kind of sanctified location, in a gallery, then people put all that stuff on it that is special. They'll read more into it.

The whole perception of art is changing through TV, though. We were talking about the Saatchi show recently weren't we?

HH: I don't know about that particular show but say what you like about Charles Saatchi but you know he does get… and also Damien Hirst – all those self-publicists, who get column inches, whatever you think about the art, it gets people along to exhibitions. The interesting thing was going to The Wallace Collection, seeing his paintings and it was teeming with people. And he's done that; he's pulled them in, hasn't he? And his Sotheby's auction was packed with people because there was almost a spectacle about it – the circus comes to town.

CL: But do you think that there is a relationship between comedians and artists?

HH: I think a lot of artists couldn't be comedians but I think comedians could be pretty good artists.

CL: Before I used to think about music and art and a lot of musicians are really into art and a lot of musicians make art. And the more I'm doing research for this project a lot of comedians or people who are into comedy – there seems to be a kind of two-way conversation going.

HH: I think it's a higher calling – to be an artist. Because the problem about being a comedian is that you rely on the audience. With comedy, I've had many jokes which I thought were really funny but if the audience doesn't laugh you end up having to drop it. Whereas as an artist you can do what you like.

CL: Yeah and also there is that myth as well that you could be an artist your whole life and not sell a painting, die and you're still an artist, whereas I don't think that happens to many comedians.

I suppose there is that very British kind of humour that we are talking about but I'm wondering how it compares to American humour. There are certain American comedians who are massive, like Richard Pryor. But there would never be a British comedian equivalent to him, but for me he is one of the funniest people ever.

HH: He is brilliant. It's an original voice. It's shocking and exciting. It's all the things that you want when you hear a good bit of music. You immediately think I want to see more of it. That's what you want from your entertainment. But there are as good comedians that have come out of Britain. We have a huge number of comedians considering what a small island this is. We tend to be more interesting. Whenever I went over to the States for the comedy festivals there were all these young comedians who were just terrible – really mundane. The thing is that over there they want to be actors. Whereas comedians over here, all we want to be is a comedian.

CL: The public really relate to comedy very easily.

HH: I'll tell you something about comedy which is a good quote – it polarizes people. In a certain way it can be like art perhaps in that, and Jasper Carrott said this – you've seen Pavarotti right? I'm not an opera fan and I don't like Pavarotti, but I recognise that he is a good singer and what he does is brilliant but with comedy, what they say is, Harry Hill or whoever it is, that is not funny. That is rubbish. Don't like it, that is rubbish. But clearly I've managed to make a living out of it. Who are all these people laughing? In some way you can't appreciate it.

But with art, you're thinking the pope thing or that pile of bricks or whatever, and you get the Daily Mail reaction and other people are stood there open-mouthed.

CL: I think it's true what you're saying. But I think for me the thing about art is that's different to that is the element of knowledge. The more you know about art the easier it is to understand what the bricks are about, because it comes from the same history and you can say that you know it's about materials and it's an investigation of what is being done, but if you don't know about the history, it's different.

HH: Well you shouldn't necessarily have to know about that to get a reaction.

I don't have the knowledge of history of art necessarily but what I'm saying is all you need to do is go there with an open mind. All that it requires is for you to decide

whether you like it or not. And you appreciate it on those terms without having to get angry about it.

What people actually get angry about is the money. If no money had changed hands before any of this stuff… like the situation with Damien Hirst… It's envy and this feeling that anyone could do it, he's got paid all this money, look at me I'm working in a shop.

CL: You're right but I think that's the tabloid line. That's the line that is always used as a kind of inroad to the art story.

HH: The other thing is this – it's the art work which is reproduced in the tabloids, so it's a photograph which is nowhere near the same as seeing it in real life. This is fundamental.

CL: That's true. But this isn't about the financial aspect of art. It's more of a media construct and that's the way that the story is often reported.

HH: It's reported that way but I think that people often feel that as well.

CL: You're right but there are a lot of things in the world which are outrageously valued. We don't get quite so wound up about football players' wages as they do over an artwork. Someone told me that more people will go to a museum on a weekend than a football match. Anyway, what is the funniest artwork you've ever seen? [LAUGHS.]

HH: I think David Shrigley's stuff is really spot on. It does what I said about comedy. It's very surprising. Also when you find out about it, it's a surprise as well because he's not what you think he is. I like the child-like aspect about it which has a lot of irony in it and it's very dry. He's so prolific and a lot of people try to copy him as well. You look at it and you think I could do that but actually there is something about it which is difficult to recreate. I like his expanding foam sculptures too.

I often get inspiration from the arts for my day work because it's about ideas a lot of the time, isn't it? A lot of

comedy is about ideas and you think if you're sitting at home writing jokes you tend to get a bit narrowed down. It's quite liberating I think. And I think talking or meeting artists who don't make a lot of money out of it and who aren't in the top game who are doing it just for love. When you are a professional comedian a lot of the time you're thinking about making a living out of it as well. Like meeting you, getting to know you and your little world is quite inspiring.

I'm not blowing smoke up your ass but it's good that you work in this field and you've got a job at the Tate and you clearly are interested in and love art. In TV the people who work on TV stations are interested in money. There's no love for it.

CL: I suppose the financial aspect of working in the arts is not worth it. If you want to make money you're in the wrong business I think.

HH: And rightly so. [LAUGHS.]

List of Exhibited Works

British Comic Art

Anonymous, printed by Robert Ibbitson
(fl. 1646–61)
Dr Dorislaw's Ghost, presented by T[ime] to unmask the Vizards of the Hollanders 1652
Engraving on paper, with letterpress, 67.6 × 43.1
The British Museum. Y.1,118
(cat. 1)

Rambout van den Hoeye (c. 1622–71)
Satirical Dutch broadside on the Commonwealth; Cromwell in regal attire, against a background of Charles 1's execution c. 1654
Engraving on paper, with letterpress, 40.4 × 46.3
The British Museum. Y,1.126

Wenceslaus Hollar (1606–77)
after Leonardo da Vinci (1452–1519)
Caricature & Deformities after Leonardo 1665
Etchings on paper, Eight works, each approx.
6.8 × 4.7
The British Museum. 1858,0626.272–6;
1858,0612.256; 1935,0716.6–7
(cat. 6)

Anonymous, published by Arthur Tooker
(active 1664–87)
A Jesuit Displaid c. 1680
Etching on paper, 44.8 × 30.8
The British Museum. 1983,1001.11

Attributed to Romeyn de Hooghe (1645–1708)
Sic itur ad Astra Scilicet
('This way to heaven of course') 1688
Engraving on paper with letterpress, 56.5 × 42.4
The British Museum. 1864,0813.273
(cat. 2)

William Hogarth (1697–1764)
The South Sea Scheme c. 1721
Etching and engraving on paper,
cut to 26.5 × 32.7
Andrew Edmunds, London
(cat. 3)

Anonymous after Pier Leone Ghezzi (1674–1755)
Dr Tom Bentley c. early 18th century
Etching on paper, 34 × 22
The British Museum. 1873,0712.643
(cat. 7)

Anonymous
Idol-Worship or the Way to Preferment 1740
Etching on paper, 39.9 × 28
The British Museum. 1868,0808.3620
(cat. 4)

Hubert François Gravelot (1699–1773)
The Devil Upon Two Sticks 1741
Pen and ink and watercolour wash on paper,
26.8 × 30.9
Tate. T08921

Hubert François Gravelot (1699–1773)
The Devil Upon Two Sticks 1741
Etching and engraving on paper with letterpress,
43.5 × 31.1
Andrew Edmunds, London

William Hogarth (1697–1764)
Characters & Caricaturas 1743
Etching on paper, 25.7 × 20.2
Andrew Edmunds, London
(cat. 5)

After José de Ribera (1591–1652)
Studies of the nose and mouth c. early 18th century
Etching on paper, 27.2 × 21.5
The British Museum. 1849,1208.32

George Bickham (1706–71)
The late Prime Minister 1743
Etching and engraving on paper, 35.8 × 25.1
Andrew Edmunds, London

William Hogarth (1697–1764)
The Bench 1753–4
Oil on canvas, maroufle to panel, 18.2 × 14.8
The Syndics of The Fitzwilliam Museum,
Cambridge

Thomas Patch (1725–82)
A Gathering of Dilettanti in a Sculpture Hall
c. 1760–1
Oil on canvas, 137.2 × 228.6
Collection of the late Sir Brinsley Ford CBE FSA
(cat. 8)

Thomas Rowlandson (1756–1827)
The Judge undated
Pencil and watercolour on paper, 21.8 × 17.4
Tate. T08531
(cat. 10)

Thomas Rowlandson (1756–1827)
Queen Anne's Bounty: Triplets
Pencil, pen and ink and watercolour on paper,
17.9 × 12.1
Tate. T09201

Thomas Rowlandson (1756–1827)
A Bench of Artists 1776
Pen and ink and pencil on paper, 27.2 × 54.8
Tate. T08142

Sleeping Parson c. 1785–95
Pearlware, 27 × 11 × 12
Brighton & Hove Museums

James Gillray (1757–1815)
Doublûres of Characters; or Strikeing Resemblances in Phisiognomy 1798
Etching, soft-ground etching and engraving with publisher's watercolour on paper, 19.1 × 25.4
Andrew Edmunds, London
(cat. 9)

Stoneware Head c. 1800
17.5 high
Brighton & Hove Museums

James Gillray (1757–1815)
Very Slippy-Weather 1808
Etching and engraving with publisher's watercolour on paper, 26 × 20.3
Andrew Edmunds, London

Theodore Lane (1800–28)
Honi Soit Qui Mal Y Pense 1821
Etching and engraving with publisher's
watercolour on paper, 26.5 × 41.4
Andrew Edmunds, London
(cat. 11)

Landlord c. 1830
Earthenware, 18.4 × 7.5 × 5.9
Brighton & Hove Museums

Landlady c. 1830
Earthenware, 17.6 × 6.6 × 5.8
Brighton & Hove Museums

Bull-Baiting Group c. 1830
Pearlware, 28 × 34.5 × 13.5
Brighton & Hove Museums
(cat. 14)

Charles Jameson Grant (fl. 1830–1846)
The Penny Trumpeter! 1832
Hand-coloured lithograph on paper,
40.5 × 24 The British Museum
(cat. 12)

Charles Jameson Grant (fl. 1830–1846)
*Political Drama No. 4: John Bull;
or, an Englishman's Fireside!* c. 1833
Wood engraving on paper, 44.2 × 27.1
UCL Art Collections, University College London

The Penny Satirist, 18 June 1842
Woodcut and letterpress on paper, 49 × 37.2
Private collection
(cat. 13)

*Cleave's Penny Gazette of Variety & Amusement,
Saturday, May 14, 1842*
Woodcut and letterpress on paper, 47 × 37.2
Private collection

John Leech (1817–64)
Cartoon, No. 1: Substance and Shadow
Punch, or the London Charivari, Vol. 5, 1843
Private collection
(cat. 17)

John Tenniel (1820–1914)
Frontispiece Punch, or the London Charivari,
Vol. 61, 1871
Private collection
(cat. 16)

William Giles Baxter (1856–88)
Ally Sloper's Half Holiday: 'The Russian Bear' 1887
Pen and brush and ink on paper, 25 × 32.6
Victoria & Albert Museum
(cat. 19)

Ally Sloper's Half Holiday comics and ephemera
c. 1880–1900
Courtesy of Roger Sabin

The Funny Wonder 7 August 1915
Comic magazine, facsimile 1972, 37.5 × 28.8
The Bill Douglas Centre for the History of
Cinema and Popular Culture, University of Exeter

Fun Book October 1915
Comic magazine, 22.6 × 32.3 (open)
The Bill Douglas Centre for the History of
Cinema and Popular Culture, University of Exeter

Scream September 1915
Comic magazine, 22.6 × 16 (closed)
The Bill Douglas Centre for the History of
Cinema and Popular Culture, University of Exeter

*Everybody's Chaplin mad, his fame is hard to beat;
They even imitate him Turning corners in the street*
c. 1915
Postcard, 13.9 × 8.7
The Bill Douglas Centre for the History of
Cinema and Popular Culture, University of Exeter

*The Knuts think they'll be quicker if they swank
they're Charlie* c. 1915
Postcard, 13.9 × 8.6
The Bill Douglas Centre for the History of
Cinema and Popular Culture, University of Exeter

HM Bateman (1887–1970)
The Missing Stamp, published in Punch,
11 January 1922
Engraving on paper, 28.2 × 37.8
The Cartoon Museum

Charles Spencelayh (1865–1958)
The Laughing Parson 1935
Oil on canvas, 50.7 × 40.7
Grundy Art Gallery, Blackpool
(cat. 18)

Leo Baxendale (b. 1930)
When the Bell Rings, published in *The Beano*,
10 December 1955
Pen and ink on card, 36.3 × 48.4
D.C. Thomson & Co. Ltd.
(cat. 20)

Adam Dant (b. 1967)
Donald Parsnips Daily Journal newsstand 1997
Painted found materials, 213.4 × 76.2 × 76.2
Courtesy the artist and Hales Gallery
(cat. 23)

David Shrigley (born 1968)
Untitled 2000
Ink on paper, 23 × 26.5
Courtesy the artist and Stephen Friedman
Gallery
(cat. 24)

Carole Windham (b. 1949)
Obadiah, Mastrr of Bursley 2000
Ceramic earthenware, oxides, underglazes,
lead glaze, enamels, 120 × 60 × 35
Private collection
(cat. 15)

Bob and Roberta Smith (b. 1963)
Stuffed – What? Me? Oh Yes 2003
Screenprint on paper, 76 × 51
Courtesy the artist and Hales Gallery

Bob and Roberta Smith (b. 1963)
Lord Archer is a political prisoner 2004
Screenprint on paper, 153 × 101
Courtesy the artist and Hales Gallery

Bob and Roberta Smith (b. 1963)
Vote Bob Smith 2004
Screenprint on paper, 119 × 42
Courtesy the artist and Hales Gallery

Glen Baxter (b. 1944)
A picture whose pictorial form is logical form is called a logical picture, Edna corrected the Bosun 2005
Ink and crayon on paper, 78 × 57
Courtesy the artist and Flowers Gallery, London
(cat. 21)

Klega (b. 1961)
Untitled 2009
Pen on canvas, 40 × 30
Courtesy the artist

Klega (b. 1961)
Untitled 2009
Pen on canvas, 40 × 30
Courtesy the artist

Klega (b. 1961)
Untitled 2009
Pen on canvas, 40 × 30
Courtesy the artist

Klega (b. 1961)
Untitled 2009
Pen on canvas, 40 × 30
Courtesy the artist

Simone Lia (b. 1973)
Voted Off 2009
Ink, photoshop, 25 × 21
Courtesy the artist
(cat. 27)

Bob and Roberta Smith (b. 1963)
10th October 2008 (Freedom George Michael)
2008
Signwriters paint on boards, 248 × 252
Courtesy the artist and Hales Gallery
(cat. 22)

Bob and Roberta Smith (b. 1963)
We Must Give Amy Her Freedom 2008
Signwriters paint on boards, 86 × 80
Courtesy the artist and Hales Gallery

Janette Parris (b. 1962)
Talent 2010
Animation
14 mins
Courtesy the artist
(cat. 26)

Social Satire & The Grotesque

William Hogarth (1697–1764) partly assisted by
Gérard Jean-Baptiste Scotin (1690– after 1755)
A Rake's Progress June 1735
Etching and engraving on paper,
Series of eight prints, each approx. 35.5 × 41
Andrew Edmunds, London
(cats. 31–2)

William Hogarth (1697–1764)
Taste in High Life c. 1742
Oil on canvas, 63 × 75
Private collection
(cat. 30)

William Hogarth (1697–1764)
*O the Roast Beef of Old England
('The Gate of Calais')* 1748
Oil on canvas, 78.8 × 94.5
Tate. N01464
(cat. 29)

Joshua Reynolds (1723–92)
Parody of Raphael's 'The School of Athens' c. 1750–2
Oil on canvas, 97 × 135
National Gallery of Ireland, Dublin
(cat. 33)

William Hogarth (1697–1764)
Gin Lane 1751
Etching and engraving on paper, 38 × 32.1
Andrew Edmunds, London

William Hogarth (1697–1764)
Beer Street 1751
Etching and engraving on paper, 39 × 32.6
Andrew Edmunds, London

William Hogarth (1697–1764)
Hogarth painting the comic muse 1757
Oil on canvas, 45.1 × 42.5
National Portrait Gallery, London
(cat. 28)

By or after John Collier ('Tim Bobbin') (1708–86)
The Hypocrite c. 1770–80
Oil on canvas, 65 × 1000
Touchstones Rochdale
(cat. 34)

After Samuel Hieronymus Grimm (1733–94)
The French Lady in London or the head dress for the year 1771 1771
Engraving on paper, 35.4 × 26.3
The British Museum. J,5.111

Philip Dawe (1750–91)
The Macaroni, a Real character at the Late Masquerade 1773
Mezzotint on paper, 35.1 × 25
The British Museum. J,5.42
(cat. 35)

Samuel Hieronymus Grimm (1733–94)
The Macaroni 1774
Watercolour on paper, 17.2 × 14.6
Victoria and Albert Museum
(cat. 37)

Attributed to Samuel Hieronymus Grimm
(1733–94)
Another Slice of Plumb Puding for Councellor Wollop
1774
Etching on paper, 25.3 × 24.9
Museum of London
(cat. 38)

Philip Dawe (1750–91)
Can you forbear laughing 1776
Mezzotint on paper, 35.4 × 25.3
The British Museum. J,5.106

Mary and / or Matthew Darley
(c. 1720–81 or later)
The Extravaganza – or, the Mountain Head Dress of 1776
Etching and engraving with publisher's watercolour paper, 35 × 24.6
Andrew Edmunds, London

Philip Dawe (1750–91)
A New Fashion'd Head Dress for Young Misses of Three Score and Ten 1777
Mezzotint on paper, 35.2 × 25
The British Museum. J,5.101
(cat. 36)

Attributed to William Doughty (1757–82)
Caricature Group c. 1780
Oil on canvas, 77.5 × 104.1
Tate. N05598

Plate illustrated with an image by 'Tim Bobbin'
c.1780
Creamware, Liverpool, 2.7 × 24.5 × 24.5
Brighton & Hove Museums

Plate showing 'Signor Gruntinelli playing on a new instrument call'd a Swinetta' c.1780
Earthenware, 2.5 × 22 × 22
Brighton & Hove Museums

After John Collier ('Tim Bobbin') (1708–86)
Stone Head c.1790s
Stone, 25.5 × 20.5 × 14
Touchstones Rochdale

James Gillray (1757–1815)
Following the Fashion 1794
Hand-coloured etching on paper, 32.7 × 35.9
The Warden and Scholars of New College, Oxford
(cat. 39)

James Gillray (1757–1815)
Metalic-Tractors 1801
Etching and engraving and aquatint with publisher's watercolour on paper, 24.6 × 31.4
Andrew Edmunds, London

Thomas Rowlandson (1756–1827)
A French Dentist shewing a specimen… 1811
Etching with publisher's watercolour on paper, 24.4 × 34.4
Andrew Edmunds, London
(cat. 41)

Thomas Rowlandson (1756–1827)
Distillers Looking into their Own Business 1811
Etching with publisher's watercolour on paper, 24.1 × 33.9
Andrew Edmunds, London
(cat. 42)

Thomas Rowlandson (1756–1827)
Dinners drest in their neatest manner 1811
Etching with publisher's watercolour on paper,
Andrew Edmunds, London

George Cruikshank (1853–1904)
Inconveniences of a Crowded Drawing Room 1818
Etching and engraving, with publisher's watercolour on paper, 25.1 × 35.4
Andrew Edmunds, London
(cat. 40)

George Cruikshank (1853–1904)
The New Union Club 1819
Etching and engraving, with publisher's watercolour on paper, 32 × 48
Andrew Edmunds, London
(cat. 43)

Edward Francis Burney (1760–1848)
Amateurs of Tye-Wig Music
('Musicians of the Old School) c.1820
Oil on canvas, 71 × 91.5
Tate. T07278

John Isaacs (b.1968)
If not now then when 2010
Wax, oil paint, steel, fabric, 210 × 120 × 150
Courtesy the artist and Museum 52

Politics

Anonymous
Get ye gone Raw Head and Bloody Bones –
here is a Child that don't fear you!! 1787
Etching and aquatint with publisher's watercolour on paper, 27.8 × 32.7
Andrew Edmunds, London

James Gillray (1757–1815)
There's more ways than one 1788
Etching with publisher's watercolour on paper, 24.5 × 24
Andrew Edmunds, London

Thomas Rowlandson (1756–1827)
Loose Principles 1789
Etching with publisher's watercolour on paper, 23.9 × 34.2
Andrew Edmunds, London

Pierantoni (called 'Sposino') after Rowlandson (1756–1827)
An Italian Marble Group of William Pitt the Younger as the Infant Hercules Strangling the Serpents Fox and North c.1790
Marble, 70.2 × 70.7 × 46
Spencer House Limited
(cat. 47)

James Gillray (1757–1815)
The Balance of Power 1791
Hand-coloured etching on paper, 44 × 28.5
The Warden and Scholars of New College, Oxford

James Gillray (1757–1815)
A Democrat or Reason & Philosophy 1793
Etching and engraving with publisher's watercolour on paper, 35.3 × 24.9
Andrew Edmunds, London
(cat. 45)

James Gillray (1757–1815)
The Slough of Despond; – Vide – The Patriot's Progress 1793
Etching and engraving with publisher's watercolour on paper, 24.7 × 34.4
Andrew Edmunds, London

James Gillray (1757–1815)
Which way shall I turn me, how shall I decide? 1793
Etching on paper, 22 × 33.3
The Warden and Scholars of New College, Oxford

James Gillray (1757–1815)
Hanging and Drowning, or Fatal Effects of the French Defeat 1797
Etching and engraving with publisher's watercolour on paper, 35.2 × 25.5
Andrew Edmunds, London

James Gillray (1757–1815)
The Giant Factotum Amusing himself 1797
Etching and engraving with publisher's watercolour on paper, 35.2 × 22.5
Andrew Edmunds, London
(cat. 46)

James Gillray (1757–1815)
The Nuptial Bower; – with the Evil One, peeping at the Charms of Eden 1797
Etching and engraving with publisher's watercolour on paper, 25.5 × 35.9
Andrew Edmunds, London

James Gillray (1757–1815)
The Tables Turn'd 1797
Etching and engraving with publisher's watercolour on paper, 25 × 35
Andrew Edmunds, London

Richard Newton (1777–98)
Buonaparte Establishing French Quarters in Italy 1797
Etching and engraving with publisher's watercolour on paper, 24.1 × 34.9
Andrew Edmunds, London

James Gillray (1756–1827)
Maniac Ravings or Little Boney in a Strong Fit 1805
Hand-coloured engraving on paper, 29.5 × 51
The Warden and Scholars of New College Oxford
(cat. 49)

James Gillray (1757–1815)
The Plumb-Pudding in Danger: or State Epicures Taking un Petit Souper 1805
Etching and engraving with publisher's watercolour on paper, 26.1 × 36.3
Andrew Edmunds, London
(cat. 48)

James Gillray (1756–1827)
Tiddy-doll, the great French-Gingerbread-Baker; drawing out a new Batch of Kings 1806
Etching and engraving with publisher's watercolour on paper, 25.6 × 38
Andrew Edmunds, London

Anonymous
Jaloux de leurs plaisir, epiant chaque geste Messieurs dit Lucifer après vous s'il en reste 1814
Hand-coloured etching on paper, 28.2 × 21.7
The British Museum. 1866,0407.934
(cat. 50)

George Cruikshank (1853–1904)
Boney receiving an account of the Battle of Vittoria – or, the little Emperor in a great passion 1813
Hand-coloured etching on paper, 23.4 × 33.3
The British Museum. 1868,0808.12727

George Cruikshank (1792–1878)
Broken Gingerbread 1814
Etching and engraving with publisher's watercolour on paper, 21.5 × 27.5
Andrew Edmunds, London

Napoleon chamber pot early 19th century
23.5 × 43 × 28.5
Brighton & Hove Museums
(cat. 51)

Carlo Pellegrini ('Ape') (1839–89)
Benjamin Disraeli, Earl of Beaconsfield
Published in Vanity Fair 30 January 1869
Watercolour on paper, 30.2 × 17.8
National Portrait Gallery
(cat. 53)

Carlo Pellegrini ('Ape') (1839–89)
William Ewart Gladstone
Published in Vanity Fair 6 February 1869
Watercolour on paper, 30.2 × 17.8
National Portrait Gallery
(cat. 54)

Harry Furniss (1854–1925)
William Ewart Gladstone (c. 1880s–1900s)
Pen and ink on paper, 28 × 23
National Portrait Gallery

Harry Furniss (1854–1925)
William Ewart Gladstone (c. 1880s–1900s)
Pen and ink on paper, 28 × 21.7
National Portrait Gallery

Harry Furniss (1854–1925)
William Ewart Gladstone (c. 1880s–1900s)
Pen and ink on paper, 17.9 × 11.4
National Portrait Gallery
(cat. 54)

Edward Linley Sambourne (1844–1910)
The Challenge, or the Rival Chanticleers 1888
Pen and ink on paper, 23.5 × 21
Victoria and Albert Museum

Max Beerbohm (1872–1956)
British Stock and Alien Inspiration 1849, 1917
Pencil and watercolour on paper, 29.8 × 41.9
Tate. A01039

David Low (1891–1963)
Dick Sheppard & Aldous Huxley 1938
Drawing on paper, 41.9 × 61
Tate. N05464
(cat. 56)

David Low (1891–1963)
Nightmare Waiting List 1938
Pen and ink on paper, 36.2 × 54.9
British Cartoon Archive, University of Kent, and New Zealand Cartoon Archive, Alexander Turnbull Library, National Library of New Zealand / Te Puna Mātauranga o Aotearoa

Joseph Flatter (1894–1988)
Illustrations to 'Mein Kampf' 1939
The beginnings of my political activities, Mein Campf, chapt. VIII
Ink on paper with letterpress, 43.8 × 29.8
Imperial War Museum
(cat. 55)

Joseph Flatter (1894–1988)
Illustrations to 'Mein Kampf' 1939
Poor Führer, he did not know of the concentration camp horrors
Ink on paper with letterpress, 30 × 44
Imperial War Museum

Joseph Flatter (1894–1988)
Illustrations to 'Mein Kampf' 1939
Der Führer's Future
Ink on paper with letterpress, 44 × 30
Imperial War Museum

Leslie Illingworth (1902–1979)
'What me? No, I never touch goldfish'
published in the Daily Mail, 17 November 1939
Pen and ink on paper, 30 × 25
Timothy S Benson
(cat. 57)

Kimon Marengo ('Kem') (1904–1988)
The Progress of Russian and German co-operation 1939
Poster, 77 × 50
Imperial War Museum

James Dyrenforth and Max Kester
Adolf in Blunderland – A political parody of Lewis Carroll's famous story, with illustrations by Norman Mainsbridge
Published by Frederick Muller, London, 1939/40
Private collection

Charlie Chaplin – The Great Dictator 1940
Press insert for trade magazine, 43.7 × 28
The Bill Douglas Centre for the History of Cinema and Popular Culture, University of Exeter

Attributed to Boris Yefimov (1900–2008)
Maneater 1941
Poster, 77 × 50
Imperial War Museum
(cat. 58)

Leslie Illingworth (1902–79)
Hold Him! I'll soon be ready to deal with him 1941
Indian ink and pencil on paper, 22 × 34
Llyfrgell Genedlaethol Cymru / The National Library of Wales, Aberystwyth

Kukrinisky
But – Russia Needs the Tools NOW! 1941
Poster, 50 × 77
Imperial War Museum

Robert and Peter Spence
Struwwelhitler – A Nazi Story Book by Doktor Schrecklichkeit
A parody on the original Struwwelpeter
Published by The Daily Sketch and Sunday Graphic, London, 1941?
Private collection

Leslie Illingworth (1902–79)
Of course, I never really meant to kill it 1942
Indian ink with pencil and gouache, 23.2 × 23.4
Llyfrgell Genedlaethol Cymru / The National Library of Wales, Aberystwyth

F.D. Klingender (1907–55)
Russia – Britain's Ally 1812–1942 1942
Published by George G. Harrap & Co. Ltd, London, 1942
Private collection
(cat. 59)

The Spirit of the Soviet Union – anti-Nazi Cartoons and Posters
Foreword by Lord Beaverbrook
Illustrations: the work of Soviet artists
Published by The Pilot Press, London, 1942
Private collection

Worker and War-Front No. 3 – 'Soviet Cartoons – High Praise from Low' 1942
3 mins, 17 secs
Film transferred to DVD
Imperial War Museum

Worker and War-Front No. 11 – 'The Grenade', cartoon animation by Carl Giles 1944
5 mins, 40 secs
Film transferred to DVD
Imperial War Museum

Gerald Scarfe (b. 1936)
Belgrano Nightmare 1982
Pen and ink on paper, 84 × 59.5
The Corporate Officer of the House of Commons
(cat. 60)

Spitting Image
Series 2, episode 3,
first transmitted 20 January 1985
Various clips featuring Margaret Thatcher
Courtesy of Spitting Image and ITV Studios Global Entertainment

Spitting Image
Private Eye – Denis Thatcher
Poster, 77 × 50
Courtesy of Spitting Image

Spitting Image
Thatcha! Ten Years of the Dragon 1989
Photograph, 20 × 20
Courtesy of Spitting Image
(cat. 61)

Spitting Image
Margaret Thatcher – the first ten years – commemorative mug 1989
Ceramic mug, 20 × 18 × 17
Courtesy of Spitting Image

Spitting Image
Margaret Thatcher – the first ten years – advertisement for the commemorative mug 1989
Printers ink on paper, 20.5 × 58.5
Courtesy of Spitting Image

Spitting Image
Sketch of Margaret Thatcher c. 1989
Pencil on paper, 36 × 22
Courtesy of Spitting Image

Spitting Image
Sketch of Margaret Thatcher c. 1989
Pencil on paper, 42 × 29
Courtesy of Spitting Image

Spitting Image
Margaret Thatcher 1989
Rubber and costume, life-size puppet
Courtesy of Spitting Image

Gerald Scarfe (b. 1936)
Torydactyl 1989
Pen and ink and watercolour on paper
84 × 59.5
Courtesy the artist

Steve Bell (b. 1951)
John Major – The Best Future for Britain 1992
Pen and ink and watercolour on paper, 26 × 18.5
Private collection
(cat. 62)

Steve Bell (b. 1951)
Hello, Cone Hotline? I have a problem… 1994
Pen and ink and watercolour on paper, 15.5 × 22.5
Mr P.J. Davies

Steve Bell (b. 1951)
Burning pants 1997
Pen and ink, watercolour and gouache on paper, 31.5 x 21.5
Courtesy of the artist

Ralph Steadman (b. 1936)
In the lap of the dogs 1997
Pen and ink on paper, 84 × 59.2
Courtesy of the artist

Ralph Steadman (b. 1936)
*Politician's legs no. I – Kicking against the pricks;
a major breakthrough* 1997
Pen and ink on paper, 59.2 × 84
Courtesy of the artist

Karmarama
Make Tea Not War 2004
Poster, 84 × 59.5
Courtesy of Karmarama
(cat. 66)

Alison Jackson (b. 1960)
Blair gives Bush a leg up 2005
Chromogenic print, 112 × 81.2
Courtesy of the artist and Hamiltons Gallery,
London
(cat. 64)

kennardphillipps
Photo Op 2005
Lightbox, 64 × 64 × 16
Courtesy of the artists
(cat. 65)

David Parkins
The Nightmare, after Fuseli 2006
Watercolour on paper, 23 × 30
The Warden and Scholars of New College,
Oxford

Martin Rowson (b. 1959)
Tony Blair as Dorian Gray 2007
Gouache over pen and ink on paper, 42 × 30
Michael Cockerell

Martin Rowson (b. 1959)
*At the end of the day, the pun is mightier than
the sword…* 2007
Gouache over pen and ink on paper, 27 × 19.5
Courtesy of the artist

Martin Rowson (b. 1959)
*Why they wanted to hold the Iraq inquiry in
private…* 2009
Gouache over pen and ink on paper, 19 × 23
Courtesy of the artist
(cat. 63)

The Worship of Bacchus

George Cruikshank (1792–1878)
The Worship of Bacchus 1860–2
Oil on canvas, 236 × 406
Tate. N00795
(cat. 67)

The Bawdy

Richard Newton (1777–98)
The Full Moon in Eclipse 1796
Etching and engraving with publisher's
watercolour on paper, 24.7 × 23.5
Andrew Edmunds, London

Richard Newton (1777–98)
What a Nice Bit 1796
Etching and engraving with publisher's
watercolour on paper, cut down to 23.9 × 32.9
Andrew Edmunds, London
(cat. 68)

Thomas Rowlandson (1756–1827)
Cunnyseurs c. 1812–27
Hand-coloured etching on paper, 14.6 × 15
The British Museum. 1977,U.521
(cat. 69)

Thomas Rowlandson (1756–1827)
Sympathy II c. 1812–27
Hand-coloured etching and aquatint on paper,
20.9 × 17
The British Museum. 1977,U.519
(cat. 70)

Aubrey Beardsley (1872–98)
Lysistrata Defending the Acropolis 1896
Pen and ink on paper, 26 × 17.9
Victoria & Albert Museum. Purchased with
assistance from the Art Fund

Aubrey Beardsley (1872–98)
The Examination of the Herald 1896
Pen and ink on paper, 26.2 × 18.1
Victoria & Albert Museum. Purchased with
assistance from the Art Fund

Aubrey Beardsley (1872–98)
The Lacedaemonian Ambassadors 1896
Pen and ink on paper, 26 × 17.8
Victoria & Albert Museum. Purchased with
assistance from the Art Fund
(cat. 71)

Donald McGill (1875–1962)
Blimey! c. 1938–9, re-issued 1946–53
Original postcard attached to Director of Public
Prosecution's index card, 21.5 × 15.5
British Cartoon Archive, University of Kent

Donald McGill (1875–1962)
A Stick of Rock, Cock? 1951
Original postcard attached to Director of Public
Prosecution's index card, 21.5 × 15.5
British Cartoon Archive, University of Kent
(cat. 76)

Donald McGill (1875–1962)
I think they're wonderful! 1952
Original postcard attached to Director of Public
Prosecution's index card, 21.5 × 15.5
British Cartoon Archive, University of Kent

Donald McGill (1875–1962)
Four nice marrows you have there, Mrs. Ramsbottom!
1954
Original postcard attached to Director of Public
Prosecution's index card, 21.5 × 15.5
British Cartoon Archive, University of Kent

H. Lime
*Yaas honeychile, if youse a good girl ah'll let youse
have ma stick o' liquorice* early 1950s
Original postcard attached to Director of Public
Prosecution's index card, 15.5 × 21.5
British Cartoon Archive, University of Kent

Gerald Scarfe (b. 1936)
Aubrey Beardsley 1967
Pen and ink on paper, 74 × 54
Courtesy of the artist
(cat. 72)

Gerald Scarfe (b. 1936)
Hugh Heffner (the Play Boy) 1969
Lithograph on paper, 74 × 53.3
Tate. P06537

Gerald Scarfe (b. 1936)
Ian Fleming as James Bond 1970
Lithograph on paper, 73.7 × 54.6
Tate. P06544

Gerald Scarfe (b. 1936)
*Mrs Mary Righteous explains her position
to the Pope* 1971
Pen and ink on paper, 74 × 54
Courtesy of the artist

Margaret Harrison (b. 1940)
Banana Woman 1971
Graphite pencil and watercolour on paper,
51.8 × 63.7
Tate. T12828
(cat. 74)

Margaret Harrison (b. 1940)
Son of Rob Roy 1971
Graphite on paper, 31.8 × 25.9
Tate. T12825

Beryl Cook (1926–2008)
Anyone for a Whipping 1972
Oil on panel, 61 × 31
Private collection
(cat. 77)

Beryl Cook (1926–2008)
Next! 1975
Oil on panel, 62 × 46
Private collection

Beryl Cook (1926–2008)
Ladies' Night (Ivor Dickie) 1981
Oil on panel, 46 × 54
Tony and Gay Laryea
(cat. 78)

Sarah Lucas (b. 1962)
Sausage Film 1990
Video
Tate. T07313

Sarah Lucas (b. 1962)
Five lists 1991
Pencil on paper in brown envelope,
Set of 5, each sheet 23 × 18
Courtesy Sadie Coles HQ, London
(cat. 81)

Sarah Lucas (b. 1962)
Seven Up 1991
Photograph, 30.5 × 40.5
Tate. P78206

Sarah Lucas (b. 1962)
Sod You Gits 1991
Photograph, 30.5 × 40.6
Tate. P78205

Sarah Lucas (b. 1962)
Chicken Knickers 1997
Photograph, 42.6 × 42.6
Tate. P78210
(cat. 80)

Ralph Steadman (b. 1936)
*16 year old nymphet trapped in the body
of a 60 year old dope fiend* 1997
Pen and ink and collage on paper, 113 × 49
Courtesy of the artist

Sarah Lucas (b. 1962)
Wanker [Sarah] 1999
Fibreglass arm, wood, spring, 55 × 17 × 30
Private collection, London,
courtesy Sadie Coles HQ, London

Graham Dury for Viz
Cockney Wanker postcard 1999
Watercolour, pen and ink on paper, 24.5 × 37
Courtesy the artist and Viz

Simon Thorp for Viz
Sid the Sexist – cover for issue 96 1999
Watercolour, pen and ink on paper, 39 × 31
Courtesy the artist and Viz

Tim Noble & Sue Webster (b. 1966; b. 1967)
Serving Suggestion 2004
Replica baked beans and sausage, tin can,
electronic mechanism on MDF plinth,
122 × 30 × 30
Courtesy of the artists
(cat. 82)

Grayson Perry (b. 1960)
Untitled 2001
Pen on paper, 21 × 30
Collection Glenn Scott Wright, London,
courtesy Victoria Miro Gallery

Shezad Dawood (b. 1974)
Translation 2003
DVD, × mins 40 secs
Courtesy of the artist and Paradise Row
(cat. 83)

Grayson Perry (b. 1960)
Image for a pot about Hans Christian Andersen
2004
Pen and ink on paper, 21 × 29.5
Private collection
(cat. 73)

Grayson Perry (b. 1960)
Untitled 2004
Pen and pencil on paper, 21 × 30
Private collection, London,
courtesy Victoria Miro Gallery

Cary Kwok (b. 1975)
Cum to Barber (1970s) 2006
Ink on paper, 29.7 × 21
Courtesy of the artist and Herald St, London

Cary Kwok (b. 1975)
Here he Pops 2007
Ink on paper, 29.7 × 21
Courtesy of the artist and Herald St, London
(cat. 75)

Graham Dury for Viz
Sid the Sexist Roman Orgy, Issue 192, January 2010
Ink on board, 33 × 33
Courtesy of the artist and Viz magazine
(cat. 79)

Simon Thorp for Viz
Fat Slags Burlesque Dance 2010
Watercolour, pen and ink on card, 43 × 33
Courtesy of the artist and Viz magazine

The Absurd

After Romeyn de Hooghe (1645–1708)
*Arlequin sur l'Hypogryphe à la Croisade Lojoliste /
Armée van de Heylige Lingue voor der Jesuiten
Monarchy* 1689
Etching and engraving with letterpress,
52.6 × 38.8
The British Museum. 1868,0808.3379
(cat. 84)

Anon ('Mark')
*Brutes Humaniz'd in Alderman Turtle &
Singe his Wife* 1775
Etching on paper, 17.5 × 24
Museum of London

Coiled Pipe c.1780
3.7 × 34.2 × 14.7
Brighton & Hove Museums

Frog and newt inside creamware cup c.1780
11.6 × 8.3 × 8.3
Brighton & Hove Museums

Paul Sandby (c.1730–1809)
Coelum ipsum petimus Stultitia 1784
Etching and aquatint on paper, 25.2 × 25.3
Museum of London
(cat. 85)

Paul Sandby (c.1730–1809)
An English Balloon 1784
Etching and aquatint on paper, 26.5 × 37.2
Museum of London

Flask in the form of a Potato c.1800
Terracotta, 8 × 21 × 10
Brighton & Hove Museums
(cat. 86)

William Heath (1794/5–1840)
March of Intellect 1829
Hand-coloured etching, 30.5 × 42.2
Andrew Edmunds, London

John Tenniel (1820–1914)
Illustrations to *Through the Looking Glass and
What Alice Found There* 1872
*Alice in the Train; Alice in the Train; Alice in the Train;
The Red King Sleeping; Alice and the Fawn; The
Walrus and the Carpenter; The Walrus, the
Carpenter and the Oysters*
Pencil on paper, Each approx. 10 × 7
Victoria and Albert Museum
(cat. 88)

John Tenniel (1820–1914)
Illustrations to *Through the Looking Glass and What
Alice Found There* 1872
*The White King picked up; Alice and the Sleeping
Queens; Alice doing Subtraction; Alice and the Red
Queen Running; Alice and the Red Queen; Alice with
the Crown; The Red King, The Red Queen etc.*
Pencil on paper, Each approx. 10 × 7
Victoria and Albert Museum

William Heath Robinson (1872–1944)
One of those horrid after Christmas Dreams
Published in The Humorist, 4th December 1926
Pen and ink on board, 41.2 × 33
The Cartoon Museum
(cat. 89)

William Heath Robinson (1872–1944)
*The Blow-Bomb – An Engine for Blowing out the
fuses of Zeppelin Bombs*, 8 December 1915
Pen and ink on paper, 45.2 × 37
The Cartoon Museum

William Heath Robinson (1872–1944)
*Skilfully camouflaged against dive bombers
our troops advance to repel invaders*
Published in The Sketch, 2 July 1941
Pen and ink on paper, 41 × 31.3
The Cartoon Museum

Ralph Steadman (b.1936)
Courtroom Scene from Alice in Wonderland 1967
Lithograph on paper, 57.1 x 79.7
Tate. P06580
(cat. 87)

David Shrigley (b.1968)
Leisure Centre 1992
Photograph, 25.4 × 25.9
Tate. P79243
(cat. 91)

Angus Fairhurst (1966–2008)
Performance Idea (A Cheap and Ill-Fitting Gorilla Suit)
1994
Cardbboard, felt-pen, fake fur, 29 × 21.5
Courtesy the Estate of Angus Fairhurst and
Sadie Coles HQ, London

Angus Fairhurst (1966–2008)
Untitled c.1994
Ink and pencil on paper, 29.7 × 21
Courtesy the Estate of Angus Fairhurst and
Sadie Coles HQ, London

Angus Fairhurst (1966–2008)
Untitled c.1994
Ink and pencil on paper, 20 × 29.5
Courtesy the Estate of Angus Fairhurst and
Sadie Coles HQ, London

Angus Fairhurst (1966–2008)
Untitled (Better Just Make That One More) c.1994
Pencil on paper, 21.6 × 30
Courtesy the Estate of Angus Fairhurst
and Sadie Coles HQ, London

Angus Fairhurst (1966–2008)
The Banana Skin in the Hall of Mirrors 1995
Pencil on paper, 30 × 21
Courtesy the Estate of Angus Fairhurst and
Sadie Coles HQ, London

Angus Fairhurst (1966–2008)
A Cheap and Ill-Fitting Gorilla Suit 1995
Video still, Betacam SP, c.4 mins
Courtesy the Estate of Angus Fairhurst and
Sadie Coles HQ, London
(cat. 100)

David Shrigley (b.1968)
Fallen Tree 1996
Photograph, 15.2 × 20.3
Tate. P79241

Angus Fairhurst (1966–2008)
The Problem with Banana Skins Divided / Inverted
1998
Acrylic rubber, Edition of ten, 7 × 36 × 36
Collection of Andrew and Stephanie Hale,
courtesy Sadie Coles HQ, London
(cat. 99)

Angus Fairhurst (1966–2008)
Trouble with Comedy 1999
Pen and paper on board, 20 × 21.6
Courtesy the Estate of Angus Fairhurst and
Sadie Coles HQ, London

Henry the VIII's Wives
Iconic Moments of the 20th Century: Vietcong 1999
C-print photograph, 102 × 140
Courtesy the artists and Galerie Iris Kadel
(cat. 98)

Henry the VIII's Wives
Iconic Moments of the 20th Century: Napalm 1999
C-print photograph, 102 × 145
Courtesy the artists and Galerie Iris Kadel

Henry the VIII's Wives
Iconic Moments of the 20th Century: Yalta 1999
C-print photograph, 102 × 135
Courtesy the artists and Galerie Iris Kadel

Henry the VIII's Wives
Iconic Moments of the 20th Century: Jack Ruby
1999
C-print photograph, 102 × 96
Courtesy the artists and Galerie Iris Kadel

Jake and Dinos Chapman (born 1966; born 1962)
Exquisite Corpse 2000
Etchings on paper
Three works from series of 20 prints;
each 23 × 18
Tate. P78460; P78468; P78470
(cat. 101)

Paul Noble (b. 1963)
huh huh 2002
Pencil on paper, 84 × 219
Michael and Fiona King, London
(cat. 102)

Angus Fairhurst (1966–2008)
Undone 2004
Bronze, 61 × 274 × 137
Courtesy the Estate of Angus Fairhurst and Sadie
Coles HQ, London

Doug Fishbone (b. 1969)
Stand-Up Guy 2004
Silent video, 5 mins 50 secs
Courtesy the artist and Rokeby Gallery
(cat. 95)

David Shrigley (b. 1968)
Untitled 2004
Ink and poster pen on paper, 55.3 × 41.8
Tate. T12358

Oliver Michaels (b. 1972)
Tube Balloon Thing 2007
Split screen sculpture, SD DV, 11 mins
Courtesy the artist
(cat. 96)

David Shrigley (b. 1968)
I'm Dead 2007
Taxidermy kitten with wooden sign and
acrylic paint, 94.5 × 50 × 50 (with plinth)
David Roberts Collection, London
(cat. 90)

David Shrigley (b. 1968)
Stop It 2007
Acrylic on metal, 142.3 × 90 × 95
Tate. T12819

Edwina Ashton (b. 1965)
Warm Hand of History 2007
DVD, 2.30min
Courtesy the artist and WORKS / PROJECTS
(cat. 92)

Edwina Ashton (b. 1965)
Fly 2003
DVD, 1.30 min
Courtesy the artist and WORKS / PROJECTS

Edwina Ashton (b. 1965)
Caravan (Precious Things)
DVD, 5 min
Courtesy the artist and WORKS / PROJECTS

Brian Griffiths (b. 1965)
The Body and Ground (or Your Lovely Smile) 2010
Canvas, scenic paint, ropes, webbing (various),
fibre glass poles, plastic poles, vintage travel
souvenir patches, net fabric, tarpaulin, duct tape,
thread, string, fixings, 350 × 580 × 450
Courtesy the artist and Vilma Gold
(cat. 93)

Shaun Doyle and Mally Malinson
Death to the Fascist Fruit Boys 2010
Installation with fibreglass and acrylic,
approx 150 × 300 × 300
Courtesy the artists
(cat. 94)

Barry Reigate (b. 1971)
Almost 2010
Jesmonite, gloss paint, acrylic, fibreglass matting,
spray paint, plywood, MDF, bolts, lampshade,
light fixture and bulb, wiring and plug, height 165
Courtesy the artist and Paradise Row
(cat. 97)

Sitting Room

Bank
The Bank 1996–7
Artist publication
Tate Library and Archive

Alan Kane (b. 1961)
Non Sequitur 2010
Table, chair and books
Courtesy the artist and Ancient & Modern

Further Reading

Art, comedy and culture – theory, criticism and analysis

Bakhtin, M. M., *Rabelais and his World*, translated by Helene Iswolsky, Bloomington IN 1984

Bergson, Henri, *Laughter: An Essay on the Meaning of the Comic*, translated by Cloudesley Brereton and Fred Rothwell (1911), Mineola, NY 2005

Bremmer, Jan and Herman Roodenburg eds, *A Cultural History of Humour: From Antiquity to the Present Day*, Oxford 1997

Freud, Sigmund, *The Joke and Its Relation to the Unconscious*, translated by Joyce Crick, London 2002

Gombrich, Ernst, and Ernst Kris, The Principles of Caricature, Cambridge 1935

Higgie, Jennifer, *The Artist's Joke*, London 2007

Hokenson, Jan Walsh, *The Idea of Comedy: History, Theory, Critique*, Cranbury NJ 2006

Klein, Sheri, *Art and Laughter*, London 2007

Kuspit, Donald, 'Tart Wit, Wise Humor,' *Artforum*, January 1991, pp. 93–101

Morreall, John, *Taking Laughter Seriously*, Albany NY 1983

Morreall, John, *Comic Relief: A Comprehensive Philosophy of Humor*, Oxford 2009

Olson, Kirby, *Comedy after Postmodernism: Rereading Comedy from Edward Lear to Charles Willeford*, Lubbock TX 2001

Williams, Robert I., 'Perceptual Play and Teaching the Aesthetics of Comedy: A Paradigm', *Journal of Aesthetic Education* 22: 2 (1988), pp. 15–33

Caricature, comicbooks and cartoons

The key source for satirical prints before 1832 remains Frederic George Stephens and Mary Dorothy George, *Catalogue of Political and Personal Satires in the Department of Prints and Drawings in the British Museum*, 11 vols, London 1870–1954. The online collection database of The British Museum, which incorporates additional information and comments, has proved an invaluable resource in the preparation of the present publication. (http://www.britishmuseum.org/research/search_the_collection_database.aspx)

Benson, Timothy S., *The Cartoon Century: Modern Britain through the eyes of its Cartoonists*, London 2009

Bills, Mark, *The Art of Satire: London in Caricature*, London 2006

Bryant, Mark, *World War II in Cartoons*, London 2005

Bryant, Mark and Simon Heneage, *Dictionary of British Cartoonists and Caricaturists 1730–1980*, Aldershot 1994

Cult Fiction: Art and Comics, exhibition catalogue, Hayward Gallery London 2007

Donald, Diana, *The Age of Caricature: Satirical Prints in the Reign of George III*, London and New Haven 1996

Feaver, William and Ann Gould, *Masters of Caricature: from Hogarth and Gillray to Scarfe and Levine*, London 1981

Gatrell, V.A.C., *City of Laughter: Sex and Satire in Eighteenth-Century London*, London 2006

George, M.D., *Hogarth to Cruikshank: Social Change in Graphic Satire*, London 1967

Gravett, Paul and Peter Stanbury, *Great British Comics: Celebrating a Century of Ripping Yarns and Wizard Wheezes*, London 2006

Hallett, Mark, *The Spectacle of Difference: Graphic Satire in the Age of Hogarth*, New Haven and London 1999

Klingender, F.D., *Hogarth and English Caricature*, New York 1944

Kunzle, David, *The History of the Comic Strip: The Nineteenth Century*, Oxford 1990

Low, David, *British Cartoonists, Caricaturists and Comic Artists*, London 1942

Pierce, Helen, *Unseemly Pictures: Graphic Satire and Politics in Early Modern England*, New Haven and London 2008

Rauser, Amelia, *Caricature Unmasked: Irony, Authenticity and Individualism in Eighteenth-Century English Prints*, Cranbury NJ 2008

Sabin, Roger, *Comics, Comix & Graphic Novels: A History of Comic Art*, London and New York 1996

Wynne Jones, Michael, *The Cartoon History of Britain*, London 1971

Notes

What's so Funny about British Art?
Martin Myrone

1. The potential scope of the subject is hinted at in Jerry Palmer's survey, 'Humor in Great Britain', in Avner Ziv, ed., *National Styles of Humor*, Westport CT 1988, pp. 85–111.

2. Steven Connor reflects on this particular point, noting that reasoned argument is assumed to be 'positively toxic to laughter' ('Writing, Thinking, Playing, Laughing', a paper developed from talks given at the Kingston Philosophy Café, 7 May 2009, and in the series 'Witty Art: Jokes and their Relation to the Arts', Institute for Theatre Studies, Freie Universität, Berlin, 14 May 2009: http://www.stevenconnor.com/wtpl/).

3. Jennifer Higgie, ed., *The Artist's Joke*, London 2007, p. 12.

4. The fact that such views are clichés does not, of course, mean that they are simply fantasies. See, for instance, Stewart Lee's thought-provoking piece on the perception of German humourlessness, 'Lost in Translation', *The Guardian*, 23 May 2006 (http://www.guardian.co.uk/world/2006/may/23/germany.features11).

5. On ideas of exceptionalism, see Stefan Collini, *Absent Minds: Intellectuals in Britain*, Oxford 2006.

6. See Jan Bremmer and Herman Roodenburg, eds, *A Cultural History of Humour: From Antiquity to the Present Day*, Oxford, 1997, pp. 1–2. See also Paul Langford, *Englishness Identified: Manners and Character 1650–1850*, Oxford 2000, pp. 289–90.

7. Anne Cornelis Veth, *Comic Art in England*, London 1930, p. 15.

8. See Jan Walsh Hokenson, *The Idea of Comedy: History, Theory, Critique*, Cranbury NJ 2006, pp. 15, 23–4.

9. Jonathan Coe, 'What British comedy says about us', from Times Online, 3 October 2009 (http://entertainment.timesonline.co.uk/tol/arts_and_entertainment/stage/comedy/article6857000.ece).

10. See, for example, Holger Hoock, *The Royal Academy of Arts and the Politics of British Culture 1760–1840*, Oxford 2003, p. 78, and for a later reference to humour as an element in British cultural history, Collini, *Absent Minds*, p. 80.

11. John Morreall, *Taking Laughter Seriously*, Albany NY 1983, p. 1.

Photo credits

Artists' copyright

12. Robert I. Williams, 'Perceptual Play and Teaching the Aesthetics of Comedy: A Paradigm', *Journal of Aesthetic Education* 22: 2 (1988), pp. 15–33 (p. 16).

13. See Sheri Klein, *Art and Laughter*, London 2007, p. 2.

14. E.B. White, 'Some Remarks on Humor' (adapted from the preface of *A Subtreasury of American Humor*, 1941) in Essays of *E.B. White*, New York 1977, p. 243.

15. James Elkins, *Pictures & Tears: A History of People Who have Cried in Front of Paintings*, New York & London 2001, p. 231.

16. 'The paradox of the human sciences is that they must constantly distrust the philosophy of action inherent in models such as game theory, which are apparently used to understand social universes resembling games. It is true that most human behaviours take place within playing fields; thus, they do not have as a principle a strategic intention such as that postulated by game theory. *In other words, social agents have "strategies" which only rarely have a true strategic intention as a principle*.' (Pierre Bourdieu, 'Is a Disinterested Act Possible?', *Practical Reason: On the Theory of Action*, Oxford 1998, p. 81 – emphasis added.)

Carry on Tate
Cedar Lewisohn

1. This is not really a Martin Heidegger quote!

2. See Monty Python's 'The Philosopher's Song'.

Frames of Reference: The Progress of Comics
Paul Gravett

1. Thierry Groensteen, Neuvième Art Blog, Angoulême, France, 2010 (http://neuviemeart.citebd.org/spip.php?page=blog_neufetdemi&id_article=2).

2. Thierry Smolderen, *Naissances de la Bande Dessinée: de William Hogarth à Winsor McCay* ('Births of the Comics: From William Hogarth to Winsor McCay'), Brussels, 2009.

3. Thierry Groensteen and Benoît Peeters, *Töpffer: L'invention de la bande dessinée* ('Töpffer: The Invention of Comics'), Paris, 1994.

4. Catherine Peters, *Thackeray's Universe: Shifting Worlds of Imagination and Reality*, London, 1987.

5. Smolderen, *Naissances*.

6. Roger Sabin, 'Ally Sloper on Stage', in *European Comic Art*, vol. 2, no. 2, Liverpool, Autumn 2009.

7. *The Royal Society of Literature Review 2006*, London, 2006.

Index

SUPPORTING TATE

Tate relies on a large number of supporters – individuals, foundations, companies and public sector sources – to enable it to deliver its programme of activities, both on and off its gallery sites. This support is essential in order for Tate to acquire works of art for the Collection, run education, outreach and exhibition programmes, care for the Collection in storage and enable art to be displayed, both digitally and physically, inside and outside Tate. Your donation will make a real difference and enable others to enjoy Tate and its Collection both now and in the future. There are a variety of ways in which you can help support Tate and also benefit as a UK or US taxpayer. Please contact us at:

Development Office
Tate
Millbank
London SW1P 4RG
Tel: 020 7887 4900
Fax: 020 7887 8098

American Patrons of Tate
520 West 27 Street Unit 404
New York, NY 10001
USA
Tel: 001 212 643 2818
Fax: 001 212 643 1001

Donations, of whatever size, are gratefully received, either to support particular areas of interest, or to contribute to general activity costs.

Gifts of Shares

We can accept gifts of quoted share and securities. All gifts of shares to Tate are exempt from capital gains tax, and higher rate taxpayers enjoy additional tax efficiencies. For further information please contact the Development Office.

Gift Aid

Through Gift Aid you can increase the value of your donation to Tate as we are able to reclaim the tax on your gift. Gift Aid applies to gifts of any size, whether regular or a one-off gift. Higher rate taxpayers are also able to claim additional personal tax relief. Contact us for further information and to make a Gift Aid Declaration.

Legacies

A legacy to Tate may take the form of a residual share of an estate, a specific cash sum or item of property such as a work of art. Legacies to Tate are free of inheritance tax, and help to secure a strong future for the Collection and galleries. For further information please contact the Development Office.

Offers in lieu of tax

Inheritance Tax can be satisfied by transferring to the Government a work of art of outstanding importance. In this case the amount of tax is reduced, and it can be made a condition of the offer that the work of art is allocated to Tate. Please contact us for details.

Tate Members

Tate Members enjoy unlimited free admission throughout the year to all exhibitions at Tate, as well as a number of other benefits such as exclusive use of our Members' Rooms and a free annual subscription to Tate Etc. Whilst enjoying the exclusive privileges of membership, you are also helping secure Tate's position at the very heart of British and modern art. Your support actively contributes to new purchases of important art, ensuring that the Tate's Collection continues to be relevant and comprehensive, as well as funding projects in London, Liverpool and St Ives that increase access and understanding for everyone.

Tate Patrons

Tate Patrons share a strong enthusiasm for art and are committed to giving significant financial support to Tate on an annual basis. The Patrons support the acquisition of works across Tate's broad collecting remit, as well as other areas of Tate activity such as conservation, education and research. The scheme provides a forum for Patrons to share their interest in art and to exchange knowledge and information in an enjoyable environment. United States taxpayers who wish to receive full tax exempt status from the IRS under Section 501 (c) (3) are able to support the Patrons through the American Patrons of Tate. For more information on the scheme please contact the Patrons office.

Corporate Membership

Corporate Membership at Tate Modern, Tate Britain and Tate Liverpool offers companies opportunities for corporate entertaining and the chance for a wide variety of employee benefits. These include special private views, special access to paying exhibitions, out-of-hours visits and tours, invitations to VIP events and talks at members' offices.

Corporate Investment

Tate has developed a range of imaginative partnerships with the corporate sector, ranging from international interpretation and exhibition programmes to local outreach and staff development programmes. We are particularly known for high-profile business to business marketing initiatives and employee benefit packages. Please contact the Corporate Fundraising team for further details.

Charity Details

The Tate Gallery is an exempt charity; the Museums & Galleries Act 1992 added the Tate Gallery to the list of exempt charities defined in the 1960 Charities Act. Tate Members is a registered charity (number 313021). Tate Foundation is a registered charity (number 1085314).

American Patrons of Tate

American Patrons of Tate is an independent charity based in New York that supports the work of Tate in the United Kingdom. It receives full tax exempt status from the IRS under section 501(c)(3) allowing United States taxpayers to receive tax deductions on gifts towards annual membership programmes, exhibitions, scholarship and capital projects. For more information contact the American Patrons of Tate office.

Mr and Mrs Stephen Wilberding
Michael S Wilson
The Wolfson Foundation
and those donors who wish to remain anonymous

Donors to Transforming Tate Britain

The Gatsby Charitable Foundation
The Manton Foundation
Ronald and Rita McAulay
The Wolfson Foundation
and those donors who wish to remain anonymous

Tate Britain Benefactors and Major Donors

We would like to acknowledge and thank the
following benefactors who have supported Tate
Britain in the period prior to 31 January 2010.

The Annenberg Foundation
Klaus Anschel
The Art Fund
The Arts & Humanities Research Council
Charles Asprey
The Estate of Frith Banbury
The Estate of Peter and Caroline Barker-Mill
Beecroft Charitable Trust
Luis Benshimol
Big Lottery Fund
Billstone Foundation
The Charlotte Bonham-Carter Charitable Trust
Mr Pontus Bonnier
Louise Bourgeois
Ivor Braka Limited
British Council
Mr and Mrs Ben Brown
C H K Charities Limited
Charities Advisory Trust
The Clothworkers' Foundation
Ron Collins
Michael Craig Martin
Department for Business, Innovation and Skills
Department for Children, Schools and Families
Department for Culture, Media and Sports
DG Education and Culture
Christian Dinesen
Anthony d'Offay
Jytte Dresing
The Estate of Maurice Farquharson
Mrs Wendy Fisher
Marc Fitch Fund
Lady Lynn Forester de Rothschild

Mildred and Martin Friedman
Henrietta Garnett
The Getty Foundation
Carolyn and Leslie Goldbart
Ralph Goldenberg
Nicholas and Judith Goodison
Marian Goodman
The Goss-Michael Foundation
Arthur and Helen Grogan
Calouste Gulbenkian Foundation
The Haberdashers' Company
Viscount and Viscountess Hampden and Family
Haunch of Venison
Damien Hirst
David Hockney
Hollick Family Charitable Trust
Houghton Hall
Cristina Iglesias
Dakis and Lietta Joannou
Sir Henry and Lady Keswick
Simon Keswick
Jack Kirkland
Leon Kossoff
LCACE (London Centre for Arts and
 Cultural Exchange)
David Leathers
The Leverhulme Trust
Mark and Liza Loveday
John Lyon's Charity
The Paul Mellon Centre for Studies in British Art
Marisa Merz
Sir Geoffroy Millais
Victoria Miro and Glen Scott Wright
The Henry Moore Foundation
Mary Moore
NADFAS
National Heritage Memorial Fund
New Art Trust
P F Charitable Trust
The Stanley Picker Trust
The Pilgrim Trust
Ms Miuccia Prada and Mr Patrizio Bertelli
The Nyda & Oliver Prenn Foundation
The Radcliffe Trust
Rootstein Hopkins Foundation
Helen and Ken Rowe
The Estate of Simon Sainsbury
The Estate of August Sander
Julião Sarmento
Mrs Sherine Sawiris
Jeffrey Steele
Norah and Norman Stone

Ian and Mercedes Stoutzker
Tate Members
David Teiger
The Estate of Mr Nicholas Themans
Jannick Thiroux
The Vandervell Foundation
The Estate of Keith Vaughan
David and Emma Verey
Sperone Westwater Gallery
The Estate of Lyn Williams
Iwan and Manuela Wirth
and those donors who wish to remain anonymous

Platinum Patrons

Ghazwa Mayassi Abu-Suud
Mr Shane Akeroyd
Mr and Mrs Edward Atkin
Beecroft Charitable Trust
Rory and Elizabeth Brooks
Lord Browne of Madingley
Mr Dónall Curtin
Ms Sophie Diedrichs-Cox
Pieter and Olga Dreesmann
Mrs Wendy Fisher
Mr David Fitzsimons
Hugh Gibson
The Goss-Michael Foundation
The Hayden Family Foundation
Vicky Hughes (Chair)
Mrs Gabrielle Jungels-Winkler
Mr Phillip Keir
Maria and Peter Kellner
Mr and Mrs Eskandar Maleki
Panos and Sandra Marinopoulos
Nonna Materkova
Mr and Mrs Scott Mead
Mrs Megha Mittal
Mr Mario Palencia
Mr and Mrs Paul Phillips
Ramzy and Maya Rasamny
Simon and Virginia Robertson
Mr and Mrs Richard Rose
Sally and Anthony Salz
Mr and Mrs J Shafran
Mrs Andrée Shore
Mr and Mrs Malek Sukkar
Mr and Mrs Stanley S. Tollman
The Flow Foundation
Poju and Anita Zabludowicz
and those who wish to remain anonymous

Gold Patrons

Ryan Allen and Caleb Kramer
Ms Thoraya Bartawi
Elena Bowes
Pierre Brahm
Broeksmit Family Foundation
Beth and Michele Colocci
Alastair Cookson
Haro Cumbusyan
Ms Carolyn Dailey
Maria de Madariaga
Flora Fraser and Peter Soros
Mr and Mrs A Ramy Goldstein
Mrs Maryam Eisler
Mr Michael Hoppen
Mrs Petra Horvat
Anne-Marie and Geoffrey Isaac
Mrs Heather Kerzner
Mr Eugenio Lopez
Fiona Mactaggart
Mrs Bona Montagu
Mr Francis Outred
Simon and Midge Palley
Catherine and Franck Petitgas
Mathew Prichard
Mr David Roberts
Mr Charles Roxburgh
Mrs Rosario Saxe-Coburg
Carol Sellars
Mrs Celia Forner Venturi
Michael and Jane Wilson
Manuela and Iwan Wirth
Barbara Yerolemou
and those who wish to remain anonymous

Silver Patrons

Agnew's
Mr Abdullah Al Turki
Helen Alexander
HRH Princess Alia Al-Senussi
Harriet Anstruther
Toby and Kate Anstruther
Mr and Mrs Zeev Aram
Mr Giorgio Armani
Sigurdur Arngrimsson
Kiran Arora
Kirtland Ash
Edgar Astaire
Daphne Warburg Astor
Ms Myrna Ayad

Mrs Jane Barker
Mr Edward Barlow
Victoria Barnsley
Jim Bartos
Mrs Nada Bayoud
Mr and Mrs Paul Bell
Mr Harold Berg
Ms Anne Berthoud
Madeleine Bessborough
Janice Blackburn
Mr and Mrs Anthony Blee
Mr Andrew Bourne
Mrs Lena Boyle
Mr Daniel Bradman
Ivor Braka
Viscountess Bridgeman
The Broere Charitable Foundation
Mr and Mrs Charles Brown
Ben and Louisa Brown
Michael Burrell
Mrs Marlene Burston
Timothy and Elizabeth Capon
Laurent and Michaela Caraffa
Matt Carey-Williams and
 Donnie Roark
Mr Francis Carnwath and
 Ms Caroline Wiseman
Lord and Lady Charles Cecil
Frank Cohen
Dr Judith Collins
Terrence Collis
Mr and Mrs Oliver Colman
Mrs Laura Comfort
Carole and Neville Conrad
Giles and Sonia Coode-Adams
Cynthia Corbett
Mark and Cathy Corbett
Thamara Corm
Tommaso Corvi-Mora
Mr and Mrs Bertrand Coste
Kathleen Crook and James Penturn
The Cowley Foundation
James Curtis
Loraine da Costa
Mrs Isobel Dalziel
Sir Howard Davies
Ms Isabelle De La Bruyère
The de Laszlo Foundation
Mr Jan De Smedt
Anne Chantal Defay Sheridan
Marco di Cesaria
Simon C Dickinson Ltd

Mr Alan Djanogly
Mrs Noelle Doumar
Ms Michelle D'Souza
Joan Edlis
Lord and Lady Egremont
John Erle-Drax
Stuart and Margaret Evans
Gerard Faggionato
Dana Farouki
Mrs Heather Farrar
Mrs Margy Fenwick
Mr Bryan Ferry
Mrs Rosamund Fokschaner
Jane and Richard Found
Joscelyn Fox
Eric and Louise Franck
Elizabeth Freeman
Michael Freund
Stephen Friedman
Julia Fuller
Carol Galley
Gapper Charitable Trust
Mrs Daniela Gareh
Mrs Joanna Gemes
Mr David Gibbons
The Swan Trust
Mr David Gill and Mr Francis Sultana
Mr Mark Glatman
Mr and Mrs Paul Goswell
Penelope Govett
Gavin Graham
Mrs Sandra Graham
Martyn Gregory
Sir Ronald Grierson
Mrs Kate Grimond
Richard and Odile Grogan
Miss Julie Grossman
Mr Nick Hackworth
Alex Haidas
Mr Benji Hall
Louise Hallett
Mr and Mrs Ryan Prince
Dr Lamees Hamdan
Mrs Sue Hammerson, CBE
Jane Hay
Richard Hazlewood
Michael and Morven Heller
Mrs Alison Henry-Davies
Mr Nigel Mark Hobden
Mr Frank Hodgson
Robert Holden
James Holland-Hibbert

Lady Hollick
Mrs Susanna Hong Rodzynek
John Huntingford
Miss Eloise Isaac
Mr Haydn John
Mr Michael Johnson
Mr Chester Jones
Jay Jopling
Mrs Brenda Josephs
Tracey Josephs
Ms Melek Huma Kabakci
Andrew Kalman
Mr Efe Kapanci
Dr Martin Kenig
Mr David Ker
Mr and Mrs Simon Keswick
Richard & Helen Keys
Ali Khadra
David Killick
Mr and Mrs Paolo Kind
Mr and Mrs James Kirkman
Brian and Lesley Knox
Helena Christina Knudsen
Ms Marijana Kolak
Mrs Caroline Koomen
Kowitz Trust
Mr Jimmy Lahoud
Steven Larcombe
Simon Lee
Zachary R Leonard
Mr Gerald Levin
Leonard Lewis
Anders and Ulla Ljungh
Mr Gilbert Lloyd
George Loudon
Mrs Siobhan Loughran Mareuse
Mark and Liza Loveday
Charlotte Lucas
Daniella Luxembourg Art
Eykyn Maclean LLC
The Mactaggart Third Fund
Mr M J Margulies
Mr and Mrs Jonathan Marks
Marsh Christian Trust
Mr Martin Mellish
Mrs R W P Mellish
Dr Rob Melville
Mr Michael Meynell
Mr Alfred Mignano
Victoria Miro
Jan Mol
Mr Fernando Moncho Lobo

Mrs Valerie Gladwin Montgomery
Mrs Roberta Moore Hobbis
Houston Morris
Erin Morris
Mrs William Morrison
Mr Stamatis Moskey
Mr David Nader
Mr and The Hon Mrs Guy Naggar
Richard Nagy
Mrs Gwen Neumann
Mrs Annette Nygren
Jacqueline O'Leary
Alberto and Andrea Olimon
Julian Opie
Pilar Ordovás
Mr O'Sullivan
Desmond Page
Maureen Paley
Dominic Palfreyman
Michael Palin
Cornelia Pallavicini
Mrs Kathrine Palmer
Phyllis Papadavid
Stephen and Clare Pardy
Ms Camilla Paul
Mr Mauro Perucchetti
Eve Pilkington
Ms Michina Ponzone-Pope
Lauren Prakke
Susan Prevezer QC
Mrs Barbara Prideaux
Valerie Rademacher
Miss Sunny Rahbar
Mrs Phyllis Rapp
Mr and Mrs James Reed
Mr and Mrs Philip Renaud
The Reuben Foundation
Sir Tim Rice
Lady Ritblat
Tim Ritchie
Mr Bruce Ritchie and Mrs Shadi Ritchie
The Sylvie Fleming Collection
Rupert & Alexandra Robson
Kimberley and Michael Robson-Ortiz
David Rocklin
Frankie Rossi
Mr James Roundell
Mr Lyon Roussel
Mr and Mrs Paul Ruddock
Mr Alex Sainsbury and Ms Elinor Jansz
Mrs Sherine Sawiris
Cherrill and Ian Scheer

Sylvia Scheuer
The Schneer Foundation
Andrew and Belinda Scott
Ms Joy Victoria Seppala-Florence
Mr Roopak Shah
Amir Shariat
Neville Shulman, CBE
Andreas B Siegfried
Andrew Silewicz
Ms Julia Simmonds
Tammy Smulders
Mrs Cindy Sofer
Louise Spence
Ms Brigitta Spinocchia
Digby Squires, Esq.
Mr and Mrs Nicholas Stanley
Miss Malgosia Stepnik
Charlotte Stevenson
Mrs Tanya Steyn
Mrs Patricia Swannell
Mr James Swartz
The Lady Juliet Tadgell
Sir Anthony and Lady Tennant
Christopher and Sally Tennant
Soren S K Tholstrup
Britt Tidelius
Emily Tsingou and Henry Bond
Melissa Ulfane
Mr and Mrs Petri Vainio
Mrs Dita Vankova
Mr Mehmet Erdinc Varlibas
Rachel Verghis
Mrs Cecilia Versteegh
Gisela von Sanden
Audrey Wallrock
Stephen and Linda Waterhouse
Offer Waterman
Terry Watkins
Mr and Mrs Mark Weiss
Jack Wendler
Miss Cheyenne Westphal
Mr Benedict Wilkinson
Mr Douglas Woolf
Mr Josh Wyatt
Mr Fabrizio Zappaterra
and those who wish to remain anonymous

North American Acquisitions Committee

Beth Rudin De Woody
Dr Kira Flanzraich
Glenn Fuhrman (Chair)

Young-Ju Park
Yana and Stephen Peel
Daniel and Elizabeth Peltz
Catherine and Franck Petitgas
Sydney Picasso
Mr and Mrs Jürgen Pierburg
Jean Pigozzi
Ms Miuccia Prada and Mr Patrizio Bertelli
Patrizia Sandretto Re Rebaudengo and
 Agostino Re Rebaudengo
Mr John Richardson
Lady Ritblat
Barrie and Emmanuel Roman
Ms Güler Sabancı
Dr and Mrs Mortimer Sackler
Mrs Lily Safra
Muriel and Freddy Salem
Dasha Shenkman
Uli and Rita Sigg
Norah and Norman Stone
John J Studzinski, CBE
David Teiger
Mr Robert Tomei
The Hon Robert H Tuttle and
 Mrs Maria Hummer-Tuttle
Mr and Mrs Guy Ullens
Paulo A W Vieira
Mr Robert and The Hon Mrs Waley-Cohen
Pierre de Weck
Angela Westwater and David Meitus
Diana Widmaier Picasso
Mrs Sylvie Winckler
The Hon Mrs Janet Wolfson de Botton, CBE
Anita and Poju Zabludowicz
Michael Zilkha
and those who wish to remain anonymous

Tate Britain Corporate Supporters

BP plc
BT
The British Land Company plc
Courvoisier
Finsbury
Goldman Sachs International
Guaranty Trust Bank
Le Méridien
Louis Vuitton
McKinsey & Company
Sotheby's
Tate & Lyle plc
and those who wish to remain anonymous

Tate Britain Corporate Members

Accenture
Clifford Chance
Deutsche Bank
Drivers Jonas
Freshfields Bruckhaus Deringer
Friends Provident plc
GAM
Hanjin Shipping Co
HSBC Holdings plc
John Lewis
Linklaters
Mace Group
Morgan Stanley
Nomura
Pearson plc
Sotheby's
Thames & Hudson
Tishman Speyer
UBS
and those who wish to remain anonymous